# PHOTOGRAPHY
## BUSINESS SECRETS

The Savvy Photographer's Guide
to Sales, Marketing, and More

Lara White

# WILEY

Photography Business Secrets

Published by
John Wiley & Sons, Inc.
10475 Crosspoint Boulevard
Indianapolis, IN 46256

Copyright © 2013 by John Wiley & Sons, Inc., Indianapolis, Indiana

Published simultaneously in Canada

ISBN: 978-1-118-48840-9

Manufactured in the United States of America

10 9 8 7 6 5 4 3

For general information on our other products and services or to obtain technical support, please contact our Customer Care Department within the U.S. at (877) 762-2974, outside the U.S. at (317) 572-3993 or fax (317) 572-4002.

*Wiley publishes in a variety of print and electronic formats and by print-on-demand. Some material included with standard print versions of this book may not be included in e-books or in print-on-demand. If this book refers to media such as a CD or DVD that is not included in the version you purchased, you may download this material at http://booksupport.wiley.com. For more information about Wiley products, visit www.wiley.com.*

**Library of Congress Control Number:** 2012956407

# About the Author

**Lara White** is a wedding photographer, educator, speaker, and author based in the San Francisco Bay Area, where she lives with her family. Prior to her career in photography, Lara spent many years in non-profit executive management, raising millions for literacy programs, victims of domestic violence, and other charitable projects for underserved populations.

She transferred many of the skills and practices that made her successful in the non-profit sector, helping her manage and grow a thriving wedding photography studio with a team of six.

Lara's effortlessly evocative wedding photographs have been featured in dozens of top-flight magazines, media, and trade journals—*Professional Photographer, Rangefinder, Grace Ormond Wedding Style, The Photo Life, This Week in Photo, Digital Photography School, Business Insider,* and scores more. But it's her business savvy that got her there. And as passionate as she is about photography, she's even more passionate about helping photographers at every stage of the game make it in this demanding business.

Lara White is the founder of PhotoMint, an educational and business development resource for photographers. In just under a year, the PhotoMint community has grown to more than 9,000 readers. Please visit PhotoMint at photomint.com/photography-business-secrets to get your bonus materials that accompany this book.

# Credits

Acquisitions Editor
Courtney Allen

Editorial Program Coordinator
Carol Kessel

Project Editor
Jennifer Bowles

Technical Editor
William Beem

Editorial Director
Robyn Siesky

Business Manager
Amy Knies

Senior Marketing Manager
Sandy Smith

Vice President and Executive Group Publisher
Richard Swadley

Vice President and Executive Publisher
Barry Pruett

Editorial Consultant
Alan Hess

Book Designer
Erik Powers

# Acknowledgments

Writing this book has literally taken a village, and many people contributed and made it possible.

### The Team

I would like to thank Courtney Allen, without your guidance and support this book would not be possible. Alan Hess, words cannot express my gratitude for all your hard work, long nights, and many pep talks. Carol Kessel, you made miracles happen behind the scenes. Jennifer Bowles, you have no idea how much I appreciate your editing skills and patience with me. William Beem, your feedback, ideas, and questions added so much to this project. Erik Powers, you are truly a gifted designer, and I count myself lucky to have had you on my team. Barry Pruett, thank you for supporting this project and making it a reality. Of course, I know there are many others behind the scenes at Wiley, and I wish to thank each and every one of you.

### Mentors and Inspiration

Many people have inspired me throughout my career. I'd like to thank Julia Woods especially—you taught me so much about this industry. I'd also like to thank Bambi Cantrell, Ann Monteith, Jeff Kent, and Scott Kurkian for your support and guidance throughout the years. Additionally, I would like to thank Ed Dale, who doggedly encouraged me for years to get on my path to photography education. And Robert Somerville, I want you to know that you are achieving your life's work—this book is proof of that.

### Peers

The photography industry has been my home for many years. I would like to thank Kevin Chin, Suzy Clement, Michelle Walker, Becker, Dane Sanders, Brook and Alisha Todd, Jamie Swanson, and Frederick Van Johnson in particular for your friendship, advice, and support. You make the industry what it is. I am also deeply grateful to all those who allowed me to interview you for this book: Tamara Lackey, Emma Case, Jody Gray, Lauren Lim, Elizabeth Halford, Lindsay Adler, Christine Tremoulet, Jamie M. Swanson, and Jenika. Ladies, your honesty, generosity, and willingness to open your hearts and share your advice, successes, and challenges with my readers make you all superheroes in my book.

## Behind the Scenes

I would like to thank Kelvin Leung for your many beautiful images gracing these pages, Noel Mallari for all your support and talent, and Ashley Jankowski for sharing your design and branding genius with the world. To my PhotoMint readers, supporters, and fans, thank you for believing in me. You are my daily inspiration.

## Family

To my dad, who has always supported and encouraged me. To my mom, who thinks I'm a superstar no matter what I do. To Brittanie, who kept me fed through many days and nights when I was working on this book. To my husband Geoff, who has inspired me, encouraged me, challenged me, supported me, and loved me through everything in life. Through your patience and love, you've taught me to be a better person. Finally, to my grandmother Catherine, who taught me to read. May your Irish eyes be smiling down upon us all.

For my ever-loving husband.

*Avec toi, je suis libre.*

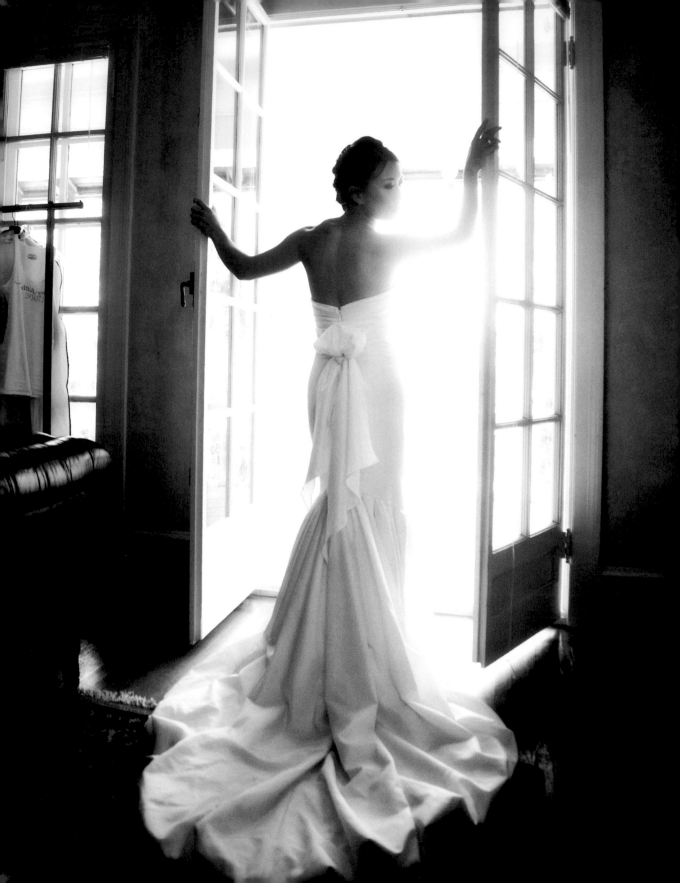

# Table of Contents

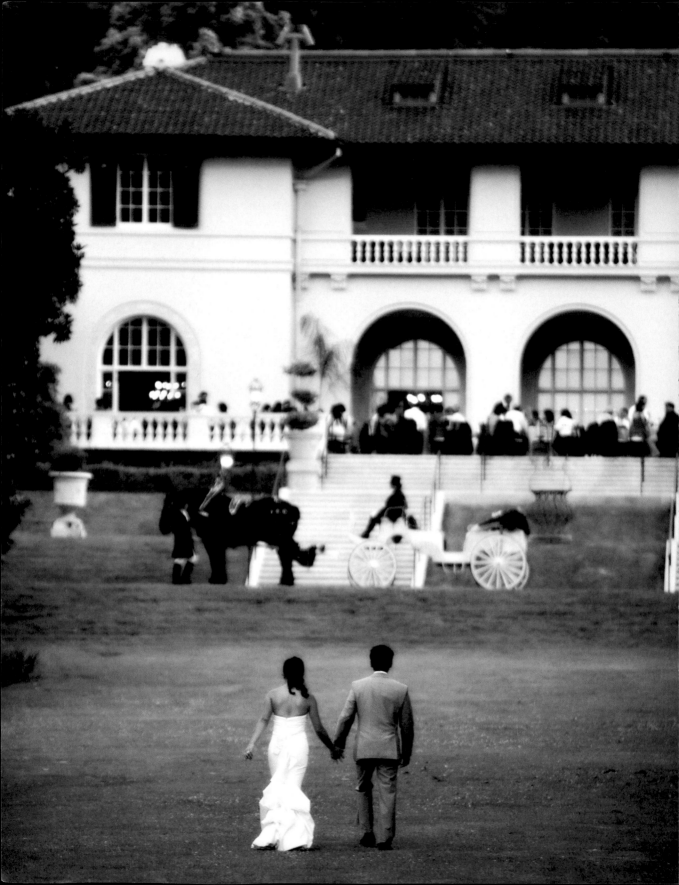

## Photography Business Secrets

# Introduction

This book is for you. If you are reading this, it means you are considering turning your passion for photography into a business. Getting paid to do what you love is something many people dream about and few experience. It's an exciting journey filled with unbelievable pinch-me moments and I wouldn't trade it for anything. However, there are also challenges, and this book will serve as a roadmap to get you where you want to go.

One of the most significant things to understand when it comes to owning a photography business is the importance of business, sales, and marketing skills. It's easy to overlook those areas and assume you can get by on your passion alone. That's not the case. Photographers who fail to realize the importance of a solid business foundation often find that they run out of steam after a few years of struggling to pay the bills. It doesn't have to be that way if you take the time to understand the fundamentals of running a business.

Whether you are just starting out, or you've been in business for a few years, you will find the knowledge, tools, and resources within this book invaluable in helping you build an amazing business you love. The book is split into four sections, and covers everything you need to know to get started.

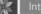 

## Section 1

*Moving from a Hobby to a Business* covers the things you need to know when considering such an important life decision. You'll find information on things like average salary ranges and lifestyle conditions that come with the job. People generally don't like to talk about money, but this is critical information when considering a major career move.

In this section I share the information I wish I knew before jumping into professional photography feet first. We also discuss how to get additional training and put together a portfolio. And of course, choosing what type of photography niche to serve is also covered.

## Section 2

*Business Fundamentals* covers the basics of starting a business, such as getting your business licenses, insurance, legal issues, writing a business plan, and putting together a budget. We also go over what you need to know about branding and how to set your pricing. Keeping your business running requires excellent customer service, and the ability to manage client expectations and day-to-day operations. To be profitable, you also need to figure out the best way to deliver images to your clients. We go over all of it.

## Section 3

*Sales and Growth* is one of my favorites. Your business needs sales in order to be successful, and I share with you the tips, tools, knowledge, and resources that will help you increase sales and grow your business. We look at developing products, sales tools, and in-person sales. We also look at 3- and 5-year photography business snapshots, so you get an idea of where your business might be in that timeframe.

## Section 4

*Marketing* outlines what brings business in the door, but it starts long before that. You have to understand your style and the type of client you are looking for first, and then figure out how to find them. Before choosing specific marketing strategies, it's important to understand what you want to accomplish through marketing, and how to track its effectiveness. Finally, we cover specific strategies you can use, from social media, word of mouth, traditional marketing, blogging, expos, getting published, and more.

What this book isn't going to tell you is what camera gear to buy or how to make better photos; there are a great many of those books already on the market. This book is a no-nonsense guide to running your photography business successfully. While my niche is the high-end weddings market, the material in this book is relevant to all fields of photography.

To offer you some different perspectives, I reached out to other photographers and asked them to openly share their knowledge. Each of them was willing to offer you a rare peek inside their businesses.

I wrote this book for *you*. It can be hard to find candid, honest, hype-free information about what it's *really* like to be a professional photographer, not just the glamorous highlights. As long as you know what to expect, you can make the right decisions for yourself and your business. Ready to get started? Let's do it.

With gratitude,

*Lara White*

For additional training, education, and to stay in touch:

- photomint.com (my website dedicated to business and marketing tools, techniques, and tips for photographers)

- Facebook.com/photominteducation

- Twitter.com/LaraWhite

## Bonus Materials

For bonus downloads including an online resource guide, please go to photomint.com/photography-business-secrets where you will find additional materials and tools.

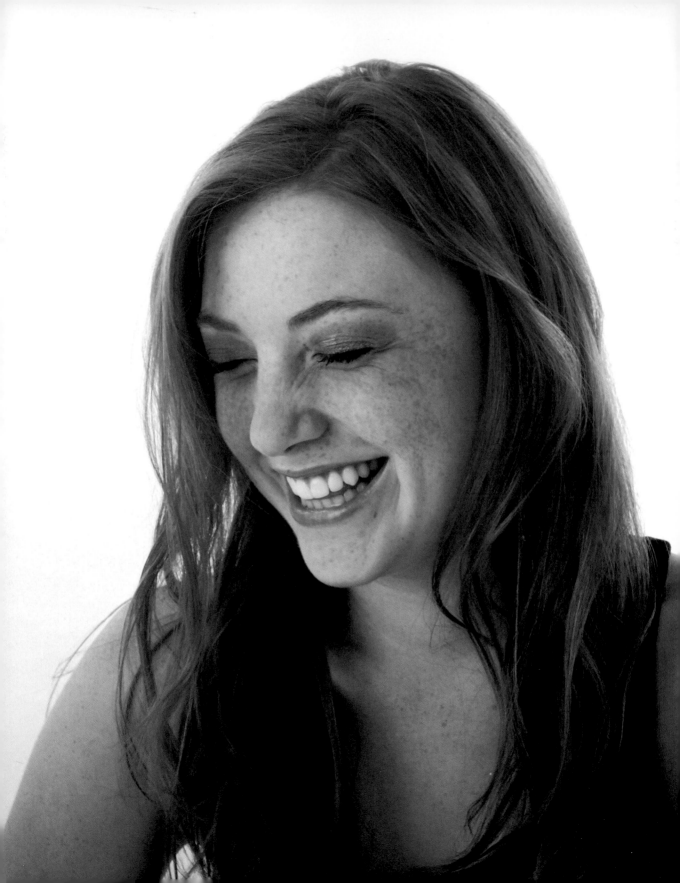

# Moving from a Hobby to a Business

# Photography as a Business

You love to take great photos and you'd like to make money doing it. You have heard that if you follow your passion, not only will you be happy, but also successful.

Having a passionate dream is great, but there is a big difference between being a great photographer and running a successful photography business. Jumping into the photography business can be pretty easy, but actually earning a living as a photographer is another story.

As photographers, we deal with specific numbers like f/stops and shutter speeds; as successful business owners, we must deal also with numbers like gross profits, overhead expenses, insurance payments, and tax withholdings. Then there is the issue of finding clients and successfully marketing your business.

Let's start at the beginning by looking at the different types of photography businesses out there and see what will work for you. Everyone is different—although you might jump for joy at the idea of spending every weekend photographing a different wedding, some would rather crawl around trying to get the perfect shot of a new puppy.

There is a lot to consider when turning your passion for photography into a business. You need to consider the changes to your lifestyle, who your clients are going to be, and what type of photography you plan to make a living on. By understanding the different paths in professional photography and where they may lead, you will be better equipped to make good business decisions.

## Business or Hobby?

Some photographers decide early on that they want to be professional photographers and go to school to earn a photography degree. Many others start with a photography hobby and at some point transition to a part-time or full-time business. So what is the difference between a hobby and a business? That is an important question, not only in legal terms but in the mindset and motivation of the photographer.

The main difference between a hobby and a business is whether you are doing the activity for profit. At some point a business has to make a profit or it ceases to exist. If your goal is to go out and take photos and make some money only by chance, that is not a business, that's a hobby.

In the United States, the Internal Revenue Service (IRS) actually determines the difference between a hobby and a business. They do it by using a wide list of criteria that include: looking at your past tax returns to see if you made a profit in at least three of the last five years, whether you depend on the income for your livelihood, and whether you carry on in a businesslike manor. This is more of a subjective look at how you conduct yourself, the records you keep, the time and money invested, and any other factors that could prove you are serious about the endeavor.

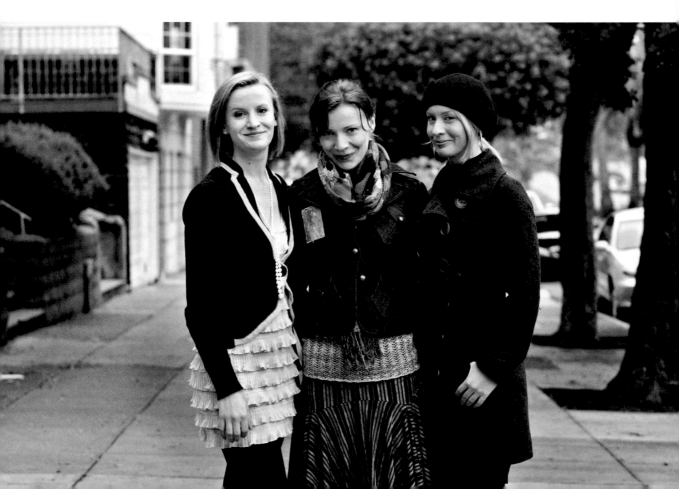

Whatever path you take to get to the point where you start a photography business, once you make that decision to be a business, you need to start acting as a business. Chapter 4 covers the business basics you'll need to know to get started, including how to apply for licenses, and your potential legal and accounting needs.

## Specialized vs. General Photography

What type of photographer are you and what type of photography business do you want to run? Are you going to be a jack-of-all-trades and cover a wide range of subjects or do you want to specialize in a specific niche? That doesn't mean that if you decide to be a wedding photographer you can never go out and shoot an event or offer corporate headshots, but your main focus makes a difference when you start to market yourself. There are pros and cons to specializing compared to being a general photographer.

Let's look at two photographers. Photographer A shoots only high-end weddings and events, while photographer B shoots weddings, portraits, maternity, and even products on occasion.

Photographer A is probably less busy shooting than photographer B, only photographing a handful of weddings a year, but A can charge more for each wedding and her website and branding will be aimed at a specific client. Photographer A will spend much more time with each client and more time building up vendor relationships. The downside is that the cash flow in the business might be sporadic and a downturn in the economy can seriously affect photographer A since she has relatively few clients. She likely has a busy season during which she works six or seven days a week plus several evenings, and a slow season when there is more flexibility and fewer hours required.

Photographer B is most likely much busier shooting different events and sessions all year. Chances are B shoots more jobs but charges less for each. Her branding and marketing needs to reach a much wider audience, and since it is more general the clients looking for a photographer who specializes might be turned off. It may also take longer to build up a steady clientele due to a wider focus or lack of a deadline-driven need for a photographer like with weddings. Photographer B also has more flexibility in setting her work hours and keeping weekend hours to a minimum. There is another big plus, and that is that she gets to photograph a variety of things, which means she never gets bored creatively. She can also generate different revenue streams, which can help with cash flow as well.

Which focus is the right one for you? Only you can answer that.

## The Path to Your Photography Business

There is no one single right path or way to create a photography business.

Some people map out a traditional path to becoming a photographer that includes a college degree in art or photography. They leave school and get a job working at a newspaper or as a freelance photographer. They gain experience and start taking jobs

on the side, and then go on to opening their own photography business. Other photographers pick up a camera as a hobby and discover a passion for making photographs that leads to a full-time business.

Then there are those who find themselves out of work and that photography hobby suddenly becomes a money-making opportunity. Or, you might be a mom who picked up a camera to record those special moments in your kids' lives and now see it as a career opportunity.

There are many different ways to end up in the same place. Now that we are all here, let's look at some of the photography careers available. Here is short list:

- *Photojournalist.* A photojournalist is a reporter who uses images instead of words. Photojournalists are different from other types of photographers in that their images are not manipulated before publishing. This is different from having a photojournalistic style, where your images look as if you took them when you were covering the event as a reporter, but you can edit the images for content and effect.

- *Event photographer.* These photographers cover everything from concerts to sporting events. They could be working for a wire service or newspaper, or they might be freelance. Many sports teams, companies, and venues have their own event photographers on staff.

- *Portrait photographer.* A portrait photographer takes photos of people, usually in a controlled environment. There are numerous specialty niches with portraits, such as maternity, boudoir, newborns, families, and high school seniors.

- *Wedding photographer.* A wedding photographer is probably the most recognized photography job.

- *Second shooter.* Sometimes the second shooter at a wedding or other event doesn't get paid, but it's a great way to gain experience and on-the-job training.

- *Wire service.* Photographers who work for the wire service cover everything from sports to movie premieres. They need to not only have access to the events, but also be able to work fast since the images have a short shelf life and competition is fierce.

- *Stock photographer.* Stock photographers create images that are used on stock image sites. The recent increase in the number of micro stock agencies means that the entry into this type of photography is low, but so is the pay. You would need to continuously come up with new images and the competition is fierce. The upside is that you can do a lot of this at your home and the schedule is up to you.

- *Pet photographer.* This photographer specializes in taking photos of animals. As pet ownership increases, the demand for pet photographers has been on the rise. You need a ton of patience and a love of animals to make this work for you.

# Full-Time Wedding Photographer

The perception of how a wedding photographer spends his time and how he actually spends it are quite different. Many people think that wedding photographers work on the weekends and make a lot of money for not much more than a day's work. Add in some time for the portraits and maybe an engagement session.

The reality is that a wedding photographer spends more time in the office and in front of the computer than anything else. The full-time wedding photographer spends a lot of time on the following tasks:

- Editing photographs and designing albums
- Meeting and following up with clients and vendors
- Bookkeeping
- Administrative tasks
- Marketing

- Meeting with potential clients
- Networking
- Attending trade shows
- Fulfilling print orders
- Managing client relationships through phone calls, emails, and meetings

The full-time wedding photographer usually starts as an assistant or second shooter for another established wedding photographer while she builds a portfolio and works out branding and marketing for her own business. It takes a lot of research and time to make a name for yourself as a wedding photographer, especially in the age when the common idea is that anyone with a camera can be a wedding photographer.

- *Fine art photographer.* These photographers make images for art's sake and usually don't have a client that pays for the work until after it is completed and up for sale. These photographers create the photos that hang on gallery walls.

## Full-Time vs. Part-Time

As I discuss later in this chapter, many times the downside of being a photographer is the work schedule. Portrait and wedding photographers might spend the regular Monday through Friday, 9-to-5 business hours working on marketing or editing images from the last session, but the main working hours for wedding and some portrait photographers are the weekend, when weddings take place and clients are available for portrait sessions. This can be a great thing because it allows you to continue to work a regular job while you transition part-time into photography.

■ *On-the-job training.* There's a dirty little secret in the industry: Many photographers start out without all the technical knowledge they should have. Even though they have a great eye for composition, some of those camera settings are still a little confusing. If you start out slow, you can focus on the jobs where you know you have the skills to get the images the client wants while also honing your technical skills.

■ *Narrowing your focus.* You know that you want to run a photography business but you are not 100% sure what you want to specialize in. Starting off part-time lets you try different things without the pressure of fully supporting yourself.

■ *Ensuring a good fit.* Not everyone is cut out to run his or her own photography business. It is better to find out if it isn't for you before committing full-time and investing a ton of money. Sometimes a love of creating images can turn into hate if the business side becomes too stressful.

■ *Relationship and contact development.* As you will see in the later chapters on sales and marketing, relationships with vendors, service providers, and others in the business are important and take time to develop. Starting slowly allows you to make these contacts without the pressure to turn them into money-generating sales right away.

■ *Learning the market.* The more time you can spend learning about the market you are entering, the more prepared you will be to create a strong business foundation.

There are a lot of great reasons to start out as a part-time photographer:

■ *Financial security.* Starting slowly is safer financially. Working a regular job while you start up your photography business allows you to still earn a living (and perhaps keep your health insurance) and not rely on the new business right away. You can also reinvest money from your jobs right back into the business. The time needed to earn a profit can be anywhere from 6 to 24 months, so having another source of income during this time is a good idea.

- *Developing your people skills.* Being a photographer requires a lot of people skills. You have to sell and network yourself with confidence, make people feel comfortable when you are photographing them, and meet with lots of potential clients while putting them at ease about working with you.

There are also advantages to jumping into the deep end and making a go as a full-time photographer:

- *Focus on growing your business.* Committing full-time allows you to focus all your energy on your photography business. More time to spend on your new business means more time to get it up and going. There are only 168 hours in a week and having 40 more of them available to your business can make a big difference.

- *Excitement and pressure.* Starting a new business is exciting. A little scary at the same time, but mainly exciting. This can keep you motivated and on top of the whole process.

- *A clean schedule.* Your schedule is wide open and when a prospective client wants to book you for a shoot, you won't have to check with your real job.

- *Love your boss.* That's right—you are your own boss. The only person you have to answer to is you. That also means that there are no more excuses.

## Part-Time Portrait/Family Photographer

The part-time portrait or family photographer has a smoother entry into the professional photography business. It is much easier to find subjects willing to let you build a portfolio when it comes to portraits than with weddings. Grab a family member or some friends and shoot away.

There are costs involved with being a portrait photographer, even if you only do it part-time. The biggest initial costs are the gear, insurance, some training, and basic marketing such as a website and business cards. Most photographers start out taking portraits using natural light and shooting on location—it's best to keep things simple at first.

Many times, family photographers start out by taking photos of their own families and then start to get friends and extended family asking for photos. It is key to remember that if this is you, when you transition from a hobby to a business you need to charge appropriately for your time. Once you have established a portfolio and are ready to begin charging for your time, you'll want to develop packages and add products. At that point, you begin incurring more costs, so you need to increase your prices to cover your costs and still have a salary that provides for your living expenses. By starting out slowly, you'll have more time as an artist to explore your style and develop your talent.

■ *Focus.* It's tough to focus on two different jobs at the same time, and usually one of them ends up suffering. If you go full-time at the start, you can focus on your business and your business alone.

■ *Few barriers.* There has never been a better time to go out on your own. The costs involved in photography are much lower than they used to be. In the past, it would cost a minimum of $10 per roll of film and then another $10 to develop those 36 exposures. Now you can use a single memory card over and over again for thousands of images with no extra costs.

■ *Faster learning curve.* There's nothing like jumping into the deep end; it's sink or swim. You'll learn faster and get your business off the ground quicker if you have no other option than to succeed.

There is one other compelling reason to go full-time—the economy. The economy is not in great shape and many people are finding themselves out of work and looking for alternate sources of income. If this is you, take a deep breath and know you are not alone. There is no better time to start your own business than during a recession. Recessions tend to be followed by periods of economic growth, so if you jump in now, you'll be positioned to take advantage of the next growth cycle.

## Lifestyle Issues

Taking the plunge and turning your passion for photography into a money-making business can be a daunting task. More than that, there are some lifestyle issues to consider. It is one thing to have a passion for photography, it is quite another to earn a living doing it. Understand what you are getting into so you can make informed decisions.

### Salary

I used to say that when I quit my cushy government job to work full-time in my photography business, it was for twice the hours and half the pay. Except I wasn't kidding! Look, let's be clear up front: Chances are you are not going to get rich as a photographer, despite what you may have heard about those rock star wedding photographers earning $10,000 or more per wedding. This is a not a field to get into if you are looking to earn a big salary. If that's a high priority to you, think long and hard, and I mean LONG and HARD, about getting into photography professionally.

Money is important. If you didn't want to earn a living as a photographer, you wouldn't be reading this book. Chances are most photographers earn less than you think. I'm not trying to scare you off; I want to ensure that you go into this field with your eyes open, and can plan accordingly.

One of the things that threw me when I got into the photography business was how hard photographers work in comparison to their salaries. I had heard wedding photographers claiming they earned $10,000 per wedding, and in doing some quick math in my head, I thought, "Wow … $10,000 x 52 weekends. Sounds great!" I was naive, and at the time I didn't think to ask how many weddings they shot per year at that rate, or what their take-home pay actually was. My husband and I pretty much immediately decided that we would become high-end wedding photographers, and we were certain of our own talent and willingness and ability to work hard and rise to the top.

I regret not having a more solid understanding of common photographers' salaries and not doing more research in the beginning on salaries and lifestyle conditions, which is why it is so important to me to offer you that opportunity.

Here is a sampling of real working photographers' salaries from PhotoMint readers. These numbers represent both ends of the spectrum—those barely getting by and a few at the top end of the earning capacity of this industry.

**Photography as a career choice needs to be about the passion of image creation, not about getting wealthy.**

- A talented fashion and wedding photographer from Manchester, England, grossed about $12,000 from part-time work. Her bookings for next year are double, so she hopes this means she is on her way to full-time.

- A full-time jack-of-all-trades photographer from Boise, Idaho, estimates he'll gross nearly $30,000 in his first year, with 267 shoots.

- An established portrait photographer in Houston, Texas, reports grossing $160,000 in total sales, and pocketing about $80,000 after expenses and taxes. She states that it took a lot of time and money invested into her business over the years to reach the point she is at now, seven years later.

- A wedding photographer in Northern California with a couple of years under her belt shares: "My business financials are a mess, I have no idea what I'm doing … I have to admit, I'm barely surviving."

- A Southern California photographer trying to make a go shooting for micro stock websites is still in the red after 18 months.

- A high-end destination wedding photographer who has been photographing weddings for more than five years grossed $150,000 and netted $60,000 last year and expects to do the same this year. His profits are higher than the average, mostly due to minimal overhead costs.

- A part-time event photographer based in Atlanta combines both studio work, which is making a profit, with live music and event photography, which is still operating at a loss. He hopes to increase the studio work to allow him to keep shooting the less profitable live events that he loves. As of now, the business is losing roughly $3,000 per year overall.

When considering what you can earn as a photographer, it's important to understand the difference between gross and net earnings. Gross earnings are the grand total that your business brings in *before* your expenses are paid. Net earnings are what are left over after all costs are deducted. Costs include rent, insurance, equipment, advertising, and all other bills.

Professional Photographers of America (PPA) recommends that photography businesses aim to keep 35% of their gross earnings as profit. That means that all those

## Inside the Numbers

From Professional Photographers of America's (PPA) 2011 Benchmark Survey: The best performing home studios took home $95,239 (owner's take-home pay), while the best performing retail studios took home $127,640 (owner's take-home pay). This should give you a sense of what is possible, salary-wise. For more details, you can access the PPA Benchmark Survey online if you are a member.

## Wondering What I Earn?

My photography business, Geoff White Photographers, is a well-established high-end wedding home studio in Northern California. We've been in business since 2004. Take-home pay for a recent year was $160,000 (after expenses). That was from work we did at 32 weddings that year, with the average booking at $9,000 prior to add-on sales.

In order to achieve that, we've worked for years to build up our referral base with the area's top wedding venues and planners. Being referred by some of the area's best wedding vendors is one of the secrets to our studio's earnings. We've also worked with PPA through their Studio Management Services to become one of the top-earning home studios in the nation.

## Cash Flow

One of the advantages about working for someone else is that you get a steady paycheck. When you work for yourself, that reliable payment is gone. Poof. Since you are now responsible for your own income, you have to take into account what happens while you are waiting for clients to pay, and what happens if they are late or if the time between jobs is longer than expected. There is also a seasonal aspect to many types of photography jobs—there are more weddings in the summer, while demand for family portraits jumps around the holiday season.

The simple truth is that, at times, clients pay late or you simply don't have enough jobs to cover your expenses. You need to take that into account, especially when starting up your business. You'll find more on cash flow in Chapter 4.

When my husband Geoff and I started out, Geoff had recently sold a tech company that he'd started and had a good nest egg in the bank to fund the next business venture, which turned out to be Geoff White Photography. At the time, I was working full-time and had full benefits. Because we had money in the bank to finance our new business and a steady income, we were able to grow the business quickly. But without that financial safety, there's no way we could have survived that year.

We officially launched our business at a bridal show in November, and from that we booked five weddings for the following year. Because we only got retainers from each of those five weddings and would not get full payment until the following summer,

brand-new photographers claiming they "earned six figures in their first year and they'll be happy to teach you their business secrets for only $1,200" probably kept only $35,000—if they were lucky. And there's nothing wrong with that, it's just not nearly as exciting and glamorous as they'd like you to believe.

When working out what a photographer earns, keep in mind your geographical location and cost of living. A photographer working in a more affluent area might earn more, but the costs of living and doing business there are likely higher.

that meant that from the time we started, in November, until about six months later, we had collected only $7,500. The rest of the payments came in the late spring and summer, but the point is, we would not have been able to survive financially on $7,500 (before taxes) for six months.

## Hours

There is something nice about a job that doesn't follow you home. That is, you go to work in the morning, put in your eight hours or so, and go home. Once you leave your job, you don't have to think about it until the next day.

When you run your own business, you can never stop thinking about it.

Trust me, I've tried.

Many people assume that one of the perks of running your own business is setting your own hours. (Cue visions of afternoons by the pool.) The reality is that you will work a lot more hours for yourself than you would working for someone else.

For example, as a successful wedding photographer you will probably work almost every weekend during the summer. Most wedding photographers also work at least several evenings each week attending networking events and meeting with potential clients. What that means in practical terms is that you won't have a summer weekend to yourself. You can kiss your weekend BBQs and Saturday night concerts goodbye. This can be even more stressful if you have kids with team sports or recitals on the weekends.

It can also take a toll on your social life because it's hard to stay connected when you miss most parties, baby showers, and get-togethers due to work. On the plus side, your wedding photographer friends will happily show up for a Monday afternoon BBQ!

Once your business is more established, it may be possible for you to have some flexibility with your working hours. I know several photographers who travel for a month or more during their slow seasons, and that can work if you plan for it and you are able to absorb a loss of profit from the jobs you won't book while you are away.

Geoff and I recently decided to go to Burning Man, a huge art festival that we had been wanting to go back to for many years. The problem was, it takes place on Labor Day weekend, which is one of our biggest booking weekends all year. We usually book two, and sometimes three, large weddings over that holiday weekend. Each year, we would say we were going to block that weekend off for ourselves, but when brides called with fantastic weddings (and big photography budgets) it was too hard to turn down. For the past two years we have gone, knowing we were losing out on $15,000 to $20,000 in bookings. For us, our business was well established, and we knew it was time to put our personal lives first for a change.

And it's not only wedding photographers who sacrifice social lives. Take event photographers who cover concerts, sporting events, or red carpet arrivals in Hollywood. They arrive hours before the events start, work frantically for the short time allotted for photography, and then race at breakneck speed to get the images sorted and edited so that they can go out on the wire services as fast as possible. There is a good chance that they are working every night of the week, which doesn't leave a lot of time for socializing except with the other photographers.

Landscape and travel photographers get up long before the sun rises and usually travel out to the perfect spot to capture the scene using that great morning light. That means going to sleep early enough to be awake at 4 am and then getting some sleep in the middle of the day (not always an easy task) and back to shooting in those golden hours around sunset. Many times,

## Check It Out

This is a great website to figure the correct height for your chair, keyboard, and monitor. All you have to do is enter your height.

ergotron.com/tabid/305/language/en-US/default.aspx

it takes several days of waiting to get the shot you need. Those are some brutal hours to work day in and day out.

### Working Conditions

At first glance it might not seem that being a photographer requires tough working conditions. We see photographers on the sidelines of sporting events, standing there with their big cameras and giant lenses. That doesn't look so hard! When we see photographers working in a studio it doesn't look tough. Just take a couple of photos of the models and hand the memory card off to an assistant.

Reality is a different story. The working conditions can have a negative impact on your health and physical wellbeing. Make no mistake, being a photographer is hard work and it can take a toll on your body.

### Health

As photographers, our bodies take a fair amount of on-the-job abuse. The crouching, the long periods of standing, the hauling gear back and forth, and the hours spent in an office all take their toll. Here are some tips that can make a huge difference during those long hours that you will spend in front of the computer:

- Use an ergonomic keyboard.

- Ditch your mouse and invest in a graphic tablet instead.

- Invest in a comfortable, adjustable chair.

- Position the top of your monitor at the same height as your eyes to avoid eye strain.

- Use good lighting in your workspace.

- Be sure to get up and stretch every 20 minutes or so—or take this a step further and opt for a standing desk.

To go along with the previous tips on improving your working conditions when at your desk, here are some tips that can help when you're shooting on location:

- *The right camera bag.* If shooting a large wedding all day, a bag with wheels for your main gear and a second bag of lighting gear and accessories is a great idea. For shooting weddings, I use a Think Tank Photo belt system, which allows me to keep my favorite lenses, memory cards, cell phone, and water bottle with me. If you are on location and have to hike a fair distance to the shooting location, maybe use a backpack with lumbar support. There is

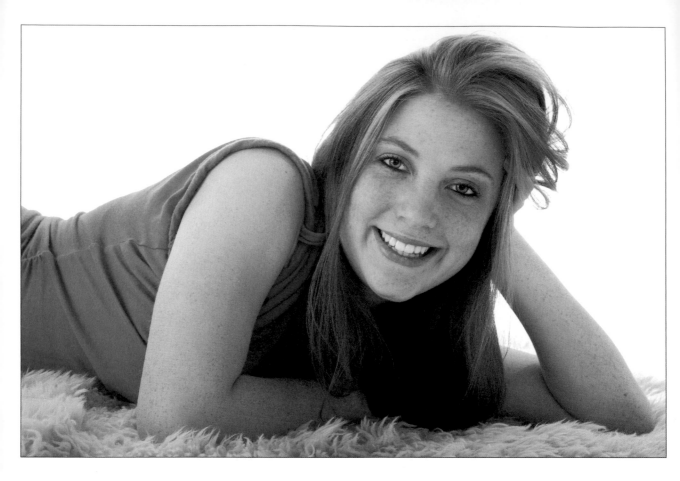

no one bag that will suit all your needs, but try to match the bag to the usage and avoid carrying too much.

- *Roller cart.* This great back-saving item doesn't have to be fancy, only sturdy enough to handle your gear. I use a Porter Case because it doubles as a handcart, so you can pile on 150 pounds of gear.

- *Water bottle.* Having a water bottle handy makes all the difference during a long day of shooting.

- *Help.* If you have an assistant, have him help you with all of the carrying and lifting.

- *Comfortable shoes.* Nothing is more helpful than a great pair of shoes when you are on your feet at a wedding all day. If nothing else, get some gel inserts for your favorite shoes.

- *Eat.* Protein bars are an easy item to keep on hand for extra energy during a long day shooting.

- *A hat.* Skin cancer is no joke and many photographers don't like to wear sunscreen on their faces since it can get on the gear. The alternative is to wear a hat.

# For on location shoots, I love using my Think Tank belt system to keep all my lenses and gear on me. The shoulder harness system helps distribute the weight evenly.

*Travel*

If you love to travel, then certain types of photography might suit you perfectly. You can develop a niche-based business based on travel, such as being a destination wedding photographer or a freelance photojournalist. A number of wedding photographers choose to specialize in destination weddings so they can travel to exotic locales.

I have travelled to Spain, Turks and Caicos, and St. Lucia for weddings, and I loved the opportunity to see and photograph other parts of the world while getting paid and having all my expenses covered. However, while there I was working pretty much the whole time. It's hard to spend the afternoon by the pool enjoying a beer when you've got an engagement session or a site walk-through at sunset. It's not all rainbows and unicorns—there is a lot of stress involved in working in other countries, such as:

- Travelling with your gear
- Dealing with transportation complications and delays
- Arranging work permits
- Coping with jet lag
- Keeping your image files safe while traveling

Plus, on the business side, the time away means office work doesn't get done on the travel days and you may lose some work since you are not there to book clients when they call.

Jobs such as hotel photographer rank high on the list of photographer dream jobs. Hotel photographers get hired by a chain and flown to each of the properties for several days to create images for marketing campaigns, brochures, and so forth. One of my secret fantasies is to be a Ritz Carlton photographer!

## On the Move

When you are shooting in a studio all day, you might not have to carry gear around or need a roller cart, but you should still wear comfortable shoes and make sure you eat and drink water during breaks. To get the best results and avoid straining your eyes, shoot tethered. That is, shoot with your camera connected to an external monitor or computer so that you can preview the images on a much bigger screen than the one on the camera.

To be able to get the tax benefits from all that driving, you need to keep records of all the miles covered and the costs involved. That can be a mountain of paperwork that many would rather put off until the end of the year. Pick up a small mileage book (found in most office supply stores) and keep it in the car to record your business mileage.

Now that you have had a chance to take a look at what's it's really like to earn a living as a photographer, you can decide if this is the right career path for you. What it comes down to is that you've got to love it, otherwise you'll burn out quickly. But if you know deep down that this is what you want to do, and you can accept the financial drawbacks and the sometimes intense hours, then read on. We needed to get that out of the way before diving in to the details of how to build your business.

It's not all about the money. What we do is deeply fulfilling on a personal level, and most corporate jobs with big salaries and full benefits can't top that at the end of the day. There are incredible moments I have captured that people will remember for the rest of their lives. It is a privilege to make a living as an artist. Are you ready? Let's get started! Now we will look at all the pieces you need to build your business from the ground up. It's going to be a wild ride, and I hope you enjoy every minute of it. ▪▪▪

### Driving

You can rack up some serious driving miles working as a photographer. Freelance photojournalists and event photographers might shoot multiple events in the same day, and that means getting from point A to point B (and sometimes point C)— usually by car. What this means is that you need a reliable car and you must calculate the costs up front. That includes the costs of gas, insurance, registration, and repairs.

# Fantasy vs. Reality

| | |
|---|---|
| It's wonderful to work at home surrounded by your family. | You can't get any work done while trying to watch your kids. You end up having to make up the work after they go to bed, creating even longer working hours. |
| You get to travel the world and someone else is paying for it. | There is a huge difference between going on vacation and flying for 8 hours, suffering from jet lag, and still having to get the job done and the images to the client on deadline. |
| Having a photography business means spending 80% of the time taking photographs and 20% of the time in front of the computer. | Running a photography business usually is 20% of the time taking photographs and 80% of the time in front of the computer. |
| Wedding photographers earn great money. | Some wedding photographers do earn great money, but it takes time to build up the business and make the connections needed to get the right clientele. |
| Covering events is a glamorous way to earn a living. | You are the hired help there to do a job, and often are treated as such. That isn't the same as going to the event as a guest at all. |
| You can set your own hours, working when you want to. | Most professional photographers work 6 to 7 days a week, often 12 or more hours at a time. |
| You can earn thousands from a single day's work. | For each day photographing, there are many hours working behind the scenes before and after the shoot. A wedding photographer might photograph an 8-hour wedding, but will spend 60+ hours working for that one client. A nature photographer may spend four days in the freezing cold to capture a single image. |
| Low overhead costs equate to high take-home pay. | Photographers tend to keep between 30-35% of what they gross—and that's considered successful. |

# Training and Experience

Anyone who has ever applied for a job has run across the experience catch-22. You need experience to get the job and you need the job to get experience. The same is true when starting your own photography business. For example, how do you get experience shooting weddings if no one will hire you to shoot their wedding because you have no experience? It is a little easier for portrait photographers since they can usually count on friends and family to act as willing models to help with practice. Ideally, the experience part comes before you go into business for yourself. This chapter provides some ideas to help you build a portfolio and get the experience you need to start your business.

## Gaining Experience

You need two types of experience to run a successful photography business. The first is photography experience, the second is business experience. Let's talk about photography experience first and we'll cover business experience in later chapters.

The first thing is to master the basics of exposure and your camera gear. That means getting out there and taking photos with your camera. Read the camera manual and, if necessary, get a third-party book explaining all the features. There is no excuse to not knowing how to use every button, dial, and menu on your camera. Nothing looks as unprofessional as a photographer who is fumbling around with his camera because he can't quickly decide on the proper settings for the scene.

One way to gain experience is to take on a personal photography project of something that you have wanted to photograph or explore. The key is to get out and take photos.

One great resource for personal projects is the Digital Photography School (digital-photography-school.com), which sends out a weekly email to subscribers that includes a personal project assignment, and readers are invited to submit their images. There are articles related to the assignment included in the email. This is a great way to try new things, grow as a photographer, and keep yourself creatively stimulated.

## On-the-Job Training

The traditional way to gain experience is to work for another photographer in the niche that you want to be in. Working for a photographer, or in a photography studio, in any capacity gives you valuable insight and experience. These jobs are few and far between, but there are opportunities out there.

Now working for another photographer is not always glamorous work—the hours are long, the pay minimal, and most of the time you'll find yourself carrying things and doing basic grunt work.

The upside is that you get on-the-job training in both photography and in how a photographer runs a business. In a studio setting, you may learn about lighting and gear. For on-location portraits, you might

### Need to Master Your Camera?

I highly recommend Photography Concentrate's "Extremely Essential Camera Skills" class. It's a multimedia 3-hour course that explains the camera basics you need to know without overwhelming you. It is particularly suited for nontechnical people. Visit photographyconcentrate.com/extremely-essential-camera-skills to find out how to sign up for it.

learn about how to interact with clients and how to help them relax in front of the camera. Even working at a Santa booth at the mall during the holidays can be beneficial. It will teach you how to work with kids, manage an on-site payment and printing system, and order products for an on-location shoot. As an aspiring portrait photographer, these are invaluable ways to master how to run mini sessions or organize a marathon portrait day.

Two web resources you can use to find jobs are:

- Craigslist.org

- The job board on the Digital Wedding Forum at digitalweddingforum.com/forum/forum.php

As a working photographer you will need to charge for your services, but when you are starting out and looking for experience you should consider the benefits to gaining the experience and building your portfolio more than the pay.

Another source of work could come from networking with other photographers in your area. Look for photo clubs or photography networking events. You never know when a photographer will need an assistant. Make sure you have business cards to give to everyone you meet.

Here are some options to consider for gaining photography experience. While these positions may not be the most creative opportunities, what you will learn is the critical people skills needed to help people relax in front of the camera, how to use camera and lighting

## Job Search

The best way to find jobs is through networking with other photographers. There are many networking groups for photographers, including local PPA chapters, SmugMug User Groups, and Pictage User Groups. Look on Meetups.com for upcoming networking opportunities in your area.

equipment, the sales process in different scenarios, networking, and building up your photography skills. Some of these are seasonal, so look out for them a month or so before the season begins.

- School yearbook portrait studio

- Portrait studio

- Santa booth at the mall

- Easter bunny booth at the mall

- Sports team portraits for kids

- Assistant/second shooter for wedding

- Wedding photo booth

- Hospital newborn photographer

- Local magazines and newspapers

- Real estate photographer

- Karate competitions

# 10 Tips for Being Second Shooter at a Wedding

A great way to earn money while building your business is to take second shooting gigs with wedding photographers. You'll need four or five weddings under your belt as a second shooter and a solid portfolio before you can expect to be paid for the task. On the upside, it's easier to find weddings you can tag along to without any particular expectations, other than to hone your skills. You can send an email to photographers in your area, inviting them to look at your portfolio and consider you for a second shooting position.

Second shooters are usually paid anywhere from $200 to $600 for the day, depending on experience and skill. You need to bring your own equipment in most cases (or rent it). Once you build a reputation as a dependable second shooter, you may be able to book gigs as a second shooter almost every weekend.

Here are 10 tips that will help you become the perfect second shooter:

1. *Act like a pro.* You'd think it goes without saying, but it's important to act like a professional at all times. This means planning ahead, familiarizing yourself with the job, arriving early, dressing professionally, and smiling.

2. *Never pass out your business card.* This is not your gig. If you try to get business from vendors or appear to be taking advantage of the opportunity, you may find yourself quickly blacklisted. Photographers talk, and they remember.

3. *Use a different approach than the primary photographer.* Be aware of the angles and lenses the main shooter uses. Instead of trying to copy her shots, go get something else. Find a different perspective; use a different lens. This way, your images offer value to the primary photographer instead of being just inferior duplicate shots. By expanding the coverage to scenes the primary photographer wasn't able to capture, or shooting the basic scenes from a completely different perspective, you offer great value while at the same time build your creative skills.

4. *Review the timeline.* One of the best ways to prepare yourself for a wedding in advance is to review the timeline. Learn the clients' names, how long the ceremony will last, when portraits will take place, and how you will get from location to location, if needed.

5. *Discuss the photographers' expectations.* Every photographer works differently, and so it's important to understand what his needs are before the big day. Some photographers need a lot of help carrying gear and watching equipment, while others operate autonomously and need as much additional shooting coverage as

you can provide. Does he want you to assist with formals or capture the cocktail hour and reception details? By understanding his needs in advance and going above and beyond to exceed his expectations, you are more likely to be called for the next job.

6. *Ask about pay and use of images beforehand.* If you expect to be paid for the day, be sure to discuss it with the photographer upfront—including if you'll be paid hourly or a day rate, and when you can expect payment. You also want to bring up the issue of using the images in your portfolio. Every professional has a different approach to this; go into the shoot with the understanding of her policy on use of the images captured on the day.

7. *Stay out of the way.* With two shooters, sometimes you'll find yourself blocking the primary's shot. Be cognizant of where the primary shooter is and make every effort to stay out of her way. If you can't get out of the way, do your best to duck down or minimize yourself until she's gotten the shot. The photographer will appreciate your effort, and it lets her know you are a team player.

8. *Provide a second perspective during the ceremony.* The ceremony is usually the key part of the day requiring a second shooter. Figure out the key positions and angles to use during the ceremony, as well as alternatives. Be aware of the coverage the primary photographer is capturing so that you can shoot from a completely different vantage point. Often the primary photographer shoots ceremonies from the middle aisle, getting the safe shots. As second shooter, you have more flexibility and can capture some amazing emotional moments from the sides, which typically offers more expression from the couple during the ceremony.

9. *Help with formals and group portraits.* Formal shots are typically one of the most stressful parts of the day for the clients as well as the photographer. Everyone wants to get them done quickly, and the lighting and location may not be ideal. Offer to assist by gathering people up; arranging them for the shots; and looking for hats, sunglasses, and purses that should be removed for the photo. If the photographer prefers, you might instead capture the cocktail hour or reception details, but always check with the photographer to see what his preference is.

10. *Explore your creativity.* Once you've gotten the shots your primary needs, take time to explore new compositions, angles, and settings. Some of my favorite images from second shooters are the ones that are the most creative. When you are a primary shooter, the pressure is on you to cover all the standard moments, whereas a second shooter has more time to play and be creative. Take advantage of the opportunity to develop your unique talent and vision.

## Building a Portfolio

Your portfolio is a sample of your best work. You will use it to show prospective clients what you can do for them. It is important to have one and to make sure it represents you and your work accurately, meaning that you are able to create similar images, using the same lighting and composition style.

You need a physical portfolio to take with you to client meetings and an electronic portfolio that clients can check out online. Here are some ideas to get you on the right track to creating a great portfolio:

■ *Shoot for free.* The fastest way to get opportunities to shoot is to do it for free. However, once you are ready to start a business you can no longer shoot for free. Learn how to use your camera and work with lighting, build your portfolio, and then you should be ready to charge for your time and act like a real business.

■ *Act as a second shooter.* If you want to be a wedding photographer, your best bet is to be a second (or third) shooter at a wedding. This means that you are the backup and might not be paid for your time (depending on your experience level), but the tradeoff is that you may be able to use the images for your portfolio. Note, though, that there are times when working as a second shooter is a work-for-hire situation where you are paid for

your time and you are not allowed to use the images in your portfolio. Make sure you work this out with the main photographer beforehand.

■ *Hire a model.* One of the best ways to create great wedding portfolio images is to hire a model or two. You might not have access to shoot a high-end wedding, but you can hire a couple of models and rent a dress and tuxedo and create the images for yourself.

■ *Use your friends and family.* They are a great source for everything from maternity, baby, family, engagement sessions, headshots, sports—just about everything you can think of. Be sure to let people know that you are simply practicing and building your portfolio, but soon you will be charging for your work.

Some things to keep in mind when putting your portfolio together:

■ *Only show your best.* This is the most important thing you can do for yourself. As photographers we are emotionally attached to every one of our images, but that does not serve us well in a business capacity. Be ruthless in culling your images down to only the very best. Each image needs to stand by itself without you needing to say anything about it. Remember, your portfolio will be judged by its weakest images.

## Only show your very best photographs in your portfolio.

- *Get a second opinion.* Once you have put together a portfolio, have someone you trust look it over—preferably someone who will give you constructive criticism and not just tell you everything looks great. One of the best ways to do this is by talking with other photographers. Check out your local photography associations—chances are they have members that are willing to look over your images.

- *Make sure that the images represent your business.* Focus your portfolio on images that feature your niche. Each image needs to show your style and be representative of what you can offer the client. You might have a fantastic image of a Hawaiian sunset but there is no place for it in portrait photographer's portfolio. If you want to be a pet photographer, your portfolio needs images of pets. You want to shoot sports? Then your portfolio needs to show sports images. I know this sounds obvious, but you would be surprised how many times I see a portfolio that shows little of what the photographer actually wants to shoot.

- *Limit the images.* When it comes to a portfolio, more is not better. A strong portfolio should have about 20 images in it at most. Anything more than that

and you start diluting the power of your own images. This also means that you need to make sure that each image is different from the others. A portfolio that uses the same models in each image, or the same game, or the same anything screams amateur. It is better to reduce the number of images and keep each unique.

■ *Update constantly.* You should update your portfolio constantly, especially as you are starting out. Every time you do a shoot, look at the best images from that shoot to see if you can add any to your portfolio to replace one or more of the weaker images.

## Workshops and Seminars

Workshops and seminars are a great way to boost your knowledge quickly in both technical skills and business acumen.

When considering which workshops to attend, be selective and choose ones that offer the most benefit—and research the instructor before deciding. Don't fall prey to wanting the easy answers and thinking that any single workshop or seminar is going to give you all the answers you need for overnight success.

There are some misguided photographers out there offering workshops after only a few years in business, promising to share their secrets of success with you. They seem to think that becoming a successful photographer is about grossing six figures in their first year (that's gross, not net!) and then promoting themselves via a cross-country workshop tour. Many of these photographers have not had enough time to fully develop their own business strategies yet, much less teach others how to do it. On top of that, as much as they are promoting themselves as being

### Workshop Images in Your Portfolio

Workshops are a great way to gain experience and learn new photography techniques. Some workshops allow the attendees to take their own photos of the instructor's setup. These are usually well-lit and nicely composed, with good-looking professional models.

The problem with using these images in your portfolio is that they are not a true representation of your skill. This becomes a problem when you are hired to create images you do not have the skill or equipment to create. For example, if you are at a lighting workshop, the images are likely being created using lights you don't have (yet) or know how to use properly (yet). A better alternative is to go back home and recreate the setup using your own model. This allows you to not only practice what you learned, but to ensure that your portfolio is an honest representation of your skills.

highly successful, it is likely that their take-home pay as photographers is closer to the $30,000 range instead of the six figures they are grossing. Not that there is anything wrong with that, but it's not quite living the rock star lifestyle they are leading you to believe.

Do your research and look for seasoned professional photographers who have been in the business long enough to know what works and what doesn't. Look to see what area the instructor excels at, and take workshops or training in that particular area of focus. Someone may be truly talented with lighting, but that doesn't mean they have mastered the art of marketing.

Some of the workshops and instructors for both photography and business that I recommend are:

- *Professional Photographers of America (PPA) Studio Management Services.* The PPA's Studio Management Services (ppa.com/studio-management-services) offer excellent workshops focusing on business basics and budgeting. They teach photographers to use the COGS (cost of goods sold) method, meaning you set your prices with an understanding of your costs to create and provide those products and services. They have access to photography studio financials from all over the country, and use this information to guide new photographers in setting appropriate pricing.

- *Jeffrey and Julia Woods.* These successful wedding and portrait photographers have been in business for over 16 years and they pass on their knowledge of subjects including time management,

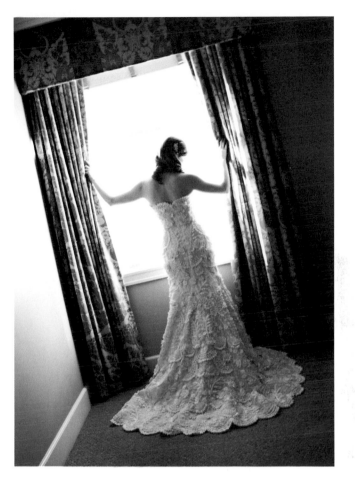

balancing your work and life, marketing, branding, and understanding all the numbers involved with running a successful business. Plus, they've done all this from a very small town. Check out theneedtochange.com.

- *Tim and Beverly Walden.* This long-time industry couple specializes in black-and-white relationship portraiture. They often give workshops focusing on either shooting techniques, or sales and marketing. Both workshops are excellent. Go to timandbevwalden.com for more information.

- *Bambi Cantrell.* Bambi has been teaching for years and was one of the first workshops Geoff took when we were starting out. Her knowledge on branding and attracting high-end clients is superb. Find her upcoming workshops at cantrellportrait.com.

- *Joe McNally lighting workshops.* *National Geographic* and *Life* magazines are just two of the many publications that Joe has worked for. He is considered a master when it comes to using both big lights and the small portable speedlights. He teaches a variety of seminars during the year, all of them focusing on light. Find out more at joemcnally.com.

## Online Training

The Internet has changed the world, including the way people learn. There are a huge number of online resources out there that can help you not only become a better photographer, but a better business person as well.

Here are some advantages of online photography training:

- *Tons of content.* There are lots of training videos and tutorials available on the Internet.

- *Different styles.* One real advantage to the number of different online resources is that they encompass a wide range of teaching styles. If you start watching one and the instructor or video style isn't to your liking, try another one.

- *Free and paid content.* There are many websites out there that have free content, and while it may not be as good as some of the paid websites, it can be a good place to start. Many of the bigger online training sites have free trial options that let you sample the content before buying it.

- *Watch on your time.* As we discussed in Chapter 1, many folks start their photography business while still working a regular job. Online training allows you to watch the classes on your schedule. This is a huge advantage over doing an in-person workshop when it is difficult to get away from your other job.

- *Re-watch.* Missed something or want to make sure you understand a technique? Just watch it again (and again) until you get it. Self-paced education is great for those trying to learn new things.

- *No travel costs.* One of the best things about online training is that you don't need to leave your house. There are no travel costs involved with getting to the class.

And, a few cons to online photography training:

- *Feedback is tough.* An online class is a one-way transmission of information, unlike actually participating in a workshop.

- *Not a substitute to real life.* Watching something on the computer (or iPad) screen does not give you any actual experience doing something. You need to put the knowledge to use on your own and practice the assignments.

Here is a list of some great free and paid options for online photography and business training resources:

- *creative LIVE:* creativelive.com

- *Kelby Training:* kelbytraining.com

- *New York Institute of Photography*: nyip.com

- *The Modern Tog:* themoderntog.com

- *Photography Concentrate:* photographyconcentrate.com

- *Psychology for Photographers:* psychologyforphotographers.com

- *Elizabeth Halford Photography:* elizabethhalford.com

- *Digital Photography School:* digital-photography-school.com

- *Digital Wedding Forum:* digitalweddingforum.com

- *FisheyeConnect:* fisheyeconnect.com

- *PhotoMint:* photomint.com (This is my site.)

The key to getting the best out of online training is to practice what you see. That means getting out there and taking the photos, practicing the postproduction tricks, and putting the business advice into action. It is not going to help if you just read about it. Grab your camera and get going! ▪ ▪ ▪

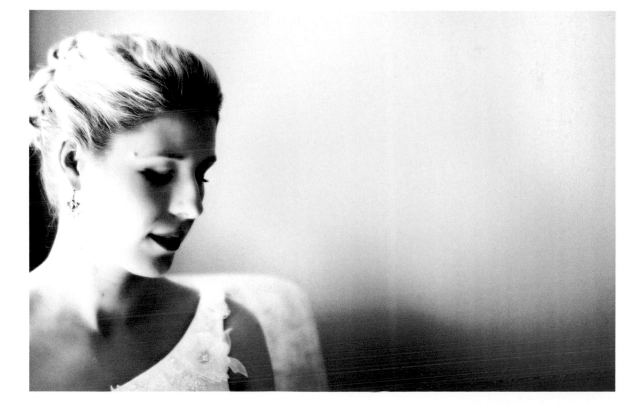

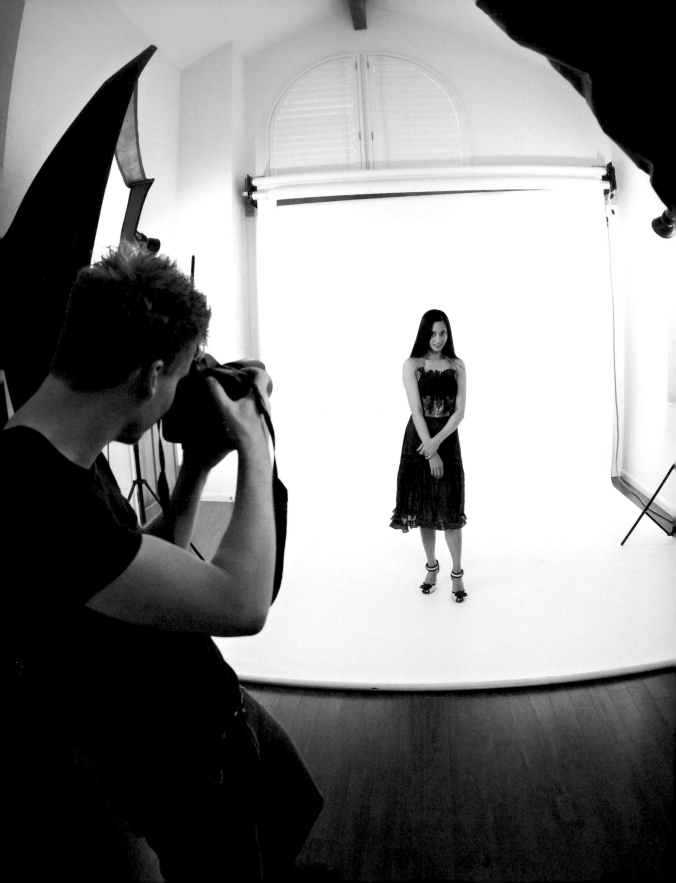

# Choosing Your Niche and Market

To run a successful business, you need to have paying clients. Obvious, I know. It does seem like many people who start up a business overlook this, though, and are genuinely surprised when they have no business, or not enough business, to make a living. It is not enough to be a good photographer; you need to know whom your clients are and what market you are selling to. There is a difference between the niche (photography specialty) and the market (clients). Before you jump in headfirst, I want you to understand these differences and how they can impact your life.

You must carefully consider all the factors when looking at both a niche and a market, as the decisions you make now will affect your business for years to come.

## The Difference Between a Niche and a Market

A niche and a market are two different things. The niche is the area of photographic specialty you are working in—perhaps weddings or newborns. The market is the clientele you serve. So for example, your niche may be weddings, but your market is high-end country club brides. Or elopements. Or alternative brides. Or your niche might be pet photography, and the market you serve is wealthy horse owners.

It's key that you understand the market you will be working in from the beginning, as your market will influence everything about your business—from the name, the logo, to how you present yourself. As a concert photographer, jeans and a black tee shirt might be perfectly acceptable to wear to work, but if you work in the wedding industry, you want to present yourself differently, and those details are guided by the market itself.

Each market requires a tailored approach to attracting and reaching that particular clientele. Marketing to country club brides is quite different from marketing to alternative brides. They have different tastes, styles, and values. Effective outreach requires an approach highly tailored to meet the needs of that particular clientele.

## The Different Types of Photography Business Niches

Some photography business niches are obvious, others are a little obscure. Many times the type of photographs you want to make dictates where you look for your clients. When you start to look for clients, you need to look at reasons why people want to spend money on photography.

Some examples of photography niches are:

- Architecture/interiors
- Editorial
- Events
- Fashion
- Fine art
- Food
- High school seniors
- Nature/landscape
- News/photojournalist/wire
- Pets
- Portraits
- Product/commercial
- Sports
- Stock
- Weddings

**Before jumping into a niche (weddings, portraits, commercial, etc.), carefully consider how the lifestyle and financial aspects will affect your personal life and goals.**

Here are some questions to ask yourself to help narrow down the niche and the market you want to serve:

- What do you enjoy photographing?

- What are the hours and working conditions of that niche and market?

- What is the salary range and how will that affect your lifestyle?

- What is the size of the market?

- What is the competition in the niche?

- Do the main competitors appear to be making a comfortable living?

- What products can you offer?

- How well do you like working with people? Families? Brides? Kids? Pets?

- How much travel will be involved?

- How much is the necessary gear going to cost?

- What are the opportunities available in that niche?

- Do you prefer working in a controlled setting like a studio or would you prefer to work outdoors?

- Do you prefer a fast-paced environment or do you like to take your time?

- Do you want to learn to work with lighting equipment, or would you prefer to work mostly with natural light?

I can't answer these questions for you, but if you carefully consider these questions and do some research into the niche, competition, market, financial viability, and other factors, you will be in a better position to make the right choices for yourself.

## Picking the Right Niche for You

A key business decision to understand is whether the niche you want to specialize in can be a profitable business. When my husband Geoff and I first starting thinking about photography as a business, Geoff wanted to be a landscape and nature photographer. After researching the market, however, we learned that it is difficult to make a living in that niche, especially with the high cost of living in the San Francisco Bay area. He chose to keep nature photography as a hobby; even though he was passionate about, it was not the right business decision for us.

When it comes to deciding in which direction to take your photography business, you need to consider pricing and clients. It's not going to work to come up with an idea you love but will not allow you to earn a living. In Chapter 4, we go deeper into business planning. For now, start making a list of prospective niches and markets you want to explore. Begin to consider which direction you want to take your business.

As an example, the following is the thought process I went through when considering expanding our existing wedding business to include a portrait studio. While I ultimately decided not to go in that

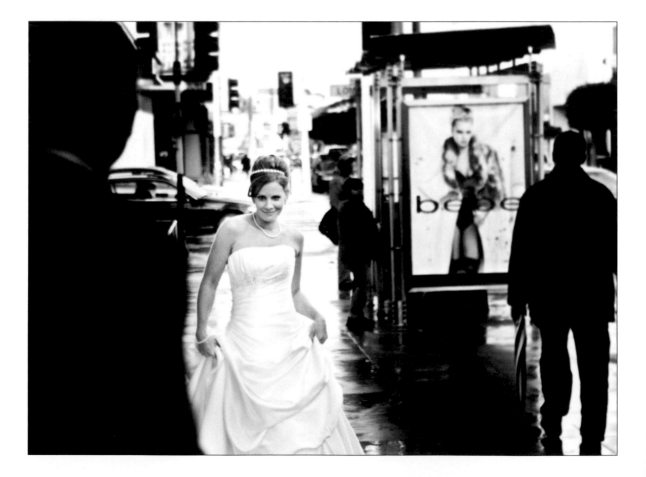

direction due to lifestyle choices, I am sharing this story to give you an idea of how to consider your options from different angles. The concepts are the same no matter which type of photography you plan to make a living on.

For a time I explored the idea of doing portraits as a new business venture. I thought we'd focus on high-end clients as we have always done with the wedding market. My goal was to design portrait sessions with a minimum sale of $1,500 (plus session fees) for custom-designed artwork. However, I found my former wedding clients balked at custom portraiture pricing and wanted almost everything for bargain prices. Even though they were willing to pay high-end pricing for their wedding photography, that didn't mean they were willing to invest in custom portraiture. Based on my needs, it didn't make sense to do all that work for a session fee and a couple of 5×7 orders.

I realized my wedding client base would not support a new portraiture business, so I would have to start from scratch marketing myself to the families in the surrounding affluent communities. Of course, this could be done, but I knew from experience it would take several years, along with a heavy marketing investment, to establish a reputation.

I looked at a different portrait model to compare the custom portraiture approach to a higher volume approach. I considered offering photographing sessions that included image files for around $800, knowing with this model there would be few product sales (when you give away the

files you are guaranteeing you will not earn hardly anything other than session fees). I calculated that I could realistically do 50 sessions per year plus weddings, which would gross $40,000.

When I compared these potential portrait numbers (and the amount of time required) to our wedding bookings, I quickly realized that the amount of time and money needed to invest in a new division of the business did not make financial sense for us, given the resources and time we were willing to invest. However, many photography businesses do very well by adding a new line to their businesses once their core niche is established. Whether or not it will work for you depends on many factors, including your location, your branding, your word-of-mouth marketing, your clients, your pricing, and your lifestyle goals.

I could put a few more hours of time into booking an extra 3 to 4 weddings and still gross the same amount as I would from booking 50 portrait sessions packages at $800 each.

Honestly, if I were to do it over I'd probably focus on portraits instead of weddings, because there are more opportunities for expansion and the hours are not as intense. With weddings, your client relationships often last for up to 2 years from booking to album delivery. That's a lot of time and customer service for one client. At first, I didn't mind all the weekends, but when you consider the many evenings that go into consultations, engagement sessions, and networking, it takes a toll on your personal life. However, these kinds of

decisions are extremely personal, and there is no right answer for everyone.

I also believe that shooting portraits is less stressful than weddings. Your clients are usually happy kids and babies rather than stressed out brides, overspent couples, and demanding wedding planners asking for more time and products for less money. Of course, there are days when I see how moved families are by the emotions I've captured for them, and it makes it all worth it. The point is, the niche you choose will have a tremendous impact on your lifestyle and personal happiness, so choose carefully.

It is important to consider the long-term, since building your clientele takes time. And that means setting your pricing and choosing a niche is not something you can change quickly once you've gotten settled into a market. After you have invested the time and energy into cultivating a certain type of client, it is not easy to change. Your established reputation, referral base, and word-of-mouth marketing may no longer apply.

Consider the salary you need to live on, the hours you can work, and what personal sacrifices you may need to make in order to work certain types of jobs. For instance, a wedding photographer works on the weekends and usually several evenings per week. However, they also have a slow season during which they can take extended time off if they want to.

People making a successful full-time living at portraits typically offer low sitting fees but no files. They rely on sales of albums, prints, wall art, folios, and other à la carte items.

## Shoot and Burn While You Learn?

If you are starting out slow while you explore different niches and business models, you may find yourself in a shoot and burn routine. To save yourself a lot of heartache, set your session fees to include not only your shooting time, but also the postproduction hours. Cull the images and minimize post processing to keep your costs and time down. The advantage to this is it allows you to get your feet wet while earning a bit of cash. However, this is not a business model, this is a hobby that you are exploring as a career. Once you decide it's how you want to make a living, you'll need to implement a full sales and marketing approach, and take your business venture seriously.

As a businessperson, you sometimes have to do things in way that ensures profitability, but it may not necessarily be what you like to do or how much *you* would pay for a service. We'd all love to create images only of what we love and give them away to anyone who would enjoy them, but that's NOT a business decision you can afford to make.

Instead of giving away all the files, create products for your images that will drive your sales and become the foundation of your profits. Some photographers use web galleries and image files as incentives toward purchasing bigger packages. Clients usually want the files to use online, and if you give them everything they want without charging for it, you end up with no after sales. If you have a low sitting fee and no after sales, you are on your way to financial ruin. If you start out including the files your clients will always expect it, which can cause problems if you later stop offering it. That's why it's critical to understand where your profits will come from and what activities will block your ability to earn a profit. For portrait photographers, that is usually including files and online gallery combined with a low sitting fee. For wedding photographers, it's not charging enough in their base fees.

If your images are the product, as in sports and commercial photography, you need to set up your business to allow you to earn your living from your shooting fees alone. That means you are not counting on after sales, and your income is going to be your daily shooting rate multiplied by the number of shoots you book per year. Therefore, your fees need to be higher than if your approach is a low shooting fee with a focus on after sales, where you will see most of your profits.

With portraits, it's all about repeat business, so don't set yourself up for failure down the road. Advice? Give these considerations a lot of thought in the beginning.

If you want to start with offering only sessions in the beginning and not get

involved in the production required for wall art, albums, and other products, then you need to set a price for the session and images that you will be happy with in the future. Think it through in terms of being a business (not just something fun) and what you want or need to earn in the long-term. If you price yourself too low in the beginning, a year or two into it you'll be fighting an uphill battle with your client base and referrals in order to increase your prices to an appropriate level.

## Networking with Photographers

Networking with other photographers is a great way to gain exposure to different niches and business models, and see how successful photographers work with their target market. You can find a mentor, get your portfolio critiqued, and even pick up some assisting or second shooting gigs. Here are a few places to start:

- Professional Photographers of America (PPA), local chapters

- SmugMug User Groups

- Pictage User Groups (PUGS)

- Society of Wedding and Portrait Photographers (SWPP) International

- Canadian Association of Professional Image Makers (CAPIC)

- Meetup photography groups

This industry is full of generous people willing to share their time and experience with up-and-comers. Many photographers, me included, think of competitors as colleagues. I recommend finding a mentor in your area who can give you some suggestions for growing your business. Working with a mentor is a great experience, because you get to learn from someone who's been there before you.

Once you have a niche picked out, it is not set in stone. You *can* change your niche and target market, but it could mean starting over with branding and marketing. It is much easier to add on related niches down the road.

For example, if you are a maternity photographer and want to expand your market, think about adding family packages in the mix as that is a natural fit with your clients' growing families. In this case, you would simply be expanding your services instead of adding an entirely new line. Sometimes the niches and clients are so closely related that additional branding and expensive marketing are not required. You could also expand your business by bringing on additional photographers in order to offer new specialties, take more sessions, or allow you to focus more on sales and marketing.

### High-Volume vs. Boutique Model

There is a fundamental decision to make when it comes to choosing your marketplace. You can either have a lot of clients paying affordable prices or fewer clients paying higher prices. Each model has its advantages and disadvantages. What works for one photographer may not work for you.

Many wedding photographers believe that the best market is the high-end wedding market, with the high-end bride as the perfect client. As a high-end photographer myself, I can assure you that is not necessarily true. There's lots of money and prestige, and it appears to be glamorous. There are definite benefits to having the

## Industry Secret

Don't assume that you'll make more money or have a more satisfying career as a high-end photographer. One of the secrets of the industry is that it's the high-volume studios with multiple photographers, operating a perfectly tuned sales and marketing system, that tend to make the most profits. Do not assume that artistic prestige and money go hand in hand in the photography industry.

high-end bride as a client but there are also drawbacks. This applies to all types of photography—the high-end portrait studio, the high-end pet photographer … you get the idea.

Here are some advantages of high-end photography:

- *Fewer shoots.* If you have a few higher paying clients, you don't need to book as many clients to make a living.

- *Potentially higher profits per shoot.* You need to keep your expenses in check to reap the higher profits from higher-end clients. It's easy to offer a high-end experience to potential clients, but that can eat into your profit quickly. Keep a close eye on expenses, like the cost of custom packaging or fancy business cards and brochures.

- *A glamorous life.* Who doesn't want to surround themselves with the high life and glamorous people? Shooting high-end events, weddings, and gallery openings, and being paid to travel to exotic locations is incredible. How about working with a client who has unlimited funds and says yes to every product idea you suggest?

- *Consistently beautiful images.* When everything's gorgeous, there isn't as much creativity required to make things look great. When you have a perfectly lit room, your clients have had their makeup and hair professionally done and are wearing designer clothes, and the floral arrangements are to die for—it's easier to create beautiful images than when you are working in a poorly lit banquet hall with tablecloths barely covering the tables and zilch for centerpieces.

- *Higher after sales.* When your clients are spending $7,000 on their wedding photography package, it's easy to generate another $2,000 or more in after sales with the right approach. When your clients are spending $2,000 on their initial package, however, it's less likely they will spend the same or more on after sale products.

- *Clients value your opinion.* As the highly paid artist, clients are paying for your expertise and opinion. It's easier on you when your clients implicitly trust you to provide the best of everything and don't worry about or fight you on the details.

Here are some negatives of the high-end model:

■ *Higher expectations.* High-end clients have high-end expectations. You need to consistently perform at a higher level. If the client is paying a premium, they expect premium service and a premium product.

This means you have to deliver on that promise no matter the circumstances. Have a heavier client or a poorly lit venue? No problem, you have the skills (and the glass) to make the images look amazing no matter the circumstances. Then there is the perception factor. You need to look the part of a high-end artist, which

## High-End Pricing to Start or Increase Your Prices Over Time?

If you want to take the high-end approach, the challenge is finding out how to break into that market. You can start with lower pricing and over time (years) keep raising your prices until you hit the sweet spot, but there are some disadvantages to that approach. You may find that you need to rebrand your business down the road in order to appeal to a higher-end clientele, and rebranding can be expensive (new logo, website, letterhead, business cards, and packaging).

The other disadvantage to raising your rates over time is that each time your prices go up significantly, your marketing investment loses most of its value. Marketing for high volume is different than boutique marketing, and you may need to start from scratch. Referral sources that you have worked hard to establish are difficult to maintain once your pricing becomes out of reach for the majority of that market. On the other hand, in order to charge high-end pricing early on in your business you must have exceptional talent, and a thorough understanding of things like exposure and lighting, as well as solid sales, marketing, and business skills.

When Geoff and I decided to go into weddings, we made the choice to establish ourselves in the high-end market immediately. Geoff was blessed with exceptional talent, and we both had strong business skills. We spent six months taking classes with the best photographers in the United States and learning everything we could. Then we found opportunities to second shoot several weddings for our portfolio. From those weddings, we created our first brochure, sample albums, and product offerings. We developed a luxury brand from the beginning, and we were only able to do so because we had savings to invest in the business. For our situation, this worked well, but it was a tremendous feat to pull off. It would not have been possible without one of us working a full-time job, serious business skills, photographic talent, many long hours, a bit of luck, and a significant financial investment.

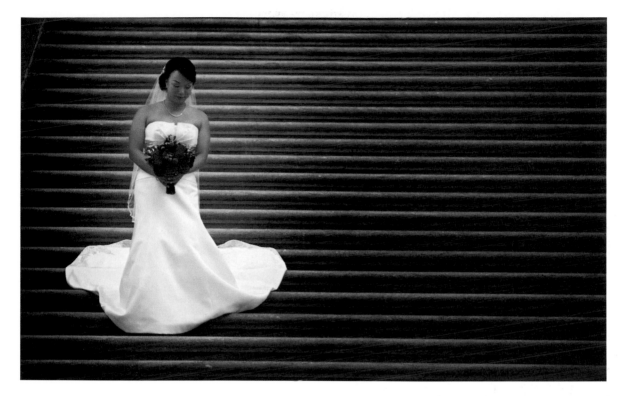

means using pro gear, dressing the part, and making sure you treat your clients up to their expectations. You can't expect to book weddings at a fancy country club and roll up in your needs-a-wash beater car.

- *Sporadic cash flow.* With fewer clients, you'll have fewer payments coming in throughout the year. That means cash flow can be sporadic. Consider this carefully, because the money for the day-to-day operations of the business needs to come from somewhere while waiting for those client payments to come in. How will you pay your bills during the slow season?

- *A smaller client pool.* There are fewer high-end clients who can afford you. If you live in a small town and are the only high-end photographer, chances are

the clients will find you. If you live in a large metropolitan center like New York City or Chicago, then chances are there will be plenty of clients—and plenty of competition.

- *More time invested in building a clientele base.* It takes a lot of time to build up a profitable clientele base. Because your services are more expensive, fewer clients can afford you. Reaching these clients is also more difficult. Traditional marketing like online ads, local advertising, trade shows (like bridal shows), and online advertising do little to nothing in terms of reaching these clients. Even the usually more effective client word of mouth doesn't always work, as not all the clients' friends and family can afford your services.

## Is the High-End Model Right for You?

In our wedding photography business, we have found that it doesn't matter how many times we ask the bride if she has looked at our packages and pricing. Half the time the bride doesn't think about costs, and sets up the meeting hoping that whoever's actually paying the bill will go along with her choice. That doesn't always happen. It can be frustrating to waste time meeting clients who were never going to book you to begin with. As a high-end photographer in the wedding niche, I am are reliant on vendor referrals, and these take time—often years—to build. If you need to be profitable right away or within the first couple of years, you'll want to seriously consider if this model is right for you.

You'll have many more inquiries and consultations that end without booking a client, as they will decide they cannot afford you.

■ *Requires excellent people skills.* With a high-end business model, clients often expect to spend a lot of time with the artist. In order to sell your services to a high-end clientele, your people skills need to be impeccable. If you are more reserved or shy (preferring to be behind the scenes), this will be a constant challenge to overcome.

■ *Much higher expenses.* One of the biggest downsides to working with higher-end clients is the higher costs involved. Going after this clientele means you need to present a high-end, quality experience from start to finish. The clients need to feel the value in the extras you provide in your presentation, products you offer, customer service, image quality, reputation, branding, and more. That's a lot of pressure. It can become expensive and time-consuming. I have seen album bags at over $50 apiece, and when combined with custom proof boxes, quality shopping bags, ribbons, tissue, custom boxes for prints, name brand water for your consultations, and all those other little touches, it adds up fast. It's easy to lose sight of how expensive all those extras are and before you know it, your profits have virtually disappeared.

There is no right answer to which path you should take. It depends on your circumstances. I am presenting some options and things to consider before you decide. Both models work equally well, but each requires a different approach in order to be successful.

## Generalist vs. Specialist

Some photographers take a more general approach instead of specializing in a particular niche. This is probably best described by Canon Explorer of Light Rick Sammon, who often says that he "specializes in not specializing"—and this works well for him.

Many photographers are attracted to this model when they start out. I understand—you want to get into the business and are willing to photograph anything. Maybe you prefer to shoot something different every day. This approach works great for many photographers but before deciding which approach is right for you, here are a few considerations:

■ *You need marketing plans for each area.* Are you a wedding photographer or do you want to cover little league games? The clients for each market are quite different, and reaching each requires a different approach. Real estate photography is a completely different niche and target market from high school seniors, and each one requires a separate marketing approach. That might mean different business cards, networking, printed materials, and portfolios.

■ *It can be tough to focus on one client at a time.* Being a generalist takes a lot of self-control, as it is easy to spread

<div style="background:#555;color:#fff;padding:1em;">

## The High-Volume Approach: Shoot More to Make More

If you decide to go for the shoot-more-to-make-more approach to your photography business, keep these things in mind.

■ The secret to a mass market approach is to think high volume—more sessions with low sitting fees and lots of product options. It puts the focus on shooting as much as possible, and cash flow is steadier throughout the year.

■ Name your business something other than your own name, so you can expand your services and hire additional photographers as your business grows. This allows the focus of the business to be on the photography, not the photographer.

■ Consider outsourcing some of the production tasks (like color correcting and editing) to free up your time for shooting more sessions and focus on the sales and marketing.

■ Keep the number of final images to a minimum. This reduces your time in postproduction and enables you to sell products more easily when the client is not overwhelmed by hundreds of images.

■ Word-of-mouth marketing works well for affordable photographers. Establish a great reputation in your community and the word will spread.

</div>

yourself thin trying to cover everything. Different types of photography require different workflows, different pricing, and different marketing; it's a lot to juggle.

■ *You need to offer lower pricing.* You typically cannot charge as much as a photographer who specializes. If clients are paying a premium, they expect the best at that type of photography.

On the flip side, there are some real advantages to not specializing, especially when you're starting out:

■ *You can find out what you like.* Not specializing in a niche right away means you can take some time and figure out not only what you enjoy shooting the most, but also what is most profitable for you.

■ *You won't get bored.* If you get bored doing the same thing repeatedly, this is a way to avoid that. Mixing up a variety of subjects can keep things fresh. One day you might be doing family portraits, the next day you might be covering a

sporting event, and you might even have a wedding lined up, either as the main shooter or as a second shooter.

- *You're learning all the time.* If you need to cover a wide variety of subjects, you have to keep up with many different techniques and lighting styles. This doesn't mean that wedding photographers or sports photographers don't need to keep learning, but it is more likely that they will have more of an established, recognizable style than the photographer who covers it all.

I hope that this gives you a lot to ponder. As you can see, there is much more than simply picking what you enjoy photographing and going for it. The niche you choose will have a tremendous impact on your life, so don't jump in without doing your homework first. The key to being successful is to understand your niche and your market, and serve it well. ▪ ▪ ▪

# SECTION 2

# Business Fundamentals

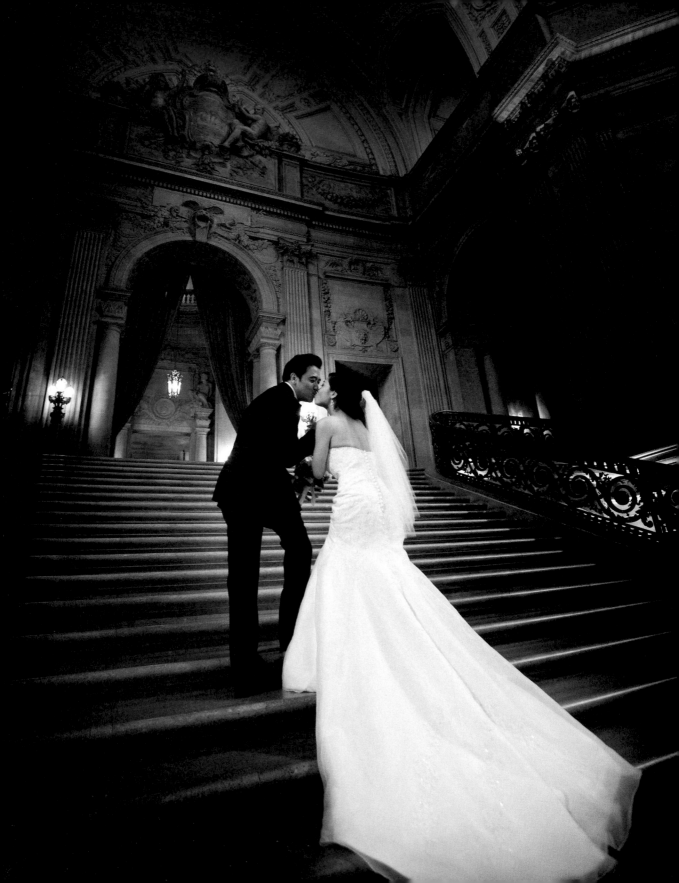

# Business Basics

Going into business for yourself can be scary, and there are a lot of aspects to take into account. This chapter will help you get organized and start on the right foot by mastering the business basics. Business skills don't come easily to some creative types, but they are key if you want to succeed. Talent alone is not enough to build a sustainable business—you must develop your business and marketing skills as well. This chapter covers the business basics. Later in the book, we'll get into sales and marketing—the heart of your business.

## On average, you'll spend 20% of your time on photography and 80% of your time on business.

The experience of being a photographer is different from being a photography business owner. Many photographers are shocked and frustrated to discover this—it's a common misconception that hobbyists make about what it's like to have a photography business. However, if you can embrace this reality, your chances of success will be greatly improved.

## Business Skills

There are some basic skills you need to embrace to succeed with your photography business. As a photographer, it's all about shooting. As a business owner, that changes significantly. The following list highlights the key skills you need.

- *Sales skills.* If you can't sell yourself or your services, you will have a problem getting your business off the ground. Earning a living will always be a struggle.

- *Ability to control your emotions.* Photographers are emotionally attached to their images—I know I am. This is what enables us to strive for better images, and it is also what can hold us back in developing a profitable business.

- *Financial management.* In basic terms, you need to distinguish between money coming in and money going out. More money coming in is your goal, in plainest terms. It's not enough to balance your checkbook. You need to keep track of outstanding invoices, cash flow, and overhead expenses.

- *People skills.* Being a great photographer is part of the equation, but to get clients to hire you, you need to have people skills. Chatting with people on the phone, networking, putting subjects at ease, and selling yourself all require good people skills.

- *Ability to work under pressure.* Clients usually want their images quickly. The pressure is on you to get the images back to your clients as soon as possible. Some types of photography jobs (like event photography or photojournalism) require images to be sent nearly immediately. (Not a job for those who like to take their time…)

- *Willingness to embrace marketing.* Marketing is critical to the success of your business. Embrace marketing, study it, and use it.

- *Being goal oriented.* It's easy to get sidetracked with editing software and spend most of your time on postproduction. But that doesn't bring in new clients, and it usually doesn't lead to profit. Figure out which activities do lead to profit and focus on them.

# The reality is that about 1 in 5 small businesses fails to make it to 5 years.

# Business Terminology

- *Income statement.* An income statement is also called a profit and loss statement (P&L), a revenue statement, or an earnings statement. It shows how money received from sales of goods and services is spent over a period of time, which then shows the profit (or loss) for that same period.

- *Balance sheet.* A balance sheet shows a business's assets, liabilities, and equity at a single point in time. The equity in a business is determined by the difference between the assets and liabilities.

- *Assets.* An asset is anything that has value in your company. This could be money in the bank, photos from the last shoot, or any products that can be converted into cash.

- *Cost of goods sold (COGS).* These are the direct costs of creating a product. For example, if you sell albums, the cost of the prints, binding, and packaging are all parts of the COGS.

- *Gross profit margin.* The gross profit is the total revenue from your sales minus the COGS.

- *Net profit.* The net profit, or net earnings, is how much money is left after all the expenses. This is often referred to as the bottom line. In most cases, this is what you earn, unless you are investing it back into the business.

- *Liabilities.* This is money that your company owes. If you have a loan or owe money for payroll, it is considered a liability.

- *Cash flow.* The cash flow of the company describes when you expect income to come in and when you have to pay money out. In a perfect world, money would come in first and expenses would be paid out after, but that doesn't always happen. For example, if you sell wedding albums, you normally order those during your slow season (when you have time to design them) but you typically don't have many payments coming in during that time. This means you could be putting out a lot of cash at a time when there isn't much coming in.

- *Digital assets.* In the photography business, these are the digital images. When discussing digital assets and digital files in general, there is a lot of different terminology, like file type and resolution, which we cover in a later chapter.

- *Budget.* Use the budget to track money coming in and expenses going out, as this enables you to determine if you are making a profit. It also helps you determine what to charge for your products and services, because you can see what your expenses and overhead costs are.

## Business Plan

Many people think creating a business plan is as much fun as public speaking or having a cavity filled. However, a good business plan is essential because it enables you to understand your potential business and decide if your plan is viable before you invest too much time and money into the venture. You might have a real passion for underwater photography—but after researching the industry and creating a business plan you might find that it is not a viable way to earn a living.

A good business plan takes time and research. Don't overcomplicate the process—this is for you, unless you plan to get a financial help (then your investor will want to review your business plan). Spend the time to do your research well, because the better your business plan, the better your understanding of the reality of starting up your business. To succeed you need a plan that explicitly lays out the path to profitability.

The following sections detail the elements of a business plan.

### Company Overview

This section of your business plan tells all about your business. Include details about your niche, such as the wedding industry or the pet industry, as well as the market you plan to serve.

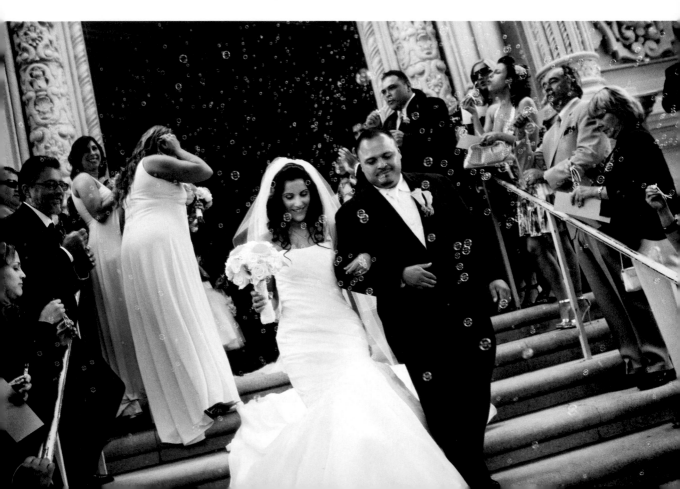

Describe exactly what your business does in detail, and include the specific part of the market that you plan to target with your business. Some of the things to cover are:

■ *Define your niche.* What type of photography services will you offer? Will you photograph commercial interiors or weddings? Research and learn as much as you can about the specific industry.

■ *Define your specific market.* Specify which group of customers within the industry you are targeting. Let's go back to the wedding photographer example. Are you going to be a high-end photographer? How many photographers currently serve this market? State exactly who the clients are, where are they are located, where they shop, and how you will find them. Is the market getting bigger, getting smaller, or staying the same size?

■ *Know the demographics.* Knowing who your clients are helps you determine where you should spend marketing money to get the best return. For example, if your target demographics are high school senior portraits, spending money on newspaper ads probably won't do much, especially compared to advertising on Facebook or other social media. Every market is different and requires a different approach.

## Objectives

In the objectives section, list your company's goals and what is needed to meet them. The more specific you are here, the better. Look at short-term, medium-term, and long-term goals. Are

you planning on growing your business by hiring employees or will you stay a one-person shop? What profits (or losses) do you expect over the first year, over 5 years, and over 7 years? How many clients do you need each year to earn a profit? How will you deal with start-up debt and what is your repayment schedule?

## Products and Services

What are you going to sell? This might seem simple since you are a photographer—but are you selling the final images, the photography service, both, or something in between? Will you sell add-on products? Do these services and products match the needs of your target market?

## Industry Analysis of the Niche

This is the in-depth research on the specific industry you plan to work within. Look at businesses in your area that already do what you do. Pay attention to the competition. How many other people are doing what you want to do? Is there place for you? This is straightforward if you are shooting weddings or senior portraits, but is a little harder to research if you want to shoot for stock image websites. Some questions to ask when looking at the industry include:

■ Who is the competition and what do they charge?

■ What is the size of the niche?

■ How well is the niche being served in your area?

■ Is there opportunity for growth within the niche?

Study the demographics of your target client. The more knowledge you have about your ideal client, the better. Where they shop, how they make spending decisions, what their turn-offs are, and what they like are all things you want to learn. Look at larger companies serving that market and study their marketing methods and communication styles to see what is effective.

### Marketing Plan

This section details your overall marketing plan. What are the traditional marketing methods used within your niche? What specific marketing methods would be most effective for your target market? How will you increase your brand awareness in your target demographic? How much will you spend on marketing?

### Operational Plan

This section deals with the day-to-day operations and management. Will you need software to run your business? Will you work from your home, or do you need a separate retail space? Will you hire help as you grow, or would you prefer to keep your business small, so you can manage it yourself? Will you want to outsource editing and postproduction once you get busy? Will you hire an accountant, an attorney, a bookkeeper?

When working in a partnership, particularly if one partner is full-time and the other is part-time (often a spouse working in the evening) be clear about each person's duties and who makes the final decisions.

You may find that the niche or the market you want to serve is not viable. Better to learn that now.

### Client Analysis of the Market

Once you've covered the industry, or niche, in detail, you need to research the specific markets within that niche. How are those particular markets being served by the competition? Is there a market that is not being served, and if so, why?

## Financial Projections

The financial projections section is the most important, and probably the hardest to complete. This is where the idea you had for a business meets the reality of actually turning a profit.

This is where your budget comes into play. By putting together a budget, you should have a realistic idea of what your expenses will be, as well as projected income. Here are a few questions to consider:

- What are your profit goals for the year?

- How many sessions do you need to book each month in order to break even?

- How many sessions do you need to book each month in order to achieve your profit goals?

- What are your financial projections for the first, third, and fifth years?

Creating a business plan is akin to having a good map when taking a long trip. It won't save you from unexpected detours but it can help you get back on track. Periodically, go back and look through the plan, and update the numbers as the business and the markets change.

## Calculate Overhead

If you don't know your overhead, you can't possibly know what you need to charge. The overhead costs are those regular expenses that are not directly related to producing your goods or services. These are the costs that occur each month, and while you should try to keep them as low as possible, they cannot be ignored. Think of these as the Daily Cost of Doing Business.

### PPA: A Worthwhile Investment

I highly recommend PPA's Studio Management Services. Besides working closely with an accountant to help you create and maintain a strong financial plan, you'll also get a business education mentor to help you set goals for your business and track your progress. Unlike working with a regular accountant, PPA accountants are experts in photography business financials.

They are expenses that occur every day whether you are doing work or not.

To estimate your actual overhead, make a list of all the expenses in the following list for a yearly period. You'll have to estimate (or guess) some of these numbers, but try to be as accurate as possible. Once you have all the numbers, add them up to find your total overhead for a year. Now, take the number and divide it by 12 for your monthly overhead expenses.

- *Rent.* If you work at home, calculate the percentage of your home used for business and that percentage of your rent or mortgage in the overhead calculation for rent. If you are a portrait photographer with a studio, your rent costs will be higher than an event photographer who does most of her photography work on location.

- *Utilities.* Electricity, heating, water, phone, and trash all come in under this category. If you have a separate office

or studio space, then all the utilities are counted. If you use a home office, you need to work out a percentage of the utility cost.

- **Web hosting.** Your monthly hosting charges are part of the overhead of doing business.

- **Insurance.** If you have a homeowner's policy with riders for your business gear, those costs would be included here. A regular homeowner's policy does

not cover business gear, particularly if they feel that the value of the gear is excessive for personal home use only.

- **Business dues, subscriptions, and publications.** Memberships in organizations and subscriptions for trade magazines get added here.

- **Education.** Include any training and educational costs that directly further your photography or business education, such as workshops, seminars, conferences, online training, or even books.

- **Professional fees.** These are fees to lawyers, accountants, and tax professionals. Many of these fees happen only once or twice a year, but need to be calculated out over the full year. For example, annual attorney fees need to be averaged out over the full year so you can get an accurate monthly expense.

- **Taxes.** Some countries (and states) have minimum taxes no matter what the company earns. This is especially true for corporations. Check with your tax professional about what you are liable for and make sure you add that into your overhead costs.

- **Maintenance.** Calculate the cost of maintenance for your office and gear. Include Canon or Nikon professional services for gear maintenance.

- **Equipment.** Your lenses might last forever, but chances are you are going to need new gear occasionally. This might be new camera bodies or lights, or a new computer. When calculating the

costs of equipment into overhead, you need to consider how many years that equipment will last and divide the cost by the number of years. That amount is what you would include in your overhead. For example, let's say you are buying a MacBook Pro for $2,200. You expect to use it four years before you need to upgrade. In this case, you'd divide the cost of the laptop by 4, and your annual overhead for that equipment would be $550.

- *Office supplies.* You need basic office supplies when running a business. That includes envelopes, stationary, paper, business cards, pens, pencils, printer ink, and cleaning supplies.

- *Shipping costs.* Postal fees as well as any shipping costs you incur, unless the client pays these costs.

- *Bank charges.* These are the fees that your bank charges you, including any interest payments on loans or credit cards.

- *Packaging.* Boxes, bags, tissue, stickers, notecards, and all those little extras that go into delivering the product to your client.

## It All Adds Up

When calculating how many clients and sessions you need each month, besides covering your monthly overhead costs you also need to cover your marketing expenses, cost of goods sold (COGS), and pay yourself. When you look at your pricing from this perspective, it is easy to see how offering a 2-hour session and image files for a few hundred dollars can equal business suicide.

## How Much Should You Aim for in Sales?

According to Professional Photographers of America's (PPA) 2011 Benchmark survey, home-based studios should aim for about $125,000 in gross sales in order to achieve a solid profit. Retail studios should aim for sales in the $200,000 to $250,000 range in order to achieve a similar profit level.

I recommend that you work with an accountant to help you create a budget and understand your overhead costs. It's a complicated process, and is worth the investment in working with a professional. A good accountant will pay for herself many times over in the additional profits and tax savings you'll gain from her expertise.

### Create a Budget

A budget is used to figure out if and how much money you will make after paying all your expenses. Having a budget is essential because it enables you to make accurate pricing decisions and lets you figure out where to invest money back into your business.

Creating a budget isn't difficult. The hardest part is being honest with yourself and making sure that your numbers are correct. With a budget, you can see where you are spending money and how much money needs to come in so that your business can grow.

The components of the budget are as follows:

- *Revenue.* This includes everything you earn for services and products. In order to estimate this, you need to figure out how many sessions per year you'll do at what price.

- *Expenses.* Your expenses include your overhead, the cost of goods sold (COGS), marketing, and any other costs associated with running your business (such as outsourcing).

- *Profits.* This is the bottom line—what is left over when you subtract the expenses from the revenue. This is your take-home pay, once expenses are covered. The basic math is:
revenue – expenses = profit.

If you've calculated your overhead expenses, now it's time to consider additional expenses such as marketing, COGS, outsourcing, and hired help.

The next step is to estimate projected income. Obviously, you'll need to have your pricing worked out (this is covered in Chapter 7). As you go through this process, you may find you need to adjust your pricing to maintain profitability, and that's OK. In fact, that's the point of all of this—to make sure your pricing will support your business.

The budget is not a document that is created once and then set aside forever. You need to update it on a regular basis. I recommend looking at the budget every quarter to make sure that your projections are on target.

## Keeping Track

Think of the projected income as a goal to achieve, and keep track of your progress. If your goal is to book 75 sessions, that means about 6 sessions per month. By keeping track of your progress, you'll stay motivated and focused.

## Business License

You need to get a business license before conducting business—it gives you the legal right to conduct business. The business license is also usually needed when opening a bank account in the business name. The rules and regulations on where and how to apply for a business license vary from place to place. In the United States, go to sba.gov/licenses-and-permits and enter your zip code to find out what is required in your area.

## Name Search

Before you name your business, you want to make sure you can legally do so. In Chapter 6 we discuss how to name your business, but this section deals with the legal aspects of choosing a business name. Most people name their photography business under their own name, but it's important to check that another photographer isn't already using that name for his or her business, otherwise you could run into complications down the road, and potentially be forced to change your business name later, once you have established yourself.

There are three places to check before you choose a business name:

- *United States Patent and Trademark Office.* Search online at uspto.gov and look for search trademarks (TESS). This allows you to search the database of registered trademarks.

- *Domain name search.* To check if your business name is available online, check Network Solutions at networksolutions.com/whois/index.jsp or do a search for domain name availability.

- *Your state.* To check if anyone else in your state is doing business under the business name you'd like to use, search for the name of your state + "business name availability" and you should be able to find your state's business listing directory.

## Types of Businesses

One of most confusing things to new photography business owners is the legal requirements to forming a business, and paying city, county, and state fees and taxes. It doesn't need to be complicated or scary. The following sections offer a brief primer on the different options for your business.

### Sole Proprietorship

This is when a single person owns the business and it is not a corporation. This

is one of the simplest ways to get started with your photography business, and I recommend it for anyone starting out who doesn't need to protect personal assets from their business, meaning you don't own property or savings that could be taken from you in a legal dispute.

The drawback is that you are personally responsible for all business debt, so if you have assets to protect (such as a home) this may not be the best option. Most photographers start out this way because it's the easiest path, and then move to another option down the road when the business is earning more money and you begin to have personal assets of value.

With a sole proprietorship, you can use your social security number for tax forms and you pay taxes through your personal income tax return. You may also need to obtain a Fictitious Name or Doing Business As (DBA) form. This is done via either the county clerk or your state government office; check online for your state.

## Limited Liability Company

Once your business is established and making enough money to provide you with personal assets (like home ownership), you may want to consider the benefits of a limited liability company (LLC).

Unlike a sole proprietorship, your personal assets are legally separated from your business. This means that if your business gets sued, your home cannot be taken from you. It also means that the owner is not personally responsible for business debts. However, there is more time and cost involved to set your business up as an LLC

## Ask the Experts

It is best to talk to an accountant, lawyer, or tax professional to get all the pros and cons of picking the right type of business. This book can't address your individual situation; this is just meant to educate you on what's involved in the process and why it's important.

(initial setup fees, annual filing fees, annual state fees). In order to maintain an LLC you have to keep good records and never co-mingle your personal finances with your business finances.

## S-Corporation

This is the most complicated of the options and should be considered when your salary is at or exceeding the six-figure mark. There is a lot of paperwork and additional time and costs involved in this option, so you want to make sure you will benefit from it.

You need a board of directors, officers, and shareholders, and you would most likely work with an attorney to help you file the paperwork. One of the biggest benefits to an S-corporation is the tax savings, which can be substantial once your business is earning consistently. After a few years as a sole proprietor, we switched Geoff White Photography to an S-corp. ■■■

# Accounting, Legal, and Insurance Concerns

There are many obstacles when starting up a business. Squaring away your accounting, legal, and insurance issues right from the start will save you many frustrating hours later on. The good news is there are accountants, lawyers, and insurance professionals available to help.

Don't skip this chapter. The information in it won't make you a better photographer, but it will increase the odds that your business is successful.

# Accounting

You might be in business because you love photography, but your business needs to make money. You will need to keep track of all your expenses and revenue. Without proper accounting, it will be impossible to judge how your business is doing financially once expenses are getting paid out and revenues are coming in at the same time.

## Setting Up Bank Accounts

One of the worst mistakes you can make is not to set up a separate bank account for your business. If you mingle money from your business with your regular checking or savings account, it becomes difficult to assess how the business is doing financially. If you don't actually know how much money the company has, it is easy to miss the warning signs that things are not going well financially.

You also need to apply for business credit cards in order to keep your business credit and your personal credit separate. This might be tough when starting out, since a new business has no credit history. Start with getting a debit card tied to the business bank account so that you can make business purchases with it. The key is not to mingle your personal funds with the business funds.

## Accepting Credit Cards

In the past, in order to accept credit cards as payment for products and services you had to set up a merchant account. You have to apply for the merchant account, and then pay a monthly fee, a transaction fee, and usually a small percentage of the transaction amount to be able to accept credit cards. All this can add up and take quite a bite out of your income.

Although accepting credit cards still is not free, thanks to products like Square it can be easier and a lot less expensive than it used to be. You can now accept credit cards by using the Square reader without having to set up a merchant account or having to pay a monthly fee. You can manually enter the credit card payments into Square, or swipe the cards through an attachment on your smart phone. For more information, visit square.com.

## Having a Hard Time Getting Approved for a Business Credit Card?

If you need a credit card for business, but can't get a one until you establish business credit, try this: Designate a personal card for business purchases only and pay it off with the business account until you have a credit history, and then apply for a card in the business name.

## Do You Need to Accept Credit Cards?

You don't have to accept credit cards, and the drawback to accepting them is the credit card fees you end up paying for every charge. However, by accepting credit cards you are removing a barrier to purchasing for your clients. They might be inclined to purchase additional products and services they would not otherwise be able to afford. When a client is splurging on a non-essential service (like photography), sometimes the bonus airline miles help justify the purchase.

### Hiring an Accountant and/or a Bookkeeper

There is some great bookkeeping software available for small businesses, which makes it easy to set up your business books and keep good records. Software applications like QuickBooks and FreshBooks allow small business owners the freedom of doing their own bookkeeping. As your business grows, though, the bookkeeping will become more complicated and take more time.

So do you need to hire an accountant or a bookkeeper, and what exactly is the difference?

- A bookkeeper does the day-to-day data entry. He makes sure invoices are sent, bills are entered in the correct categories and paid on time, expenses are correctly itemized, etc. Bookkeepers for small businesses can often take care of the paperwork in a few hours a week.

- An accountant is the person who can give you answers on your specific financial situation and can analyze your business and its financial health. She doesn't spend her time entering your data, but instead takes that data

and creates reports and information you need in order to know how your company is doing. She is also directly involved with the creation of your company's tax returns. You might work with an accountant initially to set up your financial plan, work on tax planning, and determine your overhead expenses.

## Taxes

I am not a lawyer, an accountant, or a tax consultant, so when it is time to file my personal and business taxes, I hire professionals to do the job for me. More importantly, I made sure that I talked to an accountant and a tax professional when I started my business so that I knew what was going to happen around tax time.

When you are running a business and you make a profit, you owe taxes on that profit. How much you owe and when those payments are due can vary greatly. Will you have to pay quarterly taxes? How much of your expenses are deductible? What happens if you make no profit for the first couple of years? These are all questions that need to be answered by a tax professional.

# Legal Concerns

Being a small business owner comes with a lot of rules and regulations to cover both the client and the business owner. Add to the regular laws the set of rules and regulations that deal with copyright (important to photographers) and you can get a headache just thinking about it. There are some basic things that you can do to minimize potential problems.

- *Keep good records.* Let me say that again: Keep good records. Yes, it is that important. Now, this is more than just keeping the invoices and bank statements. The records you need to keep (organized) include:
  - Your tax returns/tax records
  - Bank records
  - Employee records
  - Business permits and licenses
  - Client correspondence, including emails
  - Contracts with vendors and suppliers
  - Receipts for supplies
  - Automotive records if you use your car for business
  - A full set of accounting records

- *Use a lawyer.* Knowing all those laws is tough work and not something you should try to figure out on your own. The best advice is to have a lawyer go over your contracts and legal matters and not try to do it on your own.

## Contracts

Never work without a contract. A contract protects both you and the client by explicitly

> ## PPA
>
> Professional Photographers of America (PPA) wedding and portrait members get automatic malpractice protection that covers digital image loss, missed or missing images, and client dissatisfaction.

describing what services or products are expected by the client and what payment is expected by the photographer for those services or products.

Many people like to do business with a handshake or verbal agreement, and that seems fine—until there is a problem. As a business owner, you need to do as much as possible to reduce your legal exposure. The contract puts both parties on the same page so everyone is clear on what is expected.

The contract needs to have some specifics, including:

- Client names, addresses, and contact information

- Scope of the job and services, including:
  - Amount of time you will work at the event
  - Number of images you will deliver
  - If the image files will be provided
  - Size and quality of files (if in digital format)
  - Any finishing, such as frames and albums or custom prints
  - Time frame for delivery of the images

- Model releases and commercial use of the images

- Date of the service

- Payment amount and schedule

- Terms for how unexpected problems will be handled, such as:
  - Unsatisfied client
  - Photographer error
  - Act of God (natural disaster)

- Cancellation policy, which covers what happens if the client cancels early on or later on, and non-refundable retainers

- Signature lines for both you and the client, and if the contract is longer than a single page, a space on each page to initial signifying that the whole contract was read

Get a lawyer to help you put together your contracts. Money you spend now making sure everything is legal could save you a fortune in the long run.

One of the important, but often overlooked, parts of the contract is the section on non-refundable retainers and what happens if the client cancels the job. My usual contract terms are 1/3 of the payment is a non-refundable retainer, due upon booking. This might seem like a lot of money, but it does two very important things—it makes me committed to that client no matter what else comes up and it makes the client committed to me.

If the client cancels before the wedding has happened and a photo has been taken, why not return the retainer and just book another wedding?

It's not that simple. A lot of time and energy goes into booking a wedding, and that is part of the overall cost. You can't just go out, book another wedding at a moment's notice, and recover the lost income. In our business, to book a wedding for a specific date we usually meet with two to three couples for about 2 hours each, plus an hour of travel time (never show up late for a meeting) and an hour of preparation time for each meeting, and then about an hour of work done following up with the clients. At this point, that's roughly 15 hours of work to book a possible client for a wedding.

For us, the real-life learning experience came from a couple who first postponed the wedding, rebooking it for a year later, and then when that date rolled around, they ended up cancelling completely, leaving us with not one but two prime wedding dates without work or income. That non-refundable retainer was the only income we had from those two prime dates.

The other part of the non-refundable retainer is that the client knows that we will be there no matter what. With the contract in place, that day is all theirs. We will not book another wedding or cancel for any reason. We even state that if we cannot make it for any reason we will supply another photographer who will perform the job as well as or better than we could. Of course, for us not to be at a wedding, something *incredibly* drastic would need to happen. One year my mom experienced an emergency room visit that led to her slipping into a coma just two days before a scheduled wedding. Nevertheless, I still shot that wedding (I hired a backup to be there in case I was unable to continue) because I had a commitment to my client.

## Liability

Liability is responsibility—the responsibility of your company for all its transactions.

When you run a business as a sole proprietorship the liability of the business is also your liability. There is no getting around it. If the business owes money, you owe money, personally. Simply, any assets you own personally, like a house or car or camera gear, can be considered part of the company and may have to be liquidated if the company can't pay its liabilities. This is one of the main reasons that people form Limited Liability Companies (LLCs) or S-corporations.

## Copyright

Who owns the photos you take? Under the Federal Copyright Act of 1976, the copyright of a photograph is created and given to the photographer the minute the shutter button is depressed. Now, there are some exceptions to this:

- *Work-for-hire.* This is when you are hired by someone to photograph something and since you are in the client's employ at the time you take the photographs, he or she owns the copyright.

- *Selling the copyright.* You can sell the copyright to any of your images (as long as you own them in the first place).

## You need a contract that protects you.

You can register your images (in bulk) online with the U.S. Copyright Office at copyright.gov. There are protections that kick in when you register your work with the copyright office.

- *Federal protection.* You can get an injunction against people who are using your image against your will. It is difficult to sue if you do not register your images.

- *Damages.* If you have registered a photograph that was used without your permission, you can sue for compensatory or statutory damages and the lawyer fees.

If you don't register your images you still own the copyright, but the damages you can receive from infringement is severely limited.

There are some good resources for further information on copyright issues for photographers. Attorney Carolyn E. Wright runs a blog on the subject at photoattorney.com, and photographer Jack Reznicki and attorney Ed Greenberg have a blog and offer training at thecopyrightzone.com.

## Model Releases

A model release is a legal document signed by the subject of a photo allowing the image or images to be published in some form or another. Now, you don't need to get a model release to shoot a wedding, but you do if you want to take one of those wedding images and sell it to a stock agency or use it in an advertisement of any kind.

Keep in mind that if a person (or pet, animal, etc.) is identifiable in the image, then you need a model release to use it commercially. As good practice, you should always get your subjects to sign a model release before taking photos.

The exception to this is photographers who work events and sports. You can't climb on stage and have the lead singer of a band sign a model release before a show, walk up to the subject of a press conference, run

onto the field at a sporting event to get the players' signatures, etc. That is why those images are covered under editorial use.

Now, if you want to take one of those editorial images and sell it so that it can be used for advertising, then you will have to track down the subject and get a model release signed.

## Licensing

The license gives specific rights to the client on how he or she can use the photographs and specifically lays out what can and can't be done with the images. As a professional photographer, your images are your product, and how your product is used is important. Photographs can be licensed in one of three ways:

- Retail
- Editorial
- Commercial

When you license your images, you need to keep track of the license and the terms. You wouldn't want to accidentally license a photo that you sold to someone else on an exclusive basis. If there is a date range for termination of the license, you have an opportunity to negotiate to extend the license or negotiate its sale to someone else.

A retail license is for photographs produced for personal use—like portraits or wedding photos. This type of license produces images for sale and usually—this part is important—it is the print or digital file that is sold, not the actual rights to the image. That means that the person buying the images can't turn around and sell copies to other people unless specifically allowed to. This is key when it comes to pricing and selling your work.

Editorial usage is very limited in most cases. The images that can be used editorially are those that are newsworthy. For example, a photo of a band on stage at the local arena is considered editorial and does not require a model release. The same image used in an advertisement for a guitar company in *Rolling Stone* magazine would be commercial use, however, and would not only need a model release but a different license.

Commercial images are used to sell something. A photographer hired to photograph a product, or shoot a model wearing the latest fashion for a designer, are both commercial types of photography.

When it comes to creating the licensing agreement the basic goal is to create a set of rules that stipulates exactly how the image(s) is to be used. The language needs to be clear in defining not only what can be done with the image, but also what is

not allowed. The following are some terms that you should know when writing up a licensing description:

- *Exclusive.* When you give someone the exclusive rights to an image, it means you cannot sell it to anyone else. These rights may be limited in the scope of usage and could have a time limit placed on them. If you offer the exclusive rights to an image to a single buyer, the cost of that image should be higher than non-exclusive rights.

- *Non-exclusive.* This allows you to sell the same image to multiple clients. Clients know that the image can be used by others.

- *License fee.* This is the amount of money or other compensation paid to the copyright holder from the licensee.

- *Limited use.* This limits the usage. For example, you might license the image to be used on posters but not on shirts, or the image can be used on the Internet but not in print.

- *Unlimited use.* This allows the licensee to use the image for any purpose he wants.

- *Date range.* The longer the usages, the more it should cost the clients.

## Insurance

When should you get insurance? Once the investment you've made in your business is beyond what you could afford to replace. If you're building your portfolio with a Canon Rebel and a kit lens, you probably don't need insurance quite yet. Once you have a business laptop, professional gear, product samples, and clients, it's time to get insurance.

The basic concept is that you pay a monthly fee so when something gets lost or damaged (and something always will) you are not suddenly put out of business. Less than a year into our business, we had gone out of town for a weekend. While we were gone, there was a heavy rain that flooded our basement office. We came home to several inches of water, and our laptops and all our camera gear were ruined. Because we had business insurance, we were able to get everything replaced. But there's no way our renters insurance would have covered the loss of all that professional gear.

Talk to your insurance provider about adding business insurance coverage. Many times, you can combine multiple policies with the same carrier and get a lower overall price. Some organizations have special insurance prices and the savings can be enough to cover the cost of membership. For example, the Professional Photographers of America (PPA) has an insurance program that adds coverage when you are a member. Visit ppa.com/insurance to find out more.

<div style="border:1px solid #ccc; padding:1em;">

## Where to Get Insurance

Here are some insurance companies that work with photographers:

- *Package Choice* (packagechoice.com). For media professionals; offers packages that combine both property and liability insurance.

- *The Hartford* (thehartford.com). Used by many photographers, it offers have great small business insurance programs.

- *The Photoguard* (photoguard.co.uk). For photographers working in the UK.

- *PPA* (ppa.com/insurance). The Professional Photographers of America has some basic insurance coverage for members and options to add on equipment as well.

</div>

Let's look at the different types of insurance that you need to have and why.

### Health

Paying for your own health insurance is one of the drawbacks to business ownership, but it's important to have. If you get sick and can't work, not only will you lose income, but the medical bills can destroy your business.

### Liability

Liability insurance covers you from accidents during a shoot. If there is a chance that someone or something can get damaged while you are working, you need liability insurance. For example, if a model trips over the power cord from one of your lights and falls, you could be held responsible. Or if you are working outside photographing a car and a sudden gust of wind knocks your light over onto the car, the liability insurance will help cover the damages to the car.

### Certificate of Insurance

Not only do you need to have liability insurance, at times you need to have proof that you have insurance coverage. The Certificate of Insurance (COI) is a document that proves you have insurance and specifically states what and whom the insurance covers. Many locations not only require a COI, but also want to be covered under your policy. That means that if the model trips on their steps, you (or your insurance) are responsible for the damages, not the venue.

### Gear

Professional cameras and lenses cost a lot of money, as you well know. A top-of-the-line pro DSLR can cost over $6,000 and the pro lenses come in at $2,000 and up (all the way up to over $10,000).

Most of the time, a homeowner's policy covers cameras and equipment that are used only for a hobby, not professional gear. When it comes to insuring your

business gear, make sure you are covered for current replacement cost and not the depreciated value.

### Disability and Workers' Compensation

Having a contingency plan for your life if you get hurt on the job is a good idea for those of us who are self-employed. Remember, as a business owner you are exempt from worker's compensation, so disability insurance may be your only option.

Most states require companies to purchase workers' compensation insurance for employees. Check with your state regarding the rules for when you need workers' compensation.

### Life Insurance

If you have a family and dependents that rely on your income, consider life insurance as a way to protect them. Life insurance pays out to your surviving family members in the case of your death. Geoff and I each have life insurance policies on each other that would allow us to pay off all our debts and have an income for several years in the case of one of our deaths. If something happens to you, life insurance allows your loved ones to be taken care of financially.

■ ■ ■

# photoMint

EMPOWERING PHOTOGRAPHERS

PM

FRESH, **TASTY** &
ON THE ROCKS

EMPOWERING PHOTOGRAPHERS

ESTd 2011

PHOTOMINT

Oh!

FRESH & TASTY

CREATING *Oh!* MOMENTS

THE
*Weekly Mint*

# Your Brand

Branding can be a frustrating and confusing concept. There is a lot to consider when developing a brand, and it goes far beyond the logo. It is important to brand yourself correctly and consistently.

Your brand is the value you create, the thing that differentiates you from other photographers, your eye and vision, and the way you interact with clients. Your brand is how clients see your business, and it permeates through all parts of your business. Every touch point in your business is a part of your brand—from your email signature, website, and product packaging, to the way you dress, how you answer the phone, your reputation, and your visual style.

When Geoff and I started our photography business, Geoff's personal style was Silicon Valley appropriate—collared polo shirts and loose-fitting, pleated khakis. Upon entering the high-end wedding photography market, we realized that look did not work with the brand we were building. I delighted in giving my husband a total makeover from head to toe! His style went from business casual to artist practically overnight. This was an important move for our business because his personal style needed to align with our brand of photography.

# At its best, a brand creates a connection with your clients.

It is imperative that your branding match how you want your prospective clients to see you. If your goal is to shoot high-end weddings and formal events, you need a brand that is serious and more formal. You wouldn't want to call your company *Happy Fun Time Photos* and use logos that look like crayon writing on pink paper—although, that might work great for a photographer specializing in children's photography!

Let's be clear: Your logo is not your brand. Your brand is much more than just the logo. Your product is also not your brand. The iPad is not the brand; the brand is how you *feel* about Apple. Many people confuse branding with a logo and spend too much time and money in the early phase worrying about getting the perfect logo. It's a better use of your time to build your business by learning about who your clients are and what they want.

Building a brand and can seem time-consuming, especially when you are starting out and still developing your style. Remember that everything you do in your business is part of the brand, so always ask yourself, "Is this how I want my business to be known?" when making any decisions.

Authenticity in your brand is key. If you don't believe in what you do and the value you offer, how can you expect your clients to? Be yourself. It's one of the best ways to distinguish yourself from the competition.

Figure out what makes *you* unique, and build on that as part of your brand.

One of the ways Geoff and I did that when building the Geoff White Photographers brand was to build on our personal flair for attention to detail and passion for perfection. What this has done is draw clients who connect with that approach to us. Many of our clients are classic type A personalities who delight in the extreme attention to detail we take with shooting, image quality, image protection, products, and every other aspect of our business.

## Brandings Mistakes to Avoid

As artists, we know how important our image is and how important it is to get the branding right. Here are some of the biggest mistakes I see that photographers starting out make and how best to avoid them.

- *Focusing on branding over business.* Choosing the perfect business name, selecting the right colors, designing a new logo, putting together a new website, and creating business cards can be fun—and can take a lot of time. How do you narrow down all the color combos, fonts, and styles? It's easy to get distracted by all the choices and details. Instead of spending time working on booking clients, it's tempting to spend it looking over fonts and design elements. You want it to be

Stickler for details: One of the ways we infuse our personalities into our brand is to let clients know about our perfectionist ways when it comes to their images.

perfect, but if you spend all your time on branding and don't have any clients, it won't matter how great it looks.

During your first year I recommend studying branding, and learning what it is and what it can do, before investing in a professional branding package. Over time, you will figure out your style and evolve your brand. That way, if you feel you need to work with a branding specialist once your business has matured a bit, you will have done the work needed to create a strong vision. In the meantime, I recommend buying

a customizable predesigned template logo (more on this later in the chapter).

- *Waiting until your branding is perfect.* Networking to find clients can be scary. While it's something you probably know you should be doing, chances are you don't want to. Many times, we use not having a great portfolio or website or business card as an excuse to avoid putting ourselves out there. That is a *huge* mistake. Networking is about building relationships with people, the same people that will do business with you later. And those relationships are

not built on your branding; they're built on your people skills. You don't need a great portfolio or brochure to build great relationships with people.

- *Copying your competition.* When you start out, it is a good idea to check out the competition in your niche and look at their branding—but do not copy them. It's difficult to establish yourself if it looks like you stole your ideas from an established photographer. Do the work to develop your own style and branding, and your clients, colleagues, and even the competition will respect you.

- *Offering too many styles.* When starting out, most of us don't know our own style yet. We experiment with different angles, compositions, lens choices, and color choices. There is nothing wrong with that…unless we show this mix of styles in our portfolios or websites. It is confusing to a prospective client to see a wide range of styles in your work. Moody black-and-white landscapes, tightly cropped expressions, kids doing silly things, sepia images, an image with a vintage action right next to an image with a heavy color pop. It's too much. It's key to keep a consistent look and style in

### How I Found My Style

Composition has always been one of my photographic strengths. After spending so much time shooting couples and reviewing my work in the editing phase, I began to see that I had a preference for tight crops, creating intimate images of couples in love. That is the type of imagery I am drawn to, and it's what I like to create. As I realized this about my style, I began to focus on it even more, perfecting it. You have to give yourself time to let your style develop.

The images that Geoff White Photographers are known for have strong lines and bright color pops, both representative of our recognizable style.

your portfolio. Ask a new photographer to describe her style; chances are she will say something along the lines of "capturing the moment." This is what all photographers do, but it doesn't describe the *style*. Again, this takes time to develop, so have some patience. Don't wait until it's perfect. Branding is a process that evolves over time.

## Name Your Business

Your business name is important for multiple reasons and needs to be chosen with care. Many times a photographer uses his own name, or his name followed by the word *Photography* or *Photographer*, such as Geoff White Photographers. That is one option but it is not always the best one, depending on how you want to grow your business later (perhaps by adding other photographers to your staff).

The other option to consider is excluding your name from the business, such as Cowbelly Pet Photography. Think carefully about what your business name says about your business. It's the first impression a client gets and, once you establish your business name and reputation, it will be difficult to change later. Let's look at some things to consider before deciding on your business name.

Reasons to use your personal name as part of the business:

- You enjoy a personal approach to business. In other words, you are the brand.

- You don't see yourself expanding your business down the road.

## Keep It Short and Simple

Keep your website address short and sweet, and the same goes for your email address. For example, our website address for Geoff White Photographers is geoffwhite.com and emails go to *whoever*@geoffwhite.com. This keeps it easy to remember and type.

- You'd prefer to build the business around your personality and developing one-on-one relationships with clients.

Reasons *not* to use your personal name as part of the business:

- You want to expand the business down the road by hiring photographers and/ or other staff to take on more clients or ease off the hours a bit.

- The ability to earn profit is a key motivator for starting your business (as opposed to being more motivated by the opportunity to create art for a living).

- You can foresee selling your business one day.

- You plan to scale the business up as it grows (adding multiple locations, photographers, and product lines to serve more clients).

Ultimately, you are the one who has to live with your company name, so take time to envision where you'd like to see your business in 3 years, 5 years, 10 years, and

so on. The answer is unique to you and how you want to run your business.

When Geoff and I started our business, we didn't give much thought to the name. It seemed that everyone named their photography businesses after themselves. We purposely decided to brand the business around Geoff, as he was the only main photographer at the time.

That worked well in the beginning, until we wanted to grow the business and add staff. That's when the name of the business became a problem.

## 7 Tips to Choosing a Good Business Name

1. *Make it memorable.* It's no good to have a great business if no one can recall your name, so choose a name that can easily be remembered.

2. *Say it out loud.* How does it roll off the tongue? Is easily pronounced?

3. *Pay attention to the feeling or concepts the name conveys.* Be sure the feeling of your business name ties into the feelings you want to evoke in your customers. For example, the name Bugs and Butterflies suggests a lighthearted playfulness, which is perfect since the photography business specializes in kids.

4. *Make it easy to spell.* People need to be able to find you online. That means your business name needs to be easy to spell. Don't use weird spellings that might seem clever, as this will hurt you when people start searching for you online and can't easily figure out which listing is you. Avoid using *f* when you mean *ph*, and don't just remove letters to shorten the name.

5. *Short is usually better than long.* I know this seems simple, but a shorter name is easier to remember and is easier to type into a browser than a long name.

6. *Check the meaning.* You might be doing business in a small town in Oregon, but your business name is international. Have you heard the story of how Chevrolet introduced the Nova? In the United States it sold well but when they introduced the same car in Spanish-speaking counties the car didn't sell. At all. The reason was that in Spanish, *no va* means *doesn't go*. Who is going to buy a car named *doesn't go?*

7. *Make sure the name is available.* There are three distinct places your business name needs to be available before you can call it your own:

   - *Trademark search:* uspto.gov/trademarks

   - *Website domain name:* networksolutions.com/whois

   - *Business names in your state:* Search online for "*your state* business name search" to locate the correct database. For example, I would search for "California business name search" in order to find my state's directory of business names.

## PhotoMint Was Almost Named PhotoBacon!

When PhotoMint was only an idea and I was thinking of possible names, I toyed with the idea of calling it PhotoBacon. The concept was "bringing home the bacon...with photography." Hmm, glad I abandoned that stinker. An Australian friend reminded me that the word *bacon* has no connection with money outside the United States. I knew that the PhotoMint audience would be made up of photographers from around the world. As I thought more about what the site would be about, I realized I wanted something more elegant and sophisticated. PhotoMint addresses serious business ideas and concepts. Hence *PhotoMint* and not *PhotoBacon*.

No one wanted to talk to anyone other than Geoff. Every time the phone rang, the caller asked to speak to Geoff and seemed put off when dealing with anyone else, including me. As I began to go to more networking events, the first thing people would say to me was, "Where's Geoff?" Even though I was right in front of them, people still wanted to talk to the person at the top, and thought he had all the answers. Little did they know Geoff was shooting, while I was the one running the business side.

This problem was compounded when we expanded our services to include another photography team for weddings. We considered changing the name entirely at that point, but eventually settled on Geoff White Photographers (changing *Photography* to *Photographers*), so that we didn't lose all the branding we had built. If we were starting over, I would not use our name, as it caused problems as our business grew.

## When to Hire a Graphic Designer

Many photographers have great vision and a good graphic sense, but that doesn't make them graphic designers. A graphic designer can take an idea of a logo and turn it into a fully developed design, and some can help with creating a full branding package.

I recommend waiting to hire a graphic designer or branding specialist until after your first year in business. In your first year, you are still figuring out what your business is all about.

You don't truly understand which path your business will take yet, what type of clients you will have, and the market you are targeting. That makes it likely that your actual business and branding will evolve over the first year in business. Now I'm not saying branding isn't important; it's just that in the early days of starting a business, you likely don't know much about your brand and will be grasping at straws. It takes a

while to figure out your style, understand who your clients are, and what makes you different.

A good graphic designer can help with a logo, create website headers and banners, create a great business card and stationary, and make sure that your look is consistent over all your outlets.

When I started PhotoMint, I had some vague idea that it would be about earning money as a photographer, but didn't quite know how the brand would evolve over time. So I hired a student designer to create a simple logo featuring imagery and style from a dollar bill. From the start, I knew it wasn't quite right, but had to move forward. A year later, PhotoMint had taken on a life of its own—and it's about more than making money. I knew who my readers were, and I knew what PhotoMint was all about. It had outgrown the original logo quickly. It was time to invest in a proper branding package.

When I hired Ashley Jankowski from Braizen, PhotoMint was ready for a rebranding. I had a firm grasp on who the readers of PhotoMint are and what they needed. I also knew the direction I wanted to take PhotoMint. Her team spent a lot of time learning about PhotoMint, its audience, and the brand itself. Once they felt like they understood PhotoMint from the bottom up, they were able to create a new logo and identity based on the brand that I had already established. At the beginning of this chapter is the branding concept that Braizen put together for PhotoMint. As you can see, it's not only a logo, it's a brand. They did a fabulous job, and set a high standard for branding companies out there.

Had I gone to them in the beginning of PhotoMint, it would have been too soon. At that point, the brand was not established. I had some ideas and concepts, but was unsure of how the brand would eventually unfold, how readers would respond, and how to connect with the core audience.

At the early stages of your business, you have hopes, dreams, and ideas. Your brand is more of a seedling, an idea. Give it time to develop, and you won't regret it. When you are ready to work with a graphic designer or a branding specialist there are things you can do to make the process go smoothly.

Before

After

The original PhotoMint logo (before rebranding) and the new PhotoMint logo created by branding specialist Braizen, which perfectly expresses my vision for the PhotoMint brand.

- *Look at other logos.* Check out the logos of other photographers—especially those in your niche and market. You do not want to copy their designs. Ever. However, it will give you an idea of what you like and what you don't.

- *Get samples.* In the same way your clients shop around for photographers, you need to shop around for designers. The design process involves back-and-forth to get the logo just right and that's not easy if you don't see eye to eye.

- *Define the job.* When working with a designer be clear about your expectations. Don't assume that since he is working on a logo, he will design your business cards for the same price or create a series of web banners. If you want logo design work and a business card along with a web banner, discuss that up front.

- *Get a contract.* Just as you wouldn't shoot an event without a contract, you should never hire someone to do work for you without one. The contract needs to specify what it is you get for what cost, how many revisions, what type of files you end up with, and how you can use the logo.

- *Put together a Pinterest board.* Use Pinterest to collect ideas of colors, fonts, and designs you like. You may start to see trends and styles that particularly appeal to you.

Once you are ready to invest in a designer, you have some questions to answer. This exercise will help you develop a look and a logo that truly reflects your business.

- *Define your unique selling proposition.* What makes you different is the heart and soul of your business. How can you describe your style in a way that will not be confused with your competitors? Is it your pricing, your customer service, your eye for composition? Take the time to dig deep. Don't be afraid to ask clients or vendors you work with—they might be able to give you perspective.

- *Choose words carefully.* Don't get lost using the same tired and generic words that many photographers use. You know what I mean. "Capturing the moment" could describe any photographer.

- *Know your competition.* The more you study and understand your competitors, the easier it will be for you to carve out your own piece of the market by differentiating yourself.

- *Be yourself.* Are you funny or serious, sophisticated or relaxed, artsy or classic? By understanding your style, you can better tailor your brand to match your personality.

## Template Design

So if I suggest that you don't hire a graphic designer right away, how do you look professional in the meantime?

Template designs are great when you are in the early stages of developing your business. Instead of getting caught up in an endless loop of graphic design and the search for perfect, you can choose something that works for now so you can move on to the profitable stage of your business.

## Where Can You Get a Predesigned Logo?

Here are a few designers I recommend who offer predesigned logos and marketing kits for photographers:

- *Swoone:* swoone.com
- *Design Aglow:* designaglow.com
- *Photographer Café:* photographercafe.com
- *The Shoppe:* theshoppedesigns.com
- *Jamie Schultz Designs:* jamieschultzdesigns.com

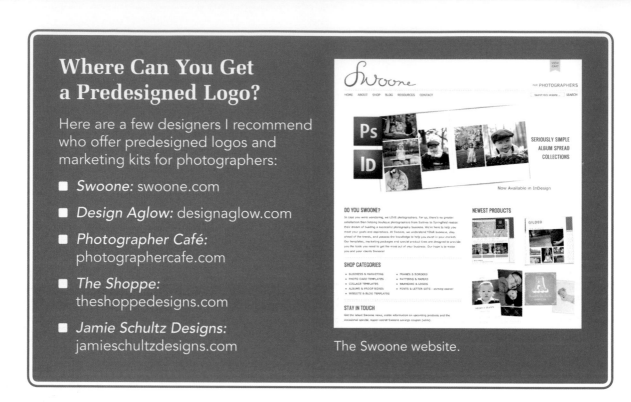

The Swoone website.

There are lots of predesigned logos for photographers you can purchase at a reasonable cost, and have your name and chosen colors swapped in within a day or so. You can find beautiful collateral kits that include a brochure, address labels, business cards, notecards, stickers, and other pieces you need to give your business a professional look. You'll have something to start with that looks professional for an affordable price and you can get back to focusing on making your business profitable.

## Logo Design

Your logo is probably the first thing that your prospective client will see. The logo is an important part of your branding and needs to convey the proper message about your business.

There are three basic types of logos:

- Text logos
- Mark or symbol logos
- A combination of the two

## By developing a strong brand you will be able to charge higher rates and reach more clients.

# GEOFF**WHITE**
## P H O T O G R A P H E R S

The Geoff White
Photographers logo
is a text style logo.

Geoff White Photographers is a text logo
(uses font only), while PhotoMint is a
combination logo, as it incorporates both
text and a symbol.

Here are some tips about designing/
choosing a logo:

- Make sure it can be scaled.
- Color is important.
- See how the logo looks in black and white.
- The style needs to match.
- Typography matters.
- It needs to be easily recognizable.
- Take your time.

When we first designed the Geoff White
Photography logo, we studied fashion
magazines and looked at ads. What we
discovered was that most high-end fashion
brands do not use any kind of mark, and
logos tend to be text only.

We also looked at the fonts used, and found
that most major fashion brands use classic
fonts that you see over and over again. We
chose Futura font for our logo, as it is a
classic font with a clean, modern feel.

We looked at different color combinations
and eventually settled on plain old black
and white. Black and white is a timeless,
classic color combination and works well
with images. At first we tried to add in a

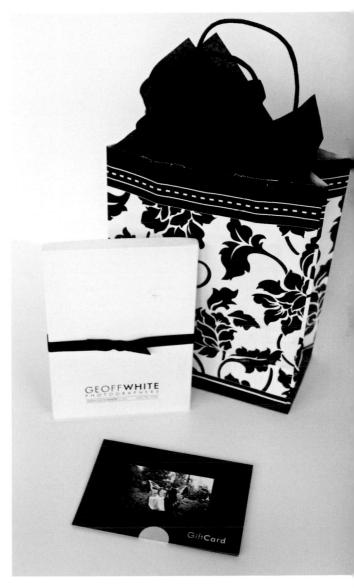

The GWP packaging incorporates the timeless colors
of black and white for a simple yet sophisticated
look that appeals to our target clientele.

third color to spice things up. We chose fuchsia, because we wanted our brand to have a sexy edge to it. What we found though, is that fuchsia felt out of place on our website, and didn't match nicely to the many vibrant images in our portfolio. I kept trying to add in colorful touches, thinking that it was needed. Eventually I dropped fuchsia and fully embraced the black and white. I began to see all sorts of gorgeous black and white patterns everywhere, and it was easy to find packaging supplies.

When you are ready to design a logo, it's key to understand who your clients are, and the personality and voice you present as your business. Start with some questions:

- What emotions do your clients experience when enjoying your product?

- What is your voice or personality? Are you funny, relaxed, and easygoing? A perfectionist? Let that be part of your brand. Find ways to infuse your personality throughout your brand. Choose fonts that convey your personality—modern, vintage, timeless, sophisticated, fun, and so on.

- How would you describe your brand? Elegant, casual, sophisticated, affordable, high-end, fun? (Don't say *vintage-modern*, the trend of the moment!)

- Are your clients mostly moms? Do they identify more with Target or with Neiman Marcus? Clients who shop at Target tend to be more drawn to light-hearted fun design, while Neiman Marcus shoppers will be drawn to a more sophisticated color palette and design.

- Do your clients tend to choose products themselves and ask lots of questions, or do they prefer to be told by the expert what is best?

- Are your clients do-it-yourselfers or busy executives? DIY'ers will want options to get more involved in the product design process, whereas busy executives will prefer to rely on the expert (you) to make most of the decisions.

- Do you like to stay on the edge of trends or do you embrace trends once they are more established? What about your clients?

## Business Cards

I have a whole drawer full of business cards. It seems that I never throw any of them away. I sort them by type of business and find myself going back to flip through them looking for a specific vender or contact. Your business card acts as your representative and needs to be congruent with your business branding. I can easily tell the high-end businesses from the feel of their cards before even looking at the design and information on them.

Business cards are meant to be touched and held, so keep these suggestions in mind when ordering your cards:

- Paper weight
- Paper texture
- Glossy or matte finish
- Die cuts and rounded corners
- Foils and special ink

**GEOFFWHITE**
P H O T O G R A P H E R S

L A R A   W H I T E  |  P R E S I D E N T
650.780.9300  LARA@GEOFFWHITE.COM  WWW.GEOFFWHITE.COM

The Geoff White Photographers business card. The back of our cards features a signature image used throughout our materials.

## What to put on your card?

- *Logo.* Your logo needs to be on your card. It ties all your branding together.

- *Company name.* The business name might already be on the card if you use a text-based logo. If your logo does not have the business name as an element, then you need to place it on a prominent part of the card. When a person looks at it, she needs to easily recognize the company/person she is looking at.

- *Phone number and email.* You want the client to be able to contact you, so make sure that the phone number(s) and email address are easily readable.

- *Address.* If you have an actual studio or office and expect to meet clients or receive mail there, you need to include your mailing address.

- *Website.* Your business has a web presence and you want people to check out your work, so you need to tell them where to go. You do not have to write out *http://* or *www.* anymore. The folks getting your business card will figure that out for themselves.

- *Name and title.* A title is not necessary if you do everything at your business but could be useful if you have employees with specific jobs.

- *Images.* As photographers, we like the idea of putting an image on our business cards, but be careful because that image will be representative of you for quite a while. Some printers offer the option to order a set of cards with a variety of images so that you can create different cards for different niches. For example, if you shoot both weddings and portraits, you could have a different card for each with a different photo. That way you can match the card to the client.

- *Tagline.* Not everyone uses or needs a tagline, but if you have one you might consider putting in on your business card to reinforce the message.

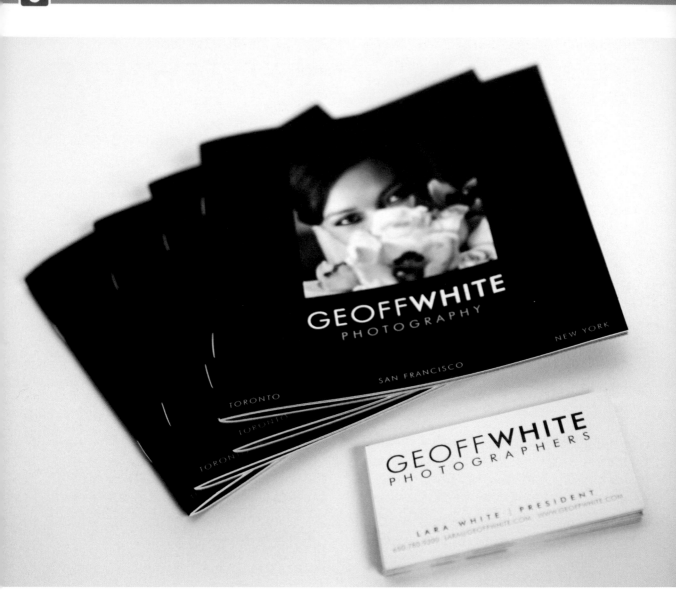

**Always carry business cards.**
You never know when you'll meet
someone who needs a photographer.

For many people your business card is their first impression of your business. There are some things to avoid when it comes to creating your business card:

- *Ordinary or poorly printed images.* Nothing makes a business card look crappy as quickly as a poorly chosen image. Make sure that the image quality is high enough to print well on the card. You're a photographer running a photography business and you'll be judged by the quality and uniqueness of the image on your card.

- *Poor quality paper.* A cheap, flimsy card says a lot about your business—none of it good. I always find it amazing when people spend lots of money on a logo and design help, and then print their cards the cheapest way possible.

- *Crowded.* Business cards are usually 2½"x3" and even if you use both sides, that's not a lot of space. Keep the layout simple, and don't cram too much information onto the card. Do they really need your fax number?

- *Using a pen to edit information.* If something in your business changes and the card is out of date, get new cards. It looks tacky and cheap to cross out information with a pen.

Keeping an empty space on the back of the card allows you to add a note or special instructions, a gallery link, or a password for the client to log into the website. Usually, the rule of thumb is not to deface a business card because it looks unprofessional, but if there is an actual spot for it, then it's fine.

## Custom Packaging

Custom packaging enhances the client's purchase like beautiful wrapping enhances a gift. Packaging is important to your business because it's a way to set your brand apart from your competitors. It's also key because it lets your customers know the value of your product.

When you ask a customer to spend $50 or more on an 8x10 print they could get at the corner store for $2, the custom packaging is a visual cue they are getting more than the paper the image is printed on. They are getting your boutique brand, your customer service, and your reputation. If you aren't certain, ask yourself this: Would you rather be seen carrying around a ripped plastic Walmart shopping bag, or a blue Tiffany shopping bag?

I still have the Tiffany bag we got when we purchased our wedding rings 11 years ago. That packaging represents an important moment in my life, so I cherish it even now. That's the power of a brand. Imagine your clients having a similar experience with your brand, and holding on to the packaging their prints came in. The packaging would serve as a reminder of the great memories you created for them.

## Your Online Presence

The Internet, and especially social media, have made it a necessity to control your online identity and monitor your brand and reputation online.

Make sure you register for a website domain name, as well as sign up for a Facebook page, a Google+ page, Twitter, and so forth. You don't have to use all these Internet identities right off the bat, but you do want to grab the name on each as soon as possible.

The other big benefit is that simply by filling out the account basics and adding a logo or a few images, you are establishing a stronger reputation online. When someone does an Internet search for your

business, you want there to be multiple hits in addition to your website. Lots of search results will give your business the appearance of being well established.

Set up the following for your business:

- Website domain name
- Facebook page
- Google+
- Twitter
- Pinterest
- YouTube
- LinkedIn
- Google Places
- Yelp

We will get into actually using all these different online identities in Chapter 16, "Marketing Strategies," but the thing to keep in mind is to be consistent across the board. Use the same name, photo, color scheme, and icon everywhere.

### Google Alerts

Google has a service that allows you to monitor the Internet for specific content. In this case, we are going to use this service to monitor our business. The first step is to go to google.com/alerts, where you can enter the search query and control what happens with the results.

1. *Search query.* This is where you add the keywords to search, such as your name and business name, and the word *photography*. For example, I have alerts set up to monitor the following: Lara White, PhotoMint,

Geoff White Photography, Geoff White Photographers, and Geoff White. This enables me to keep an eye on any online mentions of myself or my businesses.

2. *Result type.* This drop-down list allows you to narrow the results. The choices are: Everything, News, Blogs, Video, Discussions, and Books.

3. *How often.* You can receive an alert as it happens, once a day, or once a week. Personally, I think once a day is perfect since it allows you to deal with mentions on a timely basis.

4. *How many.* This is where you determine the amount of results sent. There are two choices—Only the best results or All results.

5. *Deliver to.* This is the email you want the results sent to.

Once you've filled in all the fields, click CREATE ALERT. That's it. Google will now send you alerts that match your Search query on the schedule you specified.

## Yelp

Yelp lets people leave reviews about businesses. You can create a Yelp business profile (and more) using the Yelp for Business Owners tools accessible at biz.yelp.com. If you have an account with Yelp you can log in at the top right side of the page; otherwise, you can click the *Create your free account now* button in the middle of the page.

Enter the name of your business and its location. You will then get a link to add your business to Yelp. Once you've entered

---

### Some Great Branding Specialists for Photographers

- *Get Braizen:* getbraizen.com

- *Ribbons of Red:* ribbonsofred.com

- *Bittersweet Design:* designbybittersweet.com

- *Identity Kitchen:* identitykitchen.com

---

all the information, Yelp will send you an email before your profile goes live.

Once you have a reputation online, it's important to actively monitor it for both positive and negative remarks. If an unhappy client is badmouthing your business all over town, you'd want to work with that person as quickly as possible to resolve issues before too much damage is done to your reputation. It's the same thing with your online reputation. By monitoring mentions of your business, you will spot something negative and can quickly address it. You might write a response to a bad review or take action to prevent a similar situation from happening again. You could also reach out to that person directly to resolve his complaints.

The other benefit to monitoring your brand online is that you can quickly spot positive mentions, great reviews, and unexpected editorial coverage. All of these make great fodder for your blog.

## Signature Images

When you start putting together a portfolio of your work it's smart to select a signature image. This is one you will use repeatedly in your branding and marketing to create brand recognition. You may get bored of seeing the same image after a while, but your clients (and prospective clients) won't. They will learn to recognize you by that image.

Flip through any wedding magazine and you'll find dozens of photography ads, and most of them are difficult to distinguish from one another. But imagine a client sees one particularly strong image consistently: She sees it on the photographer's business card, on the website, when visiting a venue and that image is hanging on the wall, and when flipping through bridal magazines and the image is featured in an ad. There's that same incredible image again. The bride begins to recognize your brand. And that is exactly what you want to happen.

## Brand Consistency

You want to ensure that your brand stays consistent through each touch point of your business. Here are some ways to make that happen:

Using a single signature image on your promotional and marketing materials keeps your look consistent and reinforces your brand because it's memorable.

- Use the same colors everywhere.

- Use the same photo for social media profiles, so people can recognize you from the image across different mediums.

- If your logo is soft and feminine, for example, don't introduce packaging pieces that are inconsistent with that look and feel.

- Match your working clothes to the style of your brand—if your brand is classic style, dress in a way that reflects that.

- Match your voice to your brand—if your style is casual, go for a causal tone in emails, if it's more artsy, let that come across in your blog posts, voicemail, and client correspondence.

- Consistency is also important in image treatments. For example, instead of using a variety of black and white and sepia, choose one and stick with it.

### Industry Insiders:
# Tamara Lackey on Branding for Photographers

Tamara lackey is a renowned professional photographer, author, and web series host. Besides running a full-time portrait studio, Tamara devotes a great deal of time to the photography industry by mentoring new photographers and putting out educational resources. I chatted with Tamara about her ideas on the importance of branding for photographers.

Tamara works with and advises many photographers, and she feels branding is critical to a photographer and it's important to get it right. She suggests that photographers starting a new business should spent some time studying branding so they understand exactly what branding is and what is should do for a business.

## "Branding is something that is important to study in the beginning to understand what it is."

© Tamara Lackey Photography

Branding needs to be a consistent message across everything you do and offer. If you are a high-end photographer and you talk about discounts on your website or in your client presentation, that's not a consistent message in your branding, Tamara explains. There's a disparity between messages, and it confuses your audience and dilutes your brand.

## Beginner Mistakes

What's the most common newbie branding mistake Tamara sees in the industry? Photographers who start out by trying to emulate their competition instead of separating themselves. When to try to copy your competitor in their branding, presentation, and style of images, it's an obvious imitation. Besides being noticeable to clients with a discerning eye, other photographers in your area may spot you for a newbie without your own style, instead of viewing you as a new artist to respect.

## Template Websites: Good Idea or Bad?

Wondering whether you should go with an easy and affordable template website, or splurge on something completely custom?

"For years, the advice has been to avoid a template website because it was difficult to stand out from your competition when you have a cookie cutter approach to a website. Now, templates are so customizable that two photographers can get a different look and feel from the same template."

This is great advice, as there are so many expenses in the beginning of starting your business; you want to keep your costs down so you don't go deeply into debt before you turn a profit.

## Match Your Branding to Your Target Market

Tamara shares that it's important to match your approach to branding to your target market and the methods that your potential clients use to find you. For example, when Tamara was photographing mostly high-end weddings, her target market was actually wedding vendors (as opposed to the brides themselves). In order to market to high-end wedding planners and caterers, it was critical to have polished brochures and fancy business cards that would catch the discerning eye of someone in the wedding industry who is used to working with lots of photographers.

**"Invest in reaching your target market. In order to do that, you have to know who your target market is and how they find you."**

© Tamara Lackey Photography

With her portrait business on the other hand, her clientele is reaching her mainly via word-of-mouth and online methods. Therefore, she doesn't need to invest in fancy promotional handouts, but instead invests in a great website design and search engine optimization (SEO). Those marketing methods are what bring people in the door for her, not brochures. So why waste the money on something that's not going to bring you business? By taking the time to understand your clientele and which marketing methods are effective, you can determine what pieces to invest in, and which ones are not needed.

## Should You Invest in a Branding Agency?

One of the biggest challenges for a new photographer with branding is figuring out who you are, what you are offering, and what your style is. A lucky few can answer these questions instinctively, the rest of us probably need a year or so to figure this out while our business develops.

# "Building your brand starts with you."

This is work that only you can do, and should be figured out before investing in a branding agency to create a new logo and customized website. If you haven't done the work to figure out what makes your business unique and separates you from your competition, a branding expert cannot figure that out for you, and you will mostly likely end up with something that isn't quite right, or isn't quite *you*.

"I didn't figure out my branding until a couple of years in. Most people don't have that clarity or focus right away."

This is common, and it's why I advise against investing too much in customized branding, websites, and brochures until you can truly understand what makes your work different.

## Relationship of Branding to Style

It's critical to understand your style and who your audience is, and how that relates to your branding. For example, if your style is about capturing kids at their silliest moments, you don't want your branding to scream edgy. That's a complete mismatch of your style and branding. It goes back to having a consistent message across the board. ■ ■ ■

# Pricing and Products

Different business models work for different photographers. There is no one right way to price your services, but there are some guidelines to understand so you can stay in business and earn a profit.

When pricing your services and products, there are many things to consider, including your costs to produce the product or service, your living costs, and other business expenses. Are you going to run a high-volume, low-cost business model or a low-volume, high-cost boutique business model?

When you are in business, your main goal is to earn a profit. This is different from your goals as a hobbyist. Pricing can be tricky; you want to book new clients, cover your costs, and earn a profit—otherwise it's not a business, it's a hobby.

Don't cheat yourself and rush through this process. You must put in the time to price yourself appropriately; otherwise, you might find yourself working at Starbucks next year.

There are also ways to adjust your prices by understanding how consumers shop; by using those concepts, you can create a pricing plan for your products to increase your profits.

How do you figure out how much profit you need? Here's a quick-and-dirty version to give you an approximation. Figure out the salary you need to earn and multiply it by 3 (or 4 to be conservative). This is what your business needs to gross in total sales, also known as total annual revenue.

Let's say you need a salary of $30,000 in order to make this business work for you. This means your total sessions and product sales need to be a minimum of $105,000 in gross sales. If you shoot sessions and include image files for $300, that's 350 sessions you'd need to do in a year. Not very realistic, is it?

My advice is to start with your business plan and your budget (refer back to Chapter 4). Without understanding your costs and overhead expenses, you are simply guessing. When you put together a business plan, you end up with market research and salary projections, and this kind of information should be the foundation for setting your pricing and packages. Of course, you'll need to adjust as you go.

## Need Help?

I've said it before, but I'll say it again. If you need professional help with your budget, pricing, and financials, turn to PPA's Studio Management Services. They will work closely with you to develop a financial plan, and since they work with photographers all over the country, they understand photography businesses like no one else.

## How to Price

How much should you charge for your products and services? It' a question every photographer faces and the answer is not simple—if it was, you wouldn't be struggling with it. The real problem is a lot of businesses are not sure how to price their products, and by starting too low they lose money every time they sell a product. This results in them going out of business… slowly. Pricing is no place for emotions; this is strictly business.

If you are a portrait photographer, I recommend visiting a local photography chain for a session. Not only will you get access to their pricing (which may be higher than you think) you'll also experience their sales presentation. You'd be surprised at how *effective* their tactics can be.

### Understanding Your Market

Understanding your target market, and figuring out what your ideal client is willing to pay, is an important consideration when setting your prices. You also want to consider your competitors' pricing so you have an understanding of the going rates for photography in your area.

Check competitors' websites, network with photographers, and ask mentors to give you feedback on your pricing. I do not recommend approaching competitors posing as a client. Most photographers can tell when they are being shopped by another photographer, and it can lead to a poor reputation for you.

In the Bay area where I live, wedding photography rates average from about $2,500 to $4,000. My competitors,

## Price Is Right

Do not look at your pricing from an emotional point of view (what you think you are worth, what you think your clients can afford, or what you can afford). You are running a for-profit business, and therefore you need to consider your pricing from a business point of view. Price for profit, otherwise your business may not make it.

however, serve the high-end market, with starting rates at $5,000 and some going up to the $10,000 range. How do I know this? From networking in the industry and being open and willing to share my pricing and knowledge with my colleagues (and competitors). When setting my own prices, I do not base my pricing and packages solely off my competitors, but I do consider it.

There is more on understanding your market in Chapters 3 and 13. In the end, part of the process will be experimentation on your part to see what the market will bear.

### Gross Earnings vs. Take-Home Pay

There is a big difference between your business's gross earnings and profit, which translates into your earnings. I cannot tell you how many times I have heard photographers (usually wedding photographers) talk about how they earned six figures in a year. Once you start to question the exact numbers, it turns out they *grossed* six figures but took home

about 30-35% of the gross revenue. This means you need to gross about $100,000 in sales to see a salary of about $30,000.

### Understanding Your Time and Costs

To understand the costs involved with a particular service or product, take a look at all the time involved to create the session or product from start to finish.

Make a list of everything included in a package's associated costs, such as flash drive if you include files, prints, canvas, album, album prints, shipping, proofs, proof box, packaging (bags, tissues, bows), etc. Add up everything and you have a total for your cost of goods for a package.

Now you want to understand how much time goes into creating a package. As an example, here's what you might estimate in terms of time to create a portrait package including prints, an online gallery, and a small album:

- *2.5 hours.* Client meetings and communications

- *1 hour.* Gear prep

- *2 hours.* Shoot

- *1.5 hours.* Drive to and from session

- *1 hour.* Download cards and backup files

- *2 hours.* Color correct/edit/cull

- *2 hours.* Retouch and apply actions (for a small shoot)

- *1 hour.* Prepare and order prints and proofs

- *1 hour.* Prepare image files for client and/or archival

- *1.5 hours.* Design album

- *1 hour.* Create client gallery and online slideshow

- *1 hour.* Receive and review prints from lab and album from binding company

- *.5 hour.* Package everything up (album, prints, proofs)

    *Total: 18 hours for a 2-hour portrait package*

When you see how much time goes into this package (not to mention lab, album, and packaging costs), you might find it isn't profitable for what you priced it at. (Whoops!) And this is before adding in costs of overhead, which you might not have too much of if you are starting out, but will need in order to run a business (insurance, equipment, marketing, sample products, business cards, brochures, website, and so forth).

Therefore, the pricing formula involves figuring out all of these costs—your time, the cost of goods sold (COGS), a portion of the overhead, and any other business expenses. This is how you become profitable and stay in business. You have to ensure your pricing enables you to earn a living; otherwise, you are just playing at an expensive hobby. To recap:

- *Cost of goods sold (COGS).* These are your hard costs to provide the package. Might include the album, prints, packaging, and other product costs.

- *Time required.* The number of hours you spend to create the package. Set an hourly rate you are comfortable with and that covers the expenses. Let's say $20 per hour makes it worthwhile for you: That's going to be 16.5 hours x $20 + taxes + withholding for insurance.

- *Overhead and other expenses.* As we discussed earlier, set a budget for your business to include all the expected overhead costs, and then divide that cost into the number of packages or sessions you plan to sell. Let's say the overhead and other expenses (like marketing) cost you a total of $22,000 to run your business annually. If you book 30 weddings, the cost of your overhead to factor into each wedding is about $750. That amount is a cost of doing business, and needs to be added to the price of every session or shoot. This is where many new photographers fail, and it can lead to bankruptcy. Not good!

It's a lot of work to do this initially, but it is essential if you are serious about your business. Once you get this groundwork laid, you can begin to look at different business and pricing scenarios:

- 50 portrait sessions per year (A) with an average sales package of (B)

    *A x B = estimated gross sales*

- 30 weddings (A) at an average sales package of (B)

    *A x B = estimated gross sales*

- 80 events a year (A) at an average price (B)

    *A x B = estimated gross sales*

- A combination of 20 weddings (A) with an average sales package of (B) plus 30 portrait sessions (D) with an average sales package (E)

  $(A \times B) + (D \times E) =$ *estimated gross sales*

By sketching out those different kinds of scenarios, you can see what different pricing options look like in gross sales. By doing this exercise, you will be much better prepared to create pricing, set goals, and determine the direction of your business.

Now let's look at these equations using real numbers.

## Weddings

Most established wedding photographers shoot between 15 to 45 weddings per year. The number of weddings they photograph depends on factors such as how well they market themselves, their reputation, their ability to perform well during consultations, and their understanding of appropriate pricing.

Some photographers prefer to keep their after sales (and the time involved) minimal so they can focus on shooting as many weddings as possible. On the other hand, many of those $10,000-per-wedding

photographers you hear about are perfectly happy to shoot no more than 10 weddings per year, allowing them to provide excellent customer service to a small group of clients, and to work fewer hours to be with their families.

Take some time to review the following potential scenarios to get a sense of what different pricing models could look like in your business. Keep playing with figures until you get to the number of shoots that feel reasonable and realistic for you, and then adjust pricing models to get to a salary you are comfortable with and that the market will bear.

- *Scenario 1:* 37 weddings with an average total sale of $2,800 per client (including after sales) = $103,600 in gross annual revenue. Aiming for the PPA standard of keeping about 35% of your studio's gross annual revenue, you'd earn about $36,000.

- *Scenario 2:* 45 weddings with an average total sale of $ 1,900 per client (including after sales) = $85,500 in gross annual revenue. Keeping 35% of that leaves you with almost $30,000 in take-home pay.

## Portraits

Established full-time portrait photographers tend to shoot between 50 and 250 sessions per year. An important factor that helps determine the number of sessions a photographer can do is whether she has a studio (where she can schedule several sessions per day and control the lighting) as opposed to doing sessions on location with available light (requiring more prep time and driving).

Are you interested in a high-volume business model with lower pricing, working with kids every day and shooting as much as possible? Or would you prefer a low-volume business with higher pricing, focusing on fewer clients and offering exceptional customer service? Can you see your business expanding to include several different photographers? Will you have a big focus on after sales (which takes time away from shooting to create and deliver the products)? Think about these issues and consider how *you* want to run your business.

Consider the following scenarios to get a sense of what you can earn with different pricing models. Adjust the numbers for your own situation. Once you get some final numbers you think will work for you, plug them into your budget.

- *Scenario 1:* 72 portrait sessions (6 per month) with an average total sale of $1,200 per session (including after sales) = $86,400 in gross revenue. According to PPA's formula, that leaves you with about $30,000 as your take-home pay.

**Photography is no get-rich-quick plan, but you should be able to make a living from it if you focus on the business and marketing strategies.**

## Pricing Tips

- Take time to educate your clients about what goes into photography, so they don't think you are charging $500 per hour. By educating your client on all the extra time, services, and value you provide, you are also educating them about why a cheap photographer is cheap—because he or she doesn't offer any of the extras you do.

- Build the costs of outsourcing production services (such as editing, color correcting, and album design) into your pricing upfront, even if you aren't ready to outsource yet. That way, when you get more clients, you can grow your business by outsourcing certain tasks, knowing that the cost is already built into your pricing.

- Be sure to get the session fee paid up front, at the time the session is booked. Otherwise, you'll have no-shows. The other reason you want to do this is to ensure the client has some budget left after the session to purchase products. Better to get that first payment out of the way and forgotten about.

- Many photographers suffer from early burnout for one reason: they eventually realize they aren't charging enough for their services, and with the many long hours they are working they end up making less than minimum wage. This is a *horrible* realization to come to, but it's common among photographers after they have a few years under their belts.

- Don't get caught up in comparing your prices to what you can personally afford. Most of the time, *you* are not your target client. Do you think I can personally afford my own wedding pricing, which currently begins at $12,000? *Heck no!* It's about what *they* can afford, not me.

- *Scenario 2:* 205 portrait sessions (17 per month) with an average total sale of $650 per session (including after sales) = $133,250 in gross revenue, and about $47,000 for your take-home pay.

With each of these scenarios, in order to increase profits you need to either increase the number of sessions (usually through additional marketing), the total average sale (by focusing more on your sales approach), or both. You might not get to these figures in the first year, but if you have a good road map, and you spend time planning and implementing new business, sales, and marketing strategies, you can get where you want to go.

## Consider Your Services

Are you providing a custom photography experience, or more of a get-em-in, shoot the same six poses, and get-em-out approach? Does your custom photography

service include creating portraits designed for the clients' personal tastes? Do you shoot on location, so each experience is customized to the client? Or do sessions take place at your studio with one backdrop and lighting setup, so it's easy to do multiple sessions in a day?

Be sure your pricing reflects the value of the services you are providing. Help clients understand this by educating them about the differences in your approach through the language on your website, what you say in consultations, and your handouts.

## Living Expenses

In order to stay in business, you need to be able to cover your living expenses. This means you must consider those expenses when pricing your services. For example,

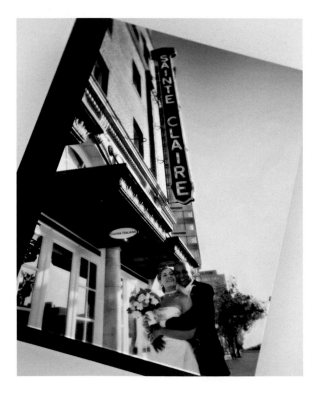

let's say you price your services at an average price of $1,500 and you expect to book 40 weddings each year. That's going to bring in a gross total of $60,000. Not too bad, right? Wrong. Once you factor in your overhead and COGS, you are lucky to end up with 35%. This means your salary is actually $19,800.

See how fast this can go downhill? The U.S. poverty threshold for 2012 for a family of three is $19,090. I'm not trying to scare you, my goal is to *educate* you on the realities of this business, so you can set appropriate pricing that will allow you to earn a decent living and keep doing what you love.

## Single-Price or Package Model?

Is it better to have a one set price or to offer packages? It depends on your personality, your goals, how much you want to shoot, your ability to sell yourself and products, and how you'd prefer to run your business. Both models work.

The first model is a single price for your time (the creative or sitting fee) and an à la carte approach to products.

Typically, this price model does not include image files; otherwise, there will be little to no after sales. If you are going to include the files, however, be sure to add the value of that on top of your creative fee.

The second model is a package model, where the client pays a flat price for both the shooting fee and products. For example, you charge a set fee for a portrait sitting and a collection of prints. A wedding photography package might include the shooting fee, an album, and some prints.

# The Pros and Cons of the Single-Price Model

**Pros:**

- *It's simple.* This pricing plan is best for those who want to shoot the photos and deliver the images, and not worry about upselling yet.

- *The client gets exactly what they want.* Sometimes the client doesn't need the prints or products, and à la carte pricing works well for them. Clients can order exactly what they need.

- *It's easier for lower budget jobs.* This type of pricing might help attract those clients on a budget who need the images taken now but can wait to get products later.

- *There's no negotiating.* Since the fee is for your time, there is little to negotiate. There is none of the trading one product for another or creating custom pricing, which can cause headaches for you and delay the booking process.

**Cons:**

- *It offers less profit.* Most photography businesses make more profit on the prints, wall portraits, albums, and extras than they do on the shooting fees. By not offering packages, you leave a fair amount of money on the table.

- *There's little chance to upsell other products.* It is tougher to upsell products if the client's mindset is to pay as little as possible for the sitting and then get their products somewhere else (like Walmart!).

- *You need to watch the time per job closely.* Since you are charging for your time, you need to make sure that the job doesn't run long.

- *You earn only when you are shooting.* In this model, you shoot more sessions, so plan your business accordingly. For example, limit your driving distance or make clients come to you. Scope out of a couple of local parks with shade where you can shoot most of your sessions.

## Single-Price Model

If using the single-price model appeals to you, make sure you charge enough for your time and assume you will not sell any additional products when putting your budget together. Remember, though, that doesn't mean you can't suggest other products. Make sure clients know what you offer and give them the opportunity to buy. Create a product guide and give it to every client, so they know the product options and prices.

When considering what to charge for a shooting fee, you need to figure out the total amount of time you spend on the job, which includes:

- Soliciting the job and meeting with the potential client

- Shooting

- Post processing

- Handling customer service, including talking with clients on the phone and answering emails

For example, if you are shooting an event and plan on being there 7 hours, you must take into account the hours required to download, sort, edit, and output the images; plan for the shoot; prep the gear; drive to and from; handle customer service and client meetings; book the client; and so forth. Instead of 7 hours, the actual time needed for the job is probably about 40 to 60 hours.

If you charge $3,000 for coverage, this is $50 to $75 per hour for 40 to 60 hours, *not* over $400 per hour for 7 hours of work (like the client might assume). Of course, you still have other expenses to include. We can't forget about adding in the additional costs of running your business, like overhead and marketing. Once you factor in *those* costs, you are left with less.

Let's say you have figured out you need to subtract $900 per wedding off the top to cover overhead and business expenses. Now we are working with only $2,100, leaving you with closer to $35 to 50 per hour. If you could earn that rate 40 hours a week, 52 weeks a year, that wouldn't be bad at all— but that's not the reality of this business.

Another way to look at this is: can you make a profit photographing a wedding for $2,000 or whatever figure you have in mind?

That depends on the number of weddings you will shoot in the year and your costs.

If you book only one wedding a month, that's a gross profit of $2,000 a month or $24,000 a year gross revenue. Is that enough? Considering the 35% model (according to the PPA), your actual earnings would be in the neighborhood of $8,400. This is not fun to think about, I know. However, do the hard work now, and save yourself many years of frustration later. It's possible to run a photography business and love your life, but you have to set yourself up for long-term success.

### Package Model

Now let's talk about package pricing. These are usually associated with weddings and portraits, but can easily be applied to other types of photography businesses. It is a matter of combining the costs of the photography time with a set of additional services or products.

But how to come up with a set of packages and what to price them? Let's say you offer three packages, one for $3,000, one for $5,000, and another for $7,000. Most people will look at the three choices and go right for the middle one. They perceive the cheapest to be the lowest quality, while the most expensive is too much, making the middle one *just right*.

Look around at how other companies do this all the time. There is a good reason the iPhone and iPod come in three sizes. Each comes with a different memory capacity and for many people it's easiest to justify getting the middle one. Seems like the best balance between memory and money, right?

# The Pros and Cons of the Package Model

**Pros:**

- *It offers more profit.* The big advantage to the package pricing model is that you can earn more money by charging for products as well as the cost for your time. The client spends more and gets more. Note that your cost of goods will be higher, as well, so of course factor that in.

- *There's opportunity for upselling before and after.* It is easier to upsell when you are already selling the base product. For example, since clients are already buying an album, it's not a big stretch to increase the number of pages—and therefore the profit. We pre-design albums with extra pages for all our clients. Selling extra album pages is a major profit generator for my business.

- *You can service a variety of clients.* You can have different package price points for different clients. It also allows a client who comes in and purchases the lowest package to upgrade later, which increases your profit from the same client.

**Cons:**

- *You have to negotiate.* The downside of this type of pricing plan is that clients feel like they can negotiate, adding one service in place of another. It can become a hassle to revise a pricing quote multiple times, *especially* if you do not know your true product costs. It's important to make sure you know the bottom line and what each of the components actually costs you so you don't end up losing money when negotiating.

- *It adds complications.* There is more to keep track of, including the ordering, creation, and delivery of the products. With albums, for example, you may not be able to get the client to confirm their order for *months* (or even years), meaning you have a lot more projects to keep track of.

- *There's more client management.* When you have products to be selected and ordered over time, there is a lot more back-and-forth communication with the client. Even though the session is long done, you might still be working with that client for many more months.

In my experience, having a set of three to five packages works extremely well. The lowest package offers good value for the budget-minded client while the top package is designed to make the others look more affordable. Most people want the middle package, as it feels like the safe choice. However, I *always* sell a few of my most expensive packages every year. When clients tell me they want the most expensive package, I always have to remind myself to act as if it's perfectly normal!

# Package Pricing Tips

■ *Include a whopper package.* Your collections should always include a whopper package, priced beyond what you think you'd ever sell. This package helps make your other packages look affordable, but it also appeals to the big spender who wants the best. Every year I sell at least one whopper package and it always floors me when a client wants that package. Those clients usually end up buying a triple volume album set in the end (because we pre-design and suggest it to them), bringing their total spending to tens of thousands of dollars. It's nice to have a few clients like this each year.

■ *Start with your highest priced package first.* This gives your clients a moment to experience the sticker shock with your highest package, and then move on to the less expensive options. By comparison, your middle package now looks affordable. This is classic pricing psychology.

■ *Offer a basic package.* This is priced to get people in the door, but it doesn't have all the bells and whistles. For example, we used to offer a package that included six hours of coverage only. We never booked this package (and we didn't want to), but because it was priced affordably it brought people in who didn't think they could afford us. Once they saw the value in our services, they were willing to invest more.

■ *Create an odd number of packages, such as three or five.* This allows for a natural middle package, which is likely your most popular. It should offer the most requested essentials in terms of coverage and products. People don't want to buy the cheapest package, but they usually don't want the most expensive one either.

■ *Keep after sales in mind.* If you like to sell extra album pages, allow room for add-ons in your packages. For example, most of our packages include 20- or 30-page album credits, and most clients purchase additional pages after they see the images.

■ *Fill your upper packages with low- or no-cost items you can produce quickly.* This adds value without driving up costs. Examples include a slideshow or a few gift prints.

■ *Take note of package items clients frequently want to swap out.* These products are not perceived to be of a high value, and in future package revisions you might want to omit these items altogether.

■ *Make sure you know the exact costs and profit of each package.* For example, if you have only $700 profit in a certain package, you might not be able to justify reducing the price at all, but you could add in a low-cost bonus item. The biggest mistake in negotiating is to agree to a price that cuts out all profit—or worse, *costs* you money.

## Working for Peanuts

There seems to be a philosophy in the photography business suggesting that those starting out need to pay their dues or work their way up the business ladder. This is the kind of advice given on many photography forums, especially when it comes to discussing pricing.

The people who are suggesting this are not on your side. Don't misunderstand me; the photography business is not easy and if you charge too much for an inferior product, your business will not succeed. Many of the photographers who think you need to suffer through the starving artist phase of your career are thinking like artists and not like business people. Chances are you may struggle financially in the first years of your business while you figure everything out, but to purposely price yourself too low (or even worse, work for free) is a recipe for financial ruin.

There is one other important thing to know about pricing yourself too low: It undervalues your work. There is a perceived value to anything you buy, and pricing is the first indication of the value of a product. Take a car mechanic for example. If you need a car repair and get quotes (say $1,000 to $1,200) from a variety of mechanics and then come across a mechanic who quotes $300, your immediate thought is he won't do as good a job as the others. The same is true for your pricing. You are telling the client how to value your work.

Finally, you need to make sure you are not giving away too many extras that cut into your profit. Are you the photographer who gives away the image files with every shoot, guaranteeing zero product sales later?

We used to give away image files with all engagement sessions. It never occurred to us how much money we were throwing away until the following happened.

One day at a wedding, we headed into the reception to photograph the details. To our absolute horror, the clients used their engagement files to decorate the entire reception. They had an album professionally designed (by someone else), a large portrait, stickers on the favors, photos as table signs, and a slideshow. The worst part was, they purchased all *kinds* of products…from someone else. Now they hadn't done anything wrong, but we were upset to see a cheap representation of our work and *we* allowed someone else to profit from our work. We should have had a great sale from the client since they obviously loved our work. The next day I changed our packages so this would never happen again.

We now offer the files as a bonus with a minimum engagement product purchase of $1,000 or more. Alternatively, clients can purchase only the files for $800. If a client is considering a product and they want the files, it can be enough to justify the purchase. It's a great way to make your clients feel they've gotten something extra.

**Are you running your business like a business, or are you running it like a hobby?**

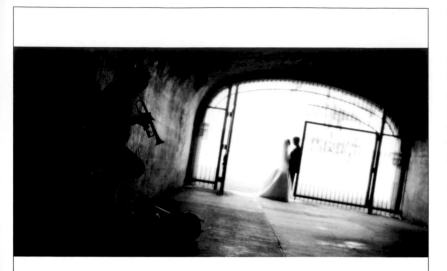

# GEOFF**WHITE**
## PHOTOGRAPHERS
## 2013 WEDDING PRICING

We use the package pricing model at Geoff White Photographers and it has been successful for us. We've found that clients often upgrade to a larger package because they see the value in the extras offered in the package just above what they originally had in mind. Here are the three packages we offered for our 2013 weddings.

## DREAM

2 Photographers up to 7 hours

20 page Magazine Album credit

Wedding Digital Negatives on CD

Wedding Gallery

12000

GEOFF**WHITE**
PHOTOGRAPHERS

## SIGNATURE

Bay Area Engagement Session

2 Photographers up to 8 hours

30 page Magazine Album credit

Two 10x10 Parent Albums (40 images each)

16x24 Gallery Wrap

Wedding Digital Negatives on CD

Wedding Gallery

$200 print credit

17000

## ULTIMATE

Bay Area Engagement Session

3 Photographers for 9 hours

Two Volume 40 page Magazine Album credit

Two 10x10 Parent Albums (40 images each)

16x24 Gallery Wrap

Wedding Digital Negatives on CD

Wedding Gallery

$300 print credit

22000

**GEOFFWHITE**
P H O T O G R A P H E R S

# Boudoir

**Eye Candy Collection   $1500**
1hr Luxury Studio or on location session
7x7 album
8 wallet prints
Online hosting of images

**Dolce Collection      $2450**
2hr Luxury Studio or on location session
10x10 album, 30 pages
$500 Wall Art credit
Mini Brag book
Gift print collection (7 gift prints)
Online hosting of images from your order
Complete set of digital negatives

**Popular Add-Ons:**
| | |
|---|---|
| Hair & Makeup | $170 |
| Gallery Wrap - small | $350 |
| Gallery Wrap - standard | $450 |
| Gallery Wrap - large | $650 |
| Brag Book | $165 |
| Bedroom Box | $800 |

Here are some portrait packages we offer at GWP.

# Maternity

**Pea in the Pod Collection   $1875**
Maternity studio session
$500 wall art credit
Newborn studio session
50 custom announcements
Gift print collection (7 gift prints, 2 poses)
Online hosting of images from your order

**Hot Mama Collection      $2225**
Maternity Studio Session
20x20 Framed "Baby Elements"
$350 Wall Art credit
Newborn studio session
50 custom announcements
Gift print collection (7 gift prints, 2 poses)
Online hosting of images from your order

**Popular Add-Ons:**
| | |
|---|---|
| Hair & Makeup | $170 |
| Extra Announcements | $3.50 each |

# The Real Cost of an 8x10

Wondering why some studios charge $50 or more for an 8x10 print? The answer is simple: They understand the costs involved in producing an 8x10. When you break down every cost involved in an 8x10, (the cost of goods sold, or COGS), you realize what you need to charge to make it profitable. Here's our cost breakdown of an 8x10:

- 8x10 printing: $2
- Retouching and ordering print: $10*
- Box: $1.50
- Postage: $3
- Tissue (to wrap print in): $0.25
- Print sleeve: $0.25
- Sticker: $0.25
- Craft paper (to wrap box): $0.25
- Address label: $0.25
- Time to package and mail: $5.*
- TOTAL COST (COGS): $22.75

* Consider going rates for shipping and retouching. Look at what your lab charges for retouching—at $15 for a head swap, $10 to remove shine, and $6 for standard retouching, it adds up quickly. How about shipping and handling? Again, look at what your lab charges to drop-ship an order. Price yourself at least at what the lab charges. It's tempting to think a head swap will only take a few minutes, but it's those little 5 minute jobs that keep you at your computer into the wee hours of the morning.

Once you look at it this way, it's easy to see why successful photographers charge what they do for an 8x10. The size of the print doesn't affect the cost much, as that's only a bit more paper. The value to your client should be in the image itself, not the cost of the paper it's printed on. At Geoff White Photographers we charge the same price for all prints 8x10 and smaller.

If you are worried about your 8x10 costs, compare your costs to the local Walmart portrait studio or Picture People, who are charging $20 and $18 per 8x10—and remember these images are typically created by people with no real photography training other than to push a button. Your work is worth more than that, right?

## Products

Let's look at some products. You need a good mix of affordable and higher priced items to ensure there is something for everyone and you are not missing out on potential sales by offering only the basic prints and albums.

If you are a sports photographer, cover the local news, or photograph concerts there is not going to be much of an opportunity for after sales. However, if you photograph high school seniors, pets, weddings, family, maternity, boudoir, or kids, after sales should be a big part of your business if you want to increase your profits. In Part 3, we'll talk about how to actually sell these products, but for now, start thinking about the different types of products you can sell.

1. *Albums.* Vendors offer a wide variety of albums for every budget. Some album companies will design, print, and bind the album, so you don't have to learn how to design albums or put time into album production, but you still get the benefit of the sale.

2. *Framed collages.* This is a popular item and it's ready to hang when the client receives it. We get our framing done through GNP Frame, and send the print directly from our photo lab to make everything super easy.

3. *Canvas wraps and metallic prints.* These are not something clients can print at home, making them great products to offer. They are ready-to-hang products, so you don't need to mess with framing.

### What Types of Products to Offer?

Look at some of the products offered by your photo lab. It's a great way to get ideas, and your lab rep will be happy to educate you about best-selling products to give you an idea of what clients are buying.

4. *Printed notecards.* Save-the-date cards, thank you cards, holiday cards, and birth announcements are popular products but you have to price them carefully in order to maintain profitability. Make sure to set a minimum order on these so you get paid for your time.

5. *Retouched image file.* This is a single image delivered in a variety of sizes and formats depending on what the client wants. Charge for the time involved in retouching and preparing these image files, otherwise you are taking time away from profitable activities when you do freebies for your clients.

6. *Proof prints.* This is a complete set of prints from a session or wedding. Proofs are usually sized at 4x6 or 5x7 and contain a complete set of the images from the shoot.

7. *Digital files.* The price of the full set of digital files needs to be high enough to make up for any after sale losses. By supplying the files you are allowing clients to get the prints and other

## My Album Suppliers

We use Leather Craftsmen for flush mount albums and Queensberry for matted albums. For engagement albums, I prefer the Leather Craftsman 700 series album with black mats and space for 20 5x7 images on the right side (so there isn't a blank page for the areas with no signatures). This has been our best seller in the engagement products category. I also offer a slightly less expensive option to the high-end matted album. I like the 10x10 Asuka Book with no more than 25 images, to minimize design time.

We also offer a template-designed coffee table style engagement album at a lower price point.

Our matted engagement album is one of our best-selling products.

products from someone else. Set the price to make the session worthwhile if this is the only purchase.

8. *Signature portrait.* The image is printed and mounted with a mat wide enough for guest signatures. If you aren't sure about the amount of space needed for the signatures, ask the frame company for advice.

9. *Slideshows.* You can put together a slideshow quickly if you have the software. The other cost involved is packaging. Slideshows can be sold individually or used as a bonus item to generate higher sales.

10. *Image boxes.* This product works particularly well for boudoir clients and as a high-end portrait product. It makes a great mantle display with a tabletop easel and is a way to help clients enjoy (and purchase) a number of images.

11. *Folios.* These are a relatively inexpensive product and are great to display a couple of small images in a hutch or office. Some album companies offer these gorgeous folios in beautiful silks.

12. *Mini accordion albums.* These are great sellers for senior portraits and baby photographers. It's an inexpensive item, easily carried in a purse and shown off to friends and family.

13. *Jewelry and handbags.* These products are popular with newborn and baby photographers. Find a specialty vendor online to order some samples.

Once you have figured out what products to offer, you need to order samples to show in client meetings, and design a product guide (using images of your samples) to give out to every client. If you don't show it, you won't sell it.

(1) Album.

(2) Framed collage.

(3) Canvas wrap.

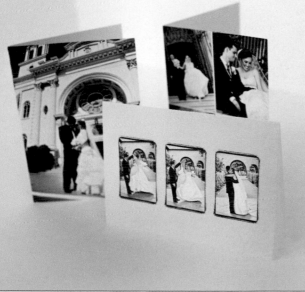

(4) Printed notecards.

(4) Save-the-date cards.

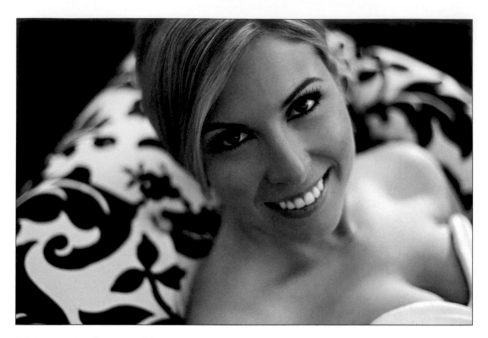

(5) Retouched image file.

(6) Proof prints.

(7) Digital files.

(8) Signature portrait.

## Not Ready for In-Person Sales?

Once you have pulled together images of all your products, compile a slideshow on your tablet to share with clients immediately following the session while clients are still on an emotional high. Take a few minutes to review all the different finished product options so they can start thinking about what they might want to order when the images are ready. It's all about planting seeds for a future sale.

(9) Slideshow.

## Product Sales Tip

Photograph all your samples as well as client product orders so you have lots of images to show of what you offer. Before each session, send clients a printed or digital product guide. If they don't know what you offer, how can they buy it? Follow up with them at the session to see what products they are thinking of. Sometimes all it takes is a gentle reminder to get the product order.

Because our starting price is high, we put it on our website. The argument for not making your pricing available online is to meet with clients in person so you can convince them of your value. In my case, however, no amount of convincing is going to make someone change her budget from $3,000 to $12,000 for wedding photography.

## Other Pricing Considerations

There are a few other issues related to pricing that may come up for you. Here's how to handle them:

### Pricing and Sales Tax

Don't be fooled into allowing clients to get away with not paying sales tax, otherwise you will get stuck with the bill. Clients may balk at this, but it's the law. Clients do not refuse to pay sales tax in retail locations, so do not allow yourself to be taken advantage of.

### Friends and Family Discounts

Should you offer your services to friends and family at cost or for free? It's only a couple of hours to shoot their wedding, right? Wrong. When you consider that you will have 40 to 60 hours involved from start to finish, it seems like a lot to ask, doesn't it? That's going to take your focus away from a paying client or marketing your business while you work on their wedding.

### Pricing on Your Website

It makes sense to put your starting price on your website in order to give potential clients an idea if they can afford your services. The more expensive you are, the smaller the client pool. In this case, you want to do some prescreening to ensure you aren't wasting your time or clients' time by giving them an idea of your pricing before they meet with you.

Are you wondering how you are going to sell all these great products? I know, sales can be scary. I hope that now you can see how essential it is to price your services carefully and offer a great product mix to benefit from after sales. In Part 3, we get to the sales process, and I'll share with you the various sales tools, techniques, tips, and tricks I use to sell all these great products. ■ ■ ■

## Selling Products When Meeting in Public Spaces

If you don't have your own space for client meetings, it's impossible to have products on display for clients to look at. However, you can still show all your great product options—just use product photos. We have images of all our products on our iPad, and showing those images is a regular part of our off-site consultations. It's a great way to plant seeds for a product sale later.

## Fantasy vs. Reality

| | |
|---|---|
| Earning $500 for an hour-long portrait shoot is great money. | There is only 1 hour of actual photography, but 7 to 10 hours of office work and retouching. |
| You don't want to nickel and dime the client for every little thing. | If you don't charge for all your services, you will lose money on every job and end up out of business. |
| Every client will buy the most expensive package. | Most will take the middle-of-the-road package, so make sure it is priced properly. |
| Every job will take the exact time you calculate and the pricing will be fine. | Sometimes jobs run long and the profit can disappear quickly. |
| You made 6 figures in your first year. (Wow, congratulations!) | You only cleared 30%, meaning you actually made $30,000. Doesn't quite have the same ring to it… |
| Your business is profitable because you get paid thousands for a day's work. | You need to consider the time and costs for all the jobs you do to see if you are actually making money. Many times photographers are surprised to find that they earn less than minimum wage. |

# Clients and Customer Service

A happy client equals more work as they return and recommend you to their friends and family. Do you know what it is that keeps a client coming back and why they recommend you to others? What is it that you did to create such goodwill? Sure, the quality of your work is important, but chances are it's your great customer service that puts them firmly on your side.

So how do you get your clients on your side? That's what this chapter is about: the basics of great customer service, including learning how to educate your clients and manage their expectations, along with suggestions of how to deal with difficult situations.

## Customer Service

Strive for great customer service all the time. Don't focus on it part-time or when something has gone wrong. Consider the last time you went out to dinner and had a great meal but lousy customer service. Did it ruin the meal? Would you recommend the restaurant to your friends and family? Chances are you would not go back because no one enjoys bad customer service.

Here's what it boils down to:
*Be nice, be genuine, and be authentic.*

Show you care about your clients and that creating a fantastic experience is a priority for you. The more the clients can relate to you and enjoy the relationship with you, the better the experience. You must build a genuine relationship with your client, one in which you care as much about the outcome as they do.

Follow these basics of great customer service and your clients will appreciate it.

- *Don't be late—ever.* Punctuality is important. Tardiness sets a bad tone for a client and makes them think you don't care or that you cannot be trusted.

We frequently order 7x7 sample vendor albums (by Asuka Book) for wedding marketing. We also order a 5x5 purse-sized album as a complimentary gift for the bride as a way to say thank you (and increase our word-of-mouth marketing).

- *Call a client instead of emailing when possible.* One-on-one human interaction is crucial when connecting with your clients and building a bond. This is especially important for discussing sensitive issues such as payments or problems.

- *Answer email and phone calls promptly.* Return phone calls and answer email within 24 hours. Wait any longer and it seems as if you don't care.

- *Put the client first.* Make the client feel special, unique, and happy with all of your services. Be understanding of what they are going through. If a client calls you with an urgent request, concern, or question call them back as soon as possible.

- *Send handwritten notes.* Clients love getting handwritten thank you notes. These personal touches set a professional tone and a sense of individualism.

- *Check your equipment.* Make sure your equipment is in good working order and that you have everything you need. Showing up without the proper equipment sends a distinct message that you don't care about the job.

- *Be positive.* Never tell the client that her hair looks bad, her attire is wrong, or that you don't like her makeup. Whatever it is that isn't working for her the day of the shoot, you need to work around as best you can.

- *Be polite.* Always say please, thank you, and you're welcome, and don't ever hang up on a client. Even if a client is being rude, sometimes he simply needs an opportunity to vent and feel his concerns are heard.

## Send Gift Prints or Thank You Freebies

Surprise and delight your clients with an unexpected gift, such as a gift print, photo stickers, a mini album, or some other low-cost item that shows you care. You can send a token gift after the session, around the holidays, or for a birthday or anniversary. Choose something that costs little but goes a long way in customer service.

- *Dress and act professionally.* Always appear professional to a client in how you look and address them.

- *Give a little extra.* Try to add a little extra something for the client. This doesn't mean giving away the store, but a little something to make them feel like they got a great deal.

- *Get feedback.* Want to know how great your customer service is? Ask the customers. Consider the two-question survey: How would you rate us from 1 to 10 and what can we do better? After enough feedback, you'll spot areas of your business that need improvement.

- *Create a great experience.* You want your clients to have a good time and relax at the shoot. Be in a good mood and have fun with them. If they enjoy themselves, it will create a great experience and they will remember that.

## Highlight a Good Deal

If you are a commercial or fashion photographer with your own lighting equipment that other photographers normally rent (and invoice the client for), you can create some goodwill by listing the rental fees on the invoice, and then showing it as a deduction, letting the client know that you are looking out for them and giving them something extra. This can be applied to many circumstances, where you show a cost for a service (the value) and then the discount.

## Managing Client Expectations

Expectations are a significant component of your client relationships. Meeting or exceeding client expectations will earn your client's trust as well as referrals and word-of-mouth marketing. Fail to meet their expectations, and the once good relationship can sour quickly.

That's why it's critical to outline up front what your clients can expect from you and the process. This also lets them know you take customer service seriously.

By the time you meet with them, your clients' initial expectations have already been set from experiences they've had in the past with photography, stories from their friends, experience working with hobbyists who don't charge, television shows, and department store portrait studios. It's up to *you* to communicate your approach to photography and what clients can expect from you. If you don't, they may expect to have a similar experience as to working with Uncle Bob photographer who spent 2 hours with them and gave them 700 image files free of charge.

It all boils down to communication. In order to give your clients the best experiences possible, start communicating with them before you even meet with them, and continue to communicate at every step along the way.

The following sections discuss some ways to lay the groundwork for managing expectations.

### Website

Make sure your website and portfolio match what you can actually do. It needs to not only show off your technical skill but also show your style. Your website and portfolio should also act as a filter so that clients looking for services you don't offer don't waste their time and yours.

# Managing expectations is about preventing problems before they happen.

Don't show work that you can't consistently produce. Your portfolio should be a representation of the work that you specialize in, and the style of images a client can expect when working with you.

Your website is a great place to introduce your pricing for common products, packages, or services. This allows a client to acclimate to your pricing, thus avoiding sticker shock later on. If your pricing is competitive, it might be to you advantage to let potential clients know your services are affordable.

## Initial Client Meeting

This is your chance to cover everything from how many images they will receive to how soon images will be ready, pricing, and the ordering process. If you don't include digital files, this is the time to cover that.

During the client meeting, cover your process in detail, and allow time for questions. Don't skip over any areas that might be a disappointment later; if you don't offer online galleries and all ordering is done in person, let clients know that up front.

## Contract

A contract that spells out exactly what the clients can expect from you and when they can expect it goes a long way toward preventing misunderstandings. That way, if there is a problem you can refer back to it. This is especially important if the client later wants something that falls outside of the agreed-upon contract.

## Client Handouts

Client handouts are another great way to outline what clients can expect from you. See the section, "Educating Your Clients," later in this chapter for examples.

## After the Session

Once the session is finished, take a moment to cover the details regarding the next steps, even if you have already covered this. Let the client know when they can expect to see images, how many images they should expect, and what the next steps are for any product orders.

Practice a talk track to address some common difficult questions and issues:

- How many images will I get?

- Can I have the outtakes?

- Can you stay an extra hour free?

- Why can't I have the RAW images?

- Why can't I get the files?

By having answers to challenging questions prepared in advance, you'll be able to handle client objections with confidence and win them over to your way of thinking. Be sure to highlight the *reasons* they will benefit, so it doesn't appear you are simply trying to get more money. For example, if a client complains that you don't offer online proofing, explain that part of the customer service you provide is expertly guiding your clients through their orders to make sure they get the best products for their needs.

One of the best things you can do to provide a great customer experience and manage expectations is to under promise and over deliver. If it normally takes you two weeks to process a shoot and get prints in, tell the client to expect images in three—that way you can surprise the client with images sooner than they were expecting. If things are behind schedule, you have a week of built-in cushion time. Here are a few ways to ensure your client's expectations are managed:

- *Understand what the expectations are.* It is difficult to manage a client's expectations if you don't know what they are. Ask what the client expects from you so you can make sure that you either deliver those results or change the expectation. Sometimes the client doesn't know what to expect, or has a fuzzy idea of what they will receive.

- *Clearly state the scope of the job.* Make sure both you and the client know the exact details of the job. If you are photographing a commercial job, for example, they need to know exactly how long you will be on-site, if there will be assistants, and when images will be delivered.

- *Don't take on more than you can do.* It is tempting to say yes to every job offer, especially when starting out. If the job is beyond what you can handle, don't

## Managing Expectations for Portrait and Wedding Clients

Here are the six most common issues that can cause problems later on if not addressed in the initial client meeting:

- How much time is included, and is there an overtime fee?

- How many images will the client receive?

- When will the client receive the images?

- What's included and what's not included in the price?

- What is the pricing for sessions, popular add-ons, and products?

- Will an online gallery be available, and if so, for how long will it be available?

By going over these basics up front, you are managing expectations from the get-go.

take it. It's a better idea to recommend a photographer more suited for the job. If you are a real estate photographer and are asked to cover a sporting event, chances are you won't have the practice or gear to do it properly. Recommend a sports photographer to the client, and when someone comes to them looking for a real estate photographer, they are likely to return the favor.

- *Explain your work/workflow.* Remember that your clients are probably not photographers and don't know how long it takes to complete the final products. Educate them about the steps in the process and how long each one takes.

## Educating Your Clients

To build long-lasting relationships with your clients you need to educate them about what you do and how you do it. Educating your clients goes beyond managing client expectations. While managing expectations has to do with communicating and preventing problems down the road, educating clients is about helping them get the most from their photography.

Think about the things that you wish clients knew in order to have a better photo session. There are a lot of things clients could do to get the most enjoyment from their photography experiences.

# WHAT to WEAR
## on your ENGAGEMENT SESSION

## STYLE

Flowing white shirts and khakis on the beach. Formal attire in jewel tones. You can't go wrong with these tried and true looks. If you are looking to showcase your personality, we encourage you to be your most stylish self! The cardinal rule of dressing for portraits is simple: choose items for the couple as if you were creating one outfit. If all of your choices were somehow on one person, would the result be pleasing, color-wise? A handy trick for those who are hesitant to break away from the monochrome method is to choose one patterned item (for example a print dress for the woman) and then select the rest of the clothing from colors within that pattern. For more formal portraits, we recommend sticking to the classics: simple solids never go out of style! The choice is entirely up to you.

Now that you know some basic tips, how do you put it all together? A good place to start is by defining the style sensibility you want your session to reflect. Do you want to capture your typical style, or perhaps a more formal or casual version of that? Look at the furniture around your home, or notice the magazine spreads to which you are drawn. Chances are that these preferences have everything to do with your clothing style and can point you in the right direction for your session wardrobe choices.

## ACCESSORIES

Our recommendation is for simple and clean lines but if you have a piece of jewelry that has sentimental value, is a fashion statement, or something you just love we'd recommend wearing it. If you are a person who wears chunky pieces of jewelry with an understated outfit, this would look great on camera. It is our recommendation that keeping the clothes or jewelry, one or the other, understated is always the best look for the camera so we don't lose you in the picture.

## HAIR & MAKE-UP

We recommend coordinating your bridal makeup trial the same day as your engagement session. This way you can have your glamorous wedding day look in your engagement photos. Professional artists will know how to apply makeup differently for the camera. You'll want a bit more drama and glamour than usual to your makeup as it appears lighter on film. Emphasize your best feature, bring your lipstick to reapply during the session, and you'll love the final results! For your hair, it is always best to bring along any bobby pins, hairspray and combs, that you might need to retouch throughout the shoot in case a gust of wind hits or you feel your hair coming out of place.

If you don't normally wear makeup, we recommend a light application for the camera to bring out your features and even out skin tone. It is our strong recommendation that you apply mascara or lipstick for the shoot to emphasize your features on camera more. If you have great eyes, a little brown liner and mascara will help to emphasize their beauty, and gives more structure to the way you appear on camera.

## DON'T BE AFRAID TO PLAY WITH COLOR IF IT SUITS YOUR PERSONALITY

Bold, deep, rich jewel tones are amazing on camera. If you know you can wear pinks, then a bright fuchsia can work. If you wear oranges, a hot auburn tangerine color will make the pictures pop. We'd say wear something that compliments your skin tone: Warm or Cool. A test to see which one you are is to hold something gold next to your skin, then something silver, and see which one looks better on you. Gold means you are warm and silver means you are cool. Find a color palette that compliments your natural skin tone and have fun with the color choice you make. Or, maybe you want just a small tint of color and opt for purple heels or yellow shoes with a black dress? It's all up to you. If color is not your preference then a structured black pant with a neutral top can work just as well.

**TIP: Vibrant colors that set off eyes and hair are always in fashion: Try red-heads in emerald solids, and blue shirts to make blue eyes sparkle.**

# the**FIRST**LOOK

A First Look is one of our favorite new trends in weddings. In case you haven't heard, a "first look" is when the bride and groom choose to see each prior to the ceremony in a more private, intimate setting. There are many reasons for doing this, and as a your photographer, we highly recommend you consider this option. Read on to hear more thoughts about it.

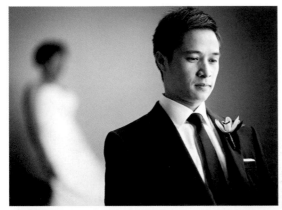

### HOW IT WORKS

We set up the first look in a beautiful and private spot, and we will typically stage the groom in one location with his back turned, and have the bride approach and tap him on the shoulder. We position ourselves to discreetly capture the expression when you first see each other as well as all the emotional moments that follow. Those few minutes alone together are most likely going to be the only time the two of you have together all day, so it's a wonderful way to connect.

We try to stay in the background so the two of you can embrace, whisper into each other's ears and spend a few quiet moments cherishing the day in each other's arms. Once you are finished, we will go right into the romantic portraits of the two of you, often finishing off with the bridal party and family portraits.

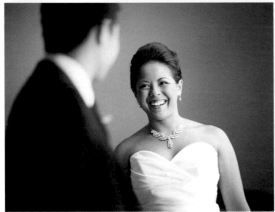

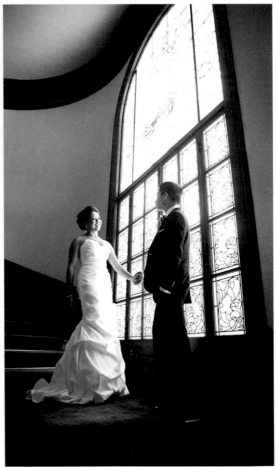

# the**FIRST**GLIMPSE

*EJ: We agreed that having a "first look" before the ceremony would be best in terms of timing. It turned out to be a great choice as we really enjoyed seeing each other in a much more private moment and pushed any remaining nerves away. We spent 45 minutes wandering around the venue, **just relishing in each other's company and soaking in the excitement of the day.***

# the BEST MOMENT
## of the DAY

Erin: *The first look is an amazing moment to share with you and your fiancé right before you walk down the aisle. I would recommend this to other brides because it allows you to not only maximize your wedding time line but to also have pictures taken when you are both looking and feeling your freshest - hair, makeup, clothes, etc. are in their best condition. It's also great to see each other before you walk down the aisle to help with your nerves a bit and know that you are doing this together, as a partnership, and that it is really one of the best days of your life. My groom got a little nervous when he first walked into the room to see me but as soon as he got to where I was eased a bit.* **That's what having a first look is all about - ease, connecting, and sharing a final single moment together.**

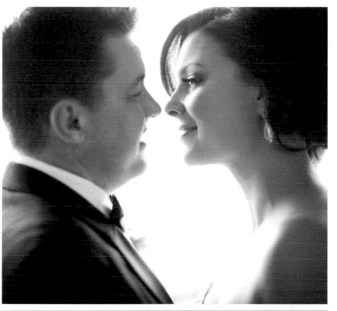

## EMOTIONAL STRESS is RELIEVED by sharing a single MOMENT TOGETHER

If you are the type to cry and get very emotional, you can do that privately with each other as a couple instead of with 100 people watching you. Sometimes brides get SO NERVOUS about walking down the aisle, they are hardly aware of what is going on. They don't really **experience the ceremony** itself because they are a bundle of nerves. **Be fully present** in the moment by getting those crazy nerves out of the way. Nothing to bring you back to center than a few moments alone with the love of your life. It works wonders, trust us!

141

For example, you know most of your female clients would benefit from professional makeup prior to the shoot. You know that a toddler is not likely to be cooperative through seven outfit changes. But how would the client know these things unless you educate them?

In our business, we identified two areas of knowledge that clients would most benefit from. If clients would take our advice around these two things, they would have vastly better engagement images and a more relaxed wedding day.

In engagement sessions, we noticed that sometimes we'd get fashion savvy clients who'd show up for their sessions dressed to the nines. Other times, clients would come straight from work, and hadn't run a comb through their hair, had bits of lunch on their clothes, or were dressed in plain, unflattering tee shirts. Not only did the well-dressed clients have more confidence at their sessions, their images turned out better because they actively participated in making that happen.

We put together a client handout on how to dress for their sessions (see handouts on previous pages), which we email to them prior to the session, as well as schedule a pre-session phone call to discuss clothing options with them over the phone. Once we began educating our clients on what to wear to their sessions, we noticed a *huge* difference. Now all of our clients arrive looking ready for a photo shoot.

With weddings, we noticed a big difference in quality when formals were done prior to the ceremony. Traditionally, formals are done following the reception, and people don't have much patience for standing and smiling when they want to be hugging and congratulating.

On the other hand, when formals are done prior to the ceremony, everyone is happy and relaxed. There's no pressure on you to get it done quickly, and families tend to enjoy the experience instead of rushing through it. However, without understanding the benefits, most couples have no reason to buck tradition. Most clients end up choosing to do what we call the *First Look*, because we take the time to educate them in our client handout (see previous pages).

# Policies

Your studio policies need to protect your company and at the same time create strong ties with your clients. Every business is different and requires different policies.

You need to establish policies for products, late appointments, cancellations, deliverables, time frames, and so forth depending on your business. Provide your policies in writing to the client. This allows them the opportunity to voice concerns or questions early on. When you write up the policies, highlight the benefits to the client so they are more likely to get onboard.

Here are a few things to consider when creating your studio policies:

■ What are common client misunderstandings in your type of business?

---

### Album Design and Ordering Policies

- GEOFF WHITE PHOTOGRAPHERS will pre-design an album with artist-selected images to give you the benefit of a complete storyline. We work with you to finalize image selections and design, offering our expertise as needed.

- Albums include two rounds of revisions. The first round is for the majority of the revisions (90%), and the second round is for final changes (10%).

- If you require additional revisions or retouching, our standard hourly design rates apply.

- Album designs allow for an average of 2.5 images per page and up to 3 images per page max average, to allow for flexibility and artistic integrity.

- Certain times of the year require longer wait periods, based on workload. The sooner you approve designs, the sooner you will receive your album.

- Album must be paid in full before order is placed.

*I understand and agree to the following:*

* *All albums delivered in California must be assessed 8.25% sales tax.*

* *The design process will not begin until this document is signed and any funds are received.*

* *The album will not be placed in final production until proposed layout is approved in writing.*

* *Once the final album order is placed, production may take up to 8-12 weeks to fulfill or longer, depending on time of year order is received, i.e. album orders placed the following year during our wedding high season will take longer due to workload.*

* *Orders placed after September 1 may not be delivered until the next calendar year.*

* *Albums are custom created products. Once this agreement is signed and received the order cannot be cancelled, nor can the album be returned.*

Signature:_____     Date: _____

- What is the goal of the policy? Preventing misunderstandings, managing client expectations, and creating great client experiences are typical reasons for implementing policies. If need be, policies may also give you the confidence to stand your ground on unreasonable requests.

- Adjust the policy. Each time you run into a misunderstanding, see if you can be clearer to prevent the problem from cropping up in the future.

Following is a sample of our album design and ordering policies. We developed these policies over time, through *much* trial and error. Now we cover the album design process several times, and clients get a clear understanding of how the process works. We discuss this in person and prior to the start of the design process. Clients also receive some template emails covering the basics before they start working on their albums.

## Handling Difficult Situations

Dealing with difficult clients can be stressful and time-consuming. We end up spending more time trying to solve their issues and make them happy than we do working with our best clients.

Sometimes the issue is your fault; you didn't manage the client's expectations, and now they are upset due to a misunderstanding that could have been prevented. Perhaps you neglected to explain your pricing, or perhaps you are several weeks behind on the delivery of the final images.

When you are at fault, the best thing to do is apologize and make it right. Immediately. Respond quickly, professionally, and do what you can to turn the situation around. An immediate phone call to listen to the client's concerns and show them you want to make it right can help curb a client's annoyance from turning into a full-blown crisis. A gift sent with an apology note goes a long way.

Other times, things happen that are not your fault. Put yourself in the clients' shoes and try to empathize. Sometimes problems can be resolved with a little TLC. If a client is unhappy with their images, is it possible to schedule an additional session? Be sure to discuss candidly what they did and didn't like about the images so you can ensure a better experience for them. The only cost to you is time, and it is well worth it to show a client you are willing to take care of them.

If you find yourself getting more and more behind with production, be proactive (before clients start complaining) and outsource some of your work. It's worth the cost to your sanity and your business to head off problems before it's too late.

Occasionally, you will get a client who simply cannot be made happy. No matter what you do, they find something to criticize. In these cases, it may be best to cut your losses and fire that client. However, before making a break, there are some things you should try:

- *Acknowledge the problem.* Letting the client know you are aware of a problem goes a long way to easing tensions and placating the client.

■ *Deal with the problem quickly.* What could be a small fix now will be harder to deal with later. Address the problem in person or with a phone call. It shows that you are taking it seriously and care about the outcome.

■ *Stay calm.* It is natural when being confronted by an upset client to match their tone, but don't. Be professional and talk in a calming tone. Sometimes simply restating the problem lets the client know you are actively listening, without admitting fault.

■ *Apologize and accept responsibility.* Nothing can disarm an angry client as fast as an apology. Don't pass the blame or make excuses. Own up to the problem and deal with it as fast as possible.

■ *Make changes.* Look at the problem and see what can be down to fix it now and make sure it doesn't happen again in the future. Maybe you offer additional time, an extra service, or some gift prints. Maybe you move their project to the top of your priority list.

■ *Stick to the policies.* You need to stay firm on your policies but offer insight into your process so that the client can understand why you do things a certain way. For example, with a client asking to see all the images taken during a shoot, explain that part of the artistic

## Take Care of the Problem. Pronto.

When dealing with any sort of problem, make it a high priority to take care of it quickly and professionally. If you're late on delivering images and the client complains, finish the job that night so you can resolve the concern immediately. Sometimes you can get the client back on your side by letting them know they matter to you.

process includes test shots, checking on lighting, and so forth, and these images are never meant for anything other than preparing to take the final image, which they received. Explain how you take extra shots in case of eye blinks and unflattering expressions, knowing those shots will be deleted since they were mess-ups.

There comes a time in every business, however, when you get a client who is unhappy no matter what you do, and the more you try to fix the problem the worse it gets. Some people use complaining as a way to get things free or discounted.

If you've done what you can, and you are not at fault, sometimes it is best to complete the job as quickly as possible and move on. You may end up with a negative online review, but it's not the end of the world.

Other times, there are personal issues beyond your control causing the client to react negatively. I recall a bride years ago who seemed disappointed in her wedding images. She didn't complain, but I could see she was not as enthusiastic as I would have expected. Later, I ran into the groom and casually asked about this. He confided that she was embarrassed because she was showing more cleavage than she had intended, and this colored her feelings toward the wedding photos.

# Fantasy vs. Reality

| | |
|---|---|
| All your clients will be delighted with your work and refer you to all their friends and family. | You will have clients who absolutely love everything you do and clients who don't. Make sure you treat all clients with the same great customer service and don't take any for granted. |
| Clients understand that you are a one-person shop and are working as fast as you can. | Every client is concerned only with their work and expects a quick turnaround. Educate your clients about how long it takes to deliver images. |
| Clients instinctively know that you are an artist, and art takes time. | Most people believe photography is simply pressing the button and printing the image. They have to be educated on what actually happens in your workflow. You know it takes time to sort, edit, and output the images, but you have to let the client know this as well. |
| Clients think of you are an artist, not charging hundreds of dollars simply to push a button. | With today's advances, it is easy for anyone to take a good photo by pushing a button and letting the app apply an action. The skill you have as a professional is making great photos under any circumstances. |
| Clients understand that you are running a business, and that while it may be an honor for you to work with them, you still need to earn a living. | Photography is undervalued in today's society. People often expect photos to be free. Our profession is one of the few careers that people are eager to do for no pay, and this has impacted the value people place on photography. |
| Clients understand how expensive it is to run a photography business, and how many hours you work. | Your clients have *no idea* what it takes to run a photography business. Chances are they believe anyone can do it. |

## Industry Insiders:
# Jenika from Psychology for Photographers

Jenika shares her insight on how photographers can tackle tough customer service issues, avoid misunderstandings, and create better client experiences, all while increasing sales. Jenika studied psychology at Yale University, and combines classroom expertise with the experience of running a portrait business through her blog, Psychology for Photographers.

## What are some of the most common customer service mistakes you see photographers making, and what do you suggest instead?

The biggest mistake I see is photographers calling things customer service that aren't actually customer service.

For example, a horror story that frequently graces my inbox goes something like this: A client wants to book a date, so the photographer sends him a contract and requests the session retainer. The client promises to pay the retainer, but the session date is drawing closer and the photographer hasn't received any money. The photographer goes ahead and books the date anyway because she wants to be nice. In her mind, this is good customer service because it's helping the client.

Can you guess how this story ends? Yes, the client cancels at the last minute or is a no-show. The photographer gets angry because she's turned away other business and lost money for that weekend. She accelerates from being nice to hopping mad in a flash. She sends threatening emails reminding the client that he still owes the retainer or a cancellation fee, but the client drops off the face of the earth. The relationship is soured before it began.

A lot of similarly unwise business behavior, pursued under the banner of being nice, gets chalked up to customer service. This is a problem for two reasons:

1. Being nice is not the same thing as customer service. Not when being nice actually means, "I was too uncomfortable to enforce sensible policies, and I lost out." Policies exist to help you run a smooth business and get things done in a timely manner. That benefits both you *and* the client. If you're constantly making exceptions and dealing with ensuing hassles, it makes it difficult to cheerfully do the astonishing, exciting, fun things that *actually* make for excellent customer service.

   Great customer service is being willing to do many fun things and a few uncomfortable things to ensure your client gets the experience they deserve. Part of customer service is ensuring you're a good match for each other to start, that you both expect the same things, and that no one will become bitter or resentful later on.

Fortunately, you can serve clients and enforce policies while still being pleasant: If a client wants a date, fantastic! They can book it by completing steps A and B. They have to wait a few days to pay? No problem! You'll just wait a few days to book the date. Of course, there's a risk the date will be taken, but you'll work with them whenever they're ready, and you can't wait to photograph them! Being cheerful and ensuring everyone gets what they need sets a great foundation for excellence in serving them later.

2. Because *being nice* often results in *getting burned*, this can make you jaded and suspicious of future clients. You become needlessly inflexible when other clients ask for reasonable help because you are afraid of being burned again. Suspicion is not a good platform on which to build good customer service.

Good customer service starts with happily and confidently laying everything out so the client knows exactly what's going to happen. Since clients rarely read the entirety of contracts, cheerfully go over it with them. A contract is not a whip to keep people in line, it's a customer service tool that protects both of you and aligns expectations for the agreement.

Discussing contracts may feel uncomfortable, but you're truly providing customer service by ensuring they won't have any ugly "sorry, it was in the contract!" surprises down the road.

*THAT is being nice.*

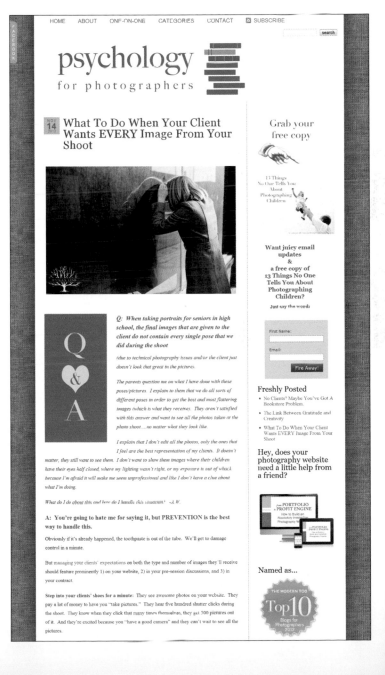

## What easy tips can you suggest for photographers to create great customer service?

- *Listen. Everybody thinks they do it, but few actually do.* Listening is the unsexy, underrated part of customer service. If you were to record a consultation and clock the playback, what percentage of the time do you spend talking? It's probably higher than you think. Listen to what people say and watch for what they don't say. And don't just listen to adults—listen to kids. If your portrait client's son spends the entire session pretending to be Buzz Lightyear, including a small print in a Toy Story frame as a gift upon delivery may get you more referrals than any other thing you could do. Because the kid won't stop talking about it.

- *Don't tell them what you can offer; ask what they're looking for.* Identifying needs and recommending specific solutions will always get you more sales and happier clients than simply handing them a list of options.

- *Ask preventative questions.* Good questions get clients thinking and help you solve problems before they happen. Here are three key questions to try:

  1. **How do you think you'll use these images?** When asked in the initial consultation, this casual question gets your sales session started before wallets are on the table. If they have no idea what they want, you can mention options well before you're selling anything, which makes them less suspicious of your recommendations. If they are already talking about wall displays and eager grandparents, you can make a mental list of tailored suggestions to bring up later in the sales session. Not only will the client be happy you remembered, it will help them feel like you're meeting their needs rather than just selling them something. This question also helps you create images that fit naturally with the products they'll buy later (e.g., you'll be watching in-session to fill a great grouping of three square canvases, and shoot appropriately).

  2. **Who else is looking forward to seeing these images?** This question helps you describe your offerings in a more personal, relevant way. Instead of a vague title like grandparent albums, you can offer something more concrete and special: "Package Three includes a smaller album that you can send to your great aunt Eunice. It can arrive at her house in Maine before Christmas." This gives them something other than the price tag to use to differentiate between packages. Knowing who else will see the images also makes thinking up client gifts a snap. Rather than a generic gift, you can write a note about how you think this metal print will hang perfectly above Grandpa's workbench. Those personal touches make excellent service unforgettable.

© Geoff White Photographers

**3.** Is there anyone who you think might be uncomfortable having their picture taken? And the follow up: "What can we do to make them more comfortable?" Rather than get there the day of the shoot and realize you've got a cranky toddler, shy teen, or obstinate uncle on your hands, you can understand the problem and brainstorm solutions with the client rather than guessing on the fly. You might even be able to prevent these issues outright: A special snack before the session, a flattering new shirt the teen picked out themselves, or a thoughtful note to the uncle beforehand can even ensure that the troublesome personalities don't surface at all. ▪ ▪ ▪

CHAPTER

# Day-to-Day Operations

The daily administration and management that keeps a business running smoothly can be overwhelming for many small business owners. Many new photographers, especially those without the experience of running their own business, go into business thinking mostly of the photography side of things and are completely unaware of the day-to-day operations and organization required.

I hear from many photographers who have been in business for years and yet their main concern still is how to stay organized. No one expects so many daily administrative tasks. With photography, it's straightforward; you shoot, and then later you process images. With a photography *business*, however, it's a different story.

To stay on top of things you must put systems in place to help you run your business efficiently. If you're spending most of your time putting out fires due to disorganization, you'll have a hard time growing your business. Without a solid system in place, routine tasks slip through the cracks and become major problems—and client relationships sour quickly if you miss deadlines, don't respond to questions, and generally have a hard time keeping track of everything.

Before we invested in studio management software, we had great customer service *during our slower months*. We'd send out a series of educational emails letting clients know exactly what to expect with the album design process so there were no surprises. We'd call families prior to sessions to discuss clothing options. We'd send out handwritten thank you notes.

However, during our busy season, that all went by the wayside. We simply couldn't keep up, nor could we remember what had or had not been done. And our client relationships suffered because of it. Once we got organized, though, and instituted a system to track each step of the process, we no longer missed the little details that make or break a client's experience.

Running a photography business eats away at your free time. No one tells you how many evenings will be spent in consultations, engagement sessions, and doing postproduction. And the weekends? Forget it, those are for clients.

That's why it's so important to stay organized. You don't have enough hours in the day to get it all done, and you probably can't afford to hire help yet. That means it's critical to put systems and routines in place so you can operate your business efficiently and effectively.

There are things you can do to organize the daily administration and operations tasks to make sure none of the pieces fall through the cracks. This might seem unnecessary if you have only a handful of clients now, but it will pay off when your business grows and you can no longer keep track of everything in your head.

What does an organized system look like? Having an organized system means that:

- You have *templates and routines* in place for repeat processes.

- Your space is *well organized* so you know where to find things.

- Your production workflow is *efficient* and repeatable.

- Your customer service is excellent, because you *stay on top of issues* before they develop into problems.

- You *prioritize* daily tasks so you work on your highest priority items first instead of whatever lands in your lap on any given day.

- You don't miss deadlines and appointments because your *calendaring system works.*

- You know how to *estimate* the time required for products, so you can set accurate delivery dates for clients.

- You *automate* tasks when possible.

- You *don't lose hours* surfing Facebook or Pinterest, or reading blogs.

- You spend *regular and frequent time* on effective marketing activities, to ensure a new client pool each year.

Set aside time each week and month for planning—put it on your calendar so the daily grind doesn't get in your way. I recommend a weekly time to plan and prioritize tasks for the upcoming week, and a monthly time to review sales goals and

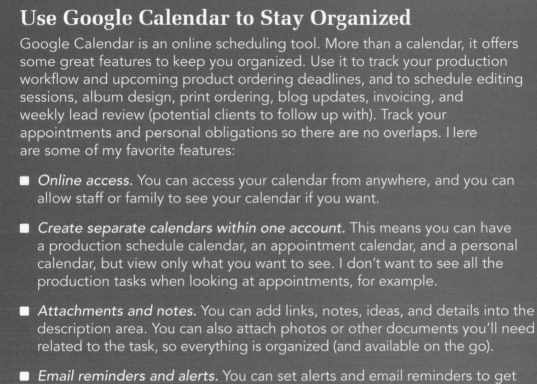

## Use Google Calendar to Stay Organized

Google Calendar is an online scheduling tool. More than a calendar, it offers some great features to keep you organized. Use it to track your production workflow and upcoming product ordering deadlines, and to schedule editing sessions, album design, print ordering, blog updates, invoicing, and weekly lead review (potential clients to follow up with). Track your appointments and personal obligations so there are no overlaps. Here are some of my favorite features:

- *Online access.* You can access your calendar from anywhere, and you can allow staff or family to see your calendar if you want.

- *Create separate calendars within one account.* This means you can have a production schedule calendar, an appointment calendar, and a personal calendar, but view only what you want to see. I don't want to see all the production tasks when looking at appointments, for example.

- *Attachments and notes.* You can add links, notes, ideas, and details into the description area. You can also attach photos or other documents you'll need related to the task, so everything is organized (and available on the go).

- *Email reminders and alerts.* You can set alerts and email reminders to get you moving for your upcoming shoot or consultation. Those reminders have saved me more than a few times!

marketing projects. These are the activities to spend regular time on in order to grow your business.

Plan now for your business to grow, and when it does you'll be ready to handle it with ease. If you aren't busy with lots of client work yet, use the time to put systems in place that will serve as the organizational foundation of your business in the years to come.

## Internal Organization

When starting out, you most likely are working solo. That means you are the one to meet with clients, send out contracts, receive payments, shoot sessions, edit photos, package up products, update the blog and Facebook, answer the phone and emails, and handle sales and marketing.

Let's get down to the nitty-gritty of creating your well-oiled machine.

## Create a Schedule

Schedule activities and batch them to save time. Instead of jumping from one little task to the next, you batch process similar activities at one time. This means you open the software once or have all the necessary tools out and take care of repeat tasks all at the same time.

When you package prints, for example, you need to get out tape, labels, wrapping paper, tissue, boxes, and stickers. You probably write little notes and need to locate client addresses as well. Instead of packaging one print at a time as each comes in, set aside print orders and package them once a week.

Here are some activities I recommend setting aside specific time for each week:

- Bookkeeping
- Culling and editing images
- Client meetings
- Following up with potential clients
- Marketing

For example, I set aside Tuesdays and Thursdays for client meetings. There is prep time involved in getting ready for a consultation, and client meetings probably require you to dress for the occasion. By keeping meetings limited to certain days each week, you save time by prepping for several meetings at once, and dressing professionally on those specific days.

Monday mornings are when I sit down and review my potential client inquiries. By making this a regular activity, you stay on top of inquiries and get more bookings. You can find more tips for staying organized and tracking leads on my PhotoMint blog at photomint.com.

I also set aside one day each month to review marketing. On that morning, I check the progress of marketing activities and that afternoon is dedicated to implementing new strategies.

## Organize Your Space

As your business grows, you will accumulate more stuff to keep track of. You'll need a place to store gear, files, and office supplies. Carve out regular times to organize your space. Not only does this save you time, it also creates a feeling of peace and harmony in your work life.

- *Clear off your desktop once a week.* Sort through those bits of paper, file client notes, organize tasks into lists, update records, and so forth.

- *Use binders.* Binders are a great place to keep track of client inquiries if your business is mostly based in the office. Make client inquiry forms and keep them in the binder, so when a prospective client calls you can grab the binder and input all their contact information, notes, and dates in one place. Each week, review the binder to follow up on leads.

- *Make client folders.* Create a file for each new client you book. Use it to store all related paperwork such as contracts, inquiry notes, package details, and so forth. You can also store most of this information online by using studio management software or an online storage system like Dropbox.

■ *Keep product orders in one place.* Keep all your print and product orders organized in one place so when it's time to place orders per your calendar, you can do them all at once. It's the worst feeling to get an email from a client wondering when her framed print will arrive, and you realize you completely forgot to order it.

■ *Set aside framing and packaging areas.* If you do framing in house, create a separate space for it and keep all your framing supplies and tools together. Create another space for packaging and shipping supplies such as boxes, labels, tissue paper, stickers, notecards, boxes, bags, and wrapping paper.

■ *Label shelves.* Labeling shelves so you know what goes where helps you stay organized by setting aside certain spaces for specific items. It also lets you know with a glance when you are running low on certain items.

■ *Organize computer files.* In the same way you organize paper files into folders, you should also organize your computer files into folders. Keep separate computer folders for client files, marketing projects, accounting, forms, and strategic planning.

■ *Use job quote and invoicing software.* If your business requires putting together job quotes and image licensing, use software to help you manage the process and provide accurate estimates.

**GWP E-session workflow**

**Scheduled Correspondence**

| ☑ Send | E-Session #1-Locations | ▾ | 1 | Day(s) ▾ | After Booking ▾ | ✕ |
| ☑ Send | E-Session #2-What to Wear | ▾ | 3 | Day(s) ▾ | After Booking ▾ | ✕ |
| ☑ Send | E-Session #3-What to Buy | ▾ | 5 | Day(s) ▾ | After Booking ▾ | ✕ |
| ☑ Send | E-Session #4-What to Expect | ▾ | 2 | Day(s) ▾ | After Booking ▾ | ✕ |

Add Correspondence

**Milestones**

**Confirm date/time**
- Email client confirmation time, meeting spot & photog cell
- Email photog meeting spot, time & date & wedding details (date, location, products)
- Facebook about upcoming session

Due Date: 1 Day(s) Before the Event

**Post Session**
- Edit Session
- Color Correct Session
- Renumber & process jpegs

Due Date: 8 Day(s) After the Event

**Create slideshow and gallery**
- Create online gallery
- Create online slideshow
- Send Studio Manager link to seperate slideshow & gallery login

Due Date: 1 Day(s) After the Previous Milestone

**Send client Slideshow without gallery**
- Send client slideshow link only

Due Date: Day of Event

**Send client online gallery**
- Customize esession email #5 for gallery release-send to client

Due Date: 1 Day(s) After the Previous Milestone

**Create Marketing Images**
- Create facebook images
- Create blog images and/or storyboards

Due Date: 1 Day(s) After the Previous Milestone

**Blog Engagement Session**
- Create blog post for session

Due Date: 1 Day(s) After the Previous Milestone

**Send Clients to Blog**
- Click to send clients email #6-blog is live

Due Date: 1 Day(s) After the Previous Milestone

☑ Send an Email - E-Session #6-Blog is Live

**Facebook favorite images**
- post images to facebook, tag clients
- create facebook album & tag clients

Due Date: 1 Day(s) After the Previous Milestone

**Upsell engagement products**
- Circle back with clients about custom products if they have not purchased yet

Due Date: 1 Day(s) After the Previous Milestone

⊕ New Milestone

**Current Milestone**

⚙ Settings   ✎ Events   📅 Due Date

💾 Save Changes

This is an example of a few things my studio management software does: Template emails are scheduled to go out automatically and a repeatable task list is created for each session, so nothing is forgotten.

## Studio Management Software

One of the biggest time-savers and organization tools that we use is studio management software. Before we started using this type of system, we had great customer service in the spring, but by the time fall came around a lot of little things had slipped through the cracks. Clients were not receiving all the information they needed at the right times, invoices were not being sent out, production was behind, and our marketing efforts were languishing. That changed when we started using studio management software because it automates so many routine tasks.

Getting a studio management system in place is like having a part-time studio manager who never forgets what he is supposed to do and provides consistent service to every client, sends invoices reminders, collects payments, and keeps you organized through every part of your business.

It takes time to set up a studio management system but it's well worth it. I recommend getting a system as soon as you have 5 to 10 clients. If we had used a management system in the beginning, we would have saved *hundreds* of hours each year that we could have put back into growing the business.

For fashion, freelance, advertising, and commercial photographers, one of the biggest challenges is figuring out how to quote for individual jobs. You want to estimate all your costs accurately so you don't end up losing money on the job, yet you want to stay competitive. Instead of trying to figure this out on your own, use

## Go Paperless

Going paperless frees up a tremendous amount of space and organizes all your documents so they can be stored online and accessed from anywhere. In order to go paperless, you need three things:

- *Scanner.* Start with scanning all your files and eliminate the need for file cabinets. Keep the scanner on your desk so you can quickly scan in paperwork and recycle it.

- *Online storage.* Services like Dropbox allow you to store documents online and access everything from your smartphone.

- *Studio management system.* Instead of using paper forms to keep track of clients, appointments, tasks, and notes, keep everything online. Evernote, a free application for Windows, Mac, iOS, and Android users, syncs your information from one device to the next, so you can access notes and files while out of the office.

photography job bidding software such as Blinkbid to help you accurately estimate a job and create invoicing.

### Office Forms

Forms give your business a professional look and help you stay organized around routine activities. You can create forms yourself and print them out as needed. You will need forms for things like payments, print orders, client inquiries, and new client tasks.

- *Payment forms.* Used to collect payments, shipping addresses, and contact information.

- *Print and product order forms.* Used to keep track of print and product orders.

- *Inquiry forms.* When you've got client inquiries coming in from emails and phone calls, these help you keep track of where leads are in the booking process.

- *New client procedures checklist.* Attach this to the front of a folder you make for each new client or set it up in Evernote. Having a checklist makes it easier to keep track of tasks, so all it takes is a quick glance once every few weeks to know you are on track.

# My Best Business Decision: Studio Management Software

There are so many tasks that a studio management system handles automatically. Here are some of the many time-savers:

- *Leads are organized and easy to keep track of.* Instead of trying to remember if you called a potential client back to get a consultation scheduled, the software keeps all your leads organized so you know exactly what stage you are in.

- *Makes it possible to go paperless* (along with the help of a scanner). Because everything is online, you no longer need paper files for each client. Everything is organized and accessible online, from anywhere.

- *Contracts get signed and paid quicker.* There's no waiting and hoping it's in the mail since it is all done online.

- *Invoicing happens automatically.* Meaning you get paid much more regularly, and there's less need for phone and email reminders (email reminders are automatically sent out).

- *No more expired credit cards.* The client is responsible for making sure payment goes through. If the card doesn't work, the system doesn't accept payment.

- *Clients get consistent service.* All those great emails that we intend to send out but somehow don't are a thing of the past. Everyone gets every email we intend: All our clients are informed about what to wear to their engagement sessions and why they should consider a first look, are thanked for their business, and so forth.

- *Album creation help.* The album cover questionnaire goes out at the right time, explaining options, pricing, and cover swatches. Sometimes we used to be moments from placing the album order, only to realize we hadn't gotten the cover selections. Now the email goes out automatically, saving us that potential delay.

This should give you a taste of what is possible. You'll want to compare several different systems to see what works best for you. It takes an initial investment of time to get set up and running, but the results are well worth it.

New client checklist.

Print order form.

Payment form.

## Production Workflow

Having a production workflow in place enables you to keep track of how much time you spend in front of the computer and what you need to charge for your time.

Stop for a minute and try to answer these questions for a normal job:

- How long does it take you to import the images from a memory card to the computer?

- How long does it take to do the first sort?

- How much time do you spend editing each image?

- How long does it take to renumber and rename the files?

- How many images are there to be edited?

- Do you need to add metadata to the images?

- How long is it before the images can be sent to the client or uploaded to a gallery?

- How long does it take to place orders for the prints, albums, or other products?

Without knowing how long each task takes, it is impossible to accurately charge for your time or develop an accurate delivery schedule. In addition to the time needed to complete the job in front of you, you also need to include the daily cost of doing business, which is the total of all your costs to operate your business on a day-to-day basis, whether or not you have a paid job that day. Because you still have to pay rent, utilities, insurance, and so forth, and those costs need to get factored into your pricing as well as the time required to do a job.

We struggled with our production workflow and time management when we first started out. A common problem for

photographers is spending too long editing a single image, and it often tends to be one the client doesn't even order! That is a huge waste of time for your business.

Break down tasks into a workflow to see where the time goes and what can be done to increase productivity and decrease your time in front of the computer.

### Create a Workflow

One of the most challenging tasks for photographers in the beginning of their business is to set up a production workflow to manage images. Everything you do, from downloading images from your camera, to culling, color correcting, renumbering, editing, and creating JPEGS, needs to be part of a workflow designed to help you do the same tasks consistently each time and keep the image files organized and safe throughout the process.

If you offer products such as albums or framed wall prints, you need a workflow in place to create those products as well. Each process requires certain steps, and you will flounder without a workflow system

designed for your needs. Since this is a business book, we aren't going to go into developing your production workflow. The following sections are what you can do to refine and adjust your workflow for optimal results.

## Refine Your Workflow

Constantly refine your workflow until it is as efficient as possible. Look at your entire production process for little areas where you can make improvements. For example, we used to order the album prints ourselves and would spend an hour or more checking them over for blemishes, and would sent prints back for correction. We wanted albums to be perfect for clients; however, we finally admitted (to ourselves) that clients were not going to notice a tiny speck on an album print. From there, it was easy to make the leap to having album companies print and bind albums for us. That change alone saves more than *40 hours* a year.

We also changed our contract terms to allow clients 1 year to complete their albums; otherwise, the contract is considered complete. This was difficult at first because I didn't want to come across as uncaring, but the truth is, it gives us the justification to insist clients complete their albums within a year so we don't have 3 years of old albums clogging up our production workflow. We used to have 20 to 30 incomplete albums at any time, now it's only a handful.

## Address Bottlenecks

In order to streamline the production process, look for and address inefficiencies and bottlenecks within your process. Once

### Desktop Workflow?

There is a trend among photography business coaches to have you set up a workflow 'board' as a backdrop on your computer monitor and keep all the folders and files on the desktop sorted that way. Don't do this, ever. If your computer crashes, often everything stored on the desktop is lost. This is not a safe way to protect your clients work. You need to work out a way to organize your files and keep them safe. What is your file backup plan? This is a tedious job, but if you set it up right at the start, you won't have to worry about it again.

you make these changes, your production workflow will be much faster. Know when to schedule production tasks to have them complete by a certain date (by understanding how long each step takes). By doing this you might be able to get some personal time back in the evenings and on weekends!

Anticipate holiday print and card orders toward the end of the year to streamline your production workflow. Figure out what products need ordering deadlines, and work backward from the vendors' deadlines. For example, many album companies require orders by mid-November to guarantee a holiday delivery. In our production workflow, once an album

is approved by a client, every image in the album is retouched, color adjustments are made, spacing is checked, and so forth. We know how much time this step takes, and we give clients a deadline well before our vendor deadline. We add several weeks to the vendor deadline to allow us plenty of cushion time.

Rather than try to figure it out each year, we standardized this date on all our communications regarding album policies. This way, our clients know about the deadline and those hoping to get their albums by the holidays know to respond quickly in order to make it happen. We do the same thing with framing, holiday card, and print orders. This has eliminated the last-minute rush for our staff and us so we can be with our families for the holidays instead of rushing to get orders out.

## Importing Images

The first step in postproduction workflow is to get the images from your camera (or more precisely, the memory card) into your computer. In certain photography jobs, this is done while the event is still going on (photojournalist or wire service photographer) while other times, this takes place days after the event.

There are two ways to do this. The first is to attach the camera directly to the computer and import the images. A *better* method is to use a dedicated memory card reader to transfer images from the memory card to the computer much faster.

Not all memory card readers are created equal. The key is to get one that uses the fastest connection to your computer and is

the right type for your memory cards. There are three types of memory cards available as I write this: the Secure Digital (SD) card, the CompactFlash (CF) card, and the XQD memory card.

Once the memory card reader (or the camera) is attached to your computer you need to import the files. The key here is to have a system in place to organize files the same way every time, allowing you to easily find what you need later. This might mean you sort everything by date or by subject, or maybe by location. For example:

- Wedding photographers might create a new folder for each wedding with subfolders containing the final edited images, the album pages, and possibly copies of the contracts and other paperwork so in the future they can look up the event by the name and have all the information in the same place.

- Sports photographers might create a folder with the team name, and then create subfolders by the dates of the games with a second level of subfolders containing the best images and the ones that were purchased.

- Stock photographers might sort everything by subject with subfolders containing the images that sell the best.

The point is that it doesn't matter what your system is, it just needs to be something you understand and can work with.

## Sorting and Editing Images

Taking images is only part of the job. You need to also sort and edit those images. That can take longer than the

actual making of the photos. The number of images you end up with after sorting and editing depends on the type of photography job you do. One of the biggest mistakes new business owners make is to edit *all* the images from a shoot—the good, the so-so, and the bad.

Be ruthless in your sorting since the fewer images you need to color correct and edit, the faster you'll be and the more you can get done.

## Image Delivery Schedule

Manage your clients' expectations by telling them up front when they can expect to receive their products. That way you don't have to spend time answering emails and phone calls about when the products are coming. Start educating your clients in the consultation, along the way, and then in a template email sent out a week after the session letting them know when to expect their images and products. For weddings, we tell clients to expect 4 to 6 weeks.

## Tethered Shooting

Tethered shooting is when the camera is connected directly to the computer while the images are being taken. Instead of the files being saved on the camera's memory card the images are saved straight to the computer. This is incredibly useful when working in a studio environment since not only are the images already on the computer for editing, but you can see exactly what you captured on the bigger computer screen.

By managing that expectation up front we don't get anxious emails from clients and we can schedule production tasks on a production calendar, so we know what to work on and when it needs to be done.

# Photo Management

There are entire books written about digital asset management, but the basics are simple. You need a way to store and access your images. The method you use may be different from mine, as all businesses are different. The key point to remember is that digital files are the life of your business and you need to treat them as such. Put a plan in place from the start for how to store and save the files you produce.

In our studio, we use a folder system that enables us to find any images from an event. We use the same set of folders for each event. The system looks like this:

- **01.** The unedited files right from the camera. Think of these as the master negatives. The images are then sorted and the ones that are selected are copied into folder 02.

- **02.** These images are stored as high-resolution 16-bit TIFF files using the Pro Photo color space. We color correct, renumber, and save these images as JPEG files in folders 03 and 05.

- **03.** High-resolution JPEG files saved in the ProPhoto color space. These are the images we use for everything else, but if we need to go back and re-edit an image, we can find the file here.

- **04.** Sometimes there are files that need a lot of editing. This is where those images are stored until we edit them. We then save the edited files to folder 03.

- **05.** The same images as in folder 03 in a low-resolution size in the sRGB color space.

📁 01 RAW

📁 02 TIFF Highres (16bit ProPhoto RGB)

📁 03 JPEG Highres (8bit ProPhoto RGB)

📁 04 REMASTERING WORK FILES

📁 05 JPEG Lowres (sRGB)

📁 06 ALBUM PICKS

📁 07 WEB PROOFING

📁 08 PREMIERE Slideshow

📁 09 PRINT ORDERS

📁 10 VENDORS

GWP file folder naming scheme.

- **06.** The images I select for the initial album design.

- **07.** The images selected for the online web gallery slideshow and shopping cart.

- **08.** This is for clients who are getting a DVD slideshow. Normally, I copy the album selections in, and then add additional images in to flesh it out to a 30-minute presentation.

- **09.** The images clients order for print, and need to be prepped and cropped before the order is placed.

- **10.** The images to be ordered for vendors. This is a key part of our vendor marketing strategy.

Your workflow could have a few more or less folders. For example, many wire service and event photographers have a two-folder system for each event. The first folder contains the RAW files; the second folder contains the exported JPEGs that get uploaded to the wire service. Since the turnaround usually needs to be less than an hour, the workflow must be tighter and more streamlined.

We *always* shoot in RAW mode. We recommend that unless you absolutely need the file shot in JPEG for space or speed reasons, you shoot in RAW as well. For wedding work it is essential. The speed of the event, coupled with the bright white dress and dark tuxedo and having to shoot in less than optimal conditions, means that you want as much of the file information available as possible when editing the images.

### Storing Images

Storing images takes up a good amount of space. As camera resolutions increase, the amount of space needed to save image files increases as well. The one truth is that at some point, your hard drive is going to fail because all hard drives fail over time. They are mechanical devices and they wear out.

Therefore, you need to make sure that your images are stored in multiple places at all times. This could be the internal hard drive in your computer and an external drive that's plugged in, or it could be two external drives. Or any combination of technologies.

To calculate how much space you need for backup, ask yourself the following questions:

## Using DVDs as Backups Is Outdated

In the past, backing up your image files to DVD discs was an acceptable option. The DVD technology could hold a lot of information, were cheap to buy, and easy to create. They were also more durable than hard drives and a lot cheaper than thumb drives. Drop a DVD on the table and chances are it would survive without a problem; drop a hard drive off the same table and there is a good chance you corrupted the drive. The problem is that many computers are now made without DVD drives and the technology seems to be on its way out. Backing up your data to a technology that is on the way out is not a good long-term solution. I recommend using custom flash drives instead.

■ *How many photos do you take?* The more images you take, the more storage space you need. It also depends on the megapixel size of your camera. Calculate the average size of a shoot and multiply it by the number of shoots you plan on doing in a year, and then double it. This will give you the amount of space you need to store the images in two locations for an entire year.

## Avoid Deleting Images in Camera

While deleting files in camera might seem like a time-saver, it can lead to image corruption and it's not worth the risk. Besides, at that size you cannot tell if the image is in focus.

- *How long do you need to keep the images?* Will you potentially lose sales if you delete them or are the images clogging up space? Can the images be used for stock photography later? Most portrait photographers do not store images forever, as they will lose sales if the customer feels no urgency to purchase. Wedding photographers tend to hold on to images for a set period of years and then release files or clear them out.

- *Will you need to access the images regularly?* The ease of access to your data is important to consider when deciding how to store images. After the final print or product is delivered, do you need to access the images on your main working computer, or can you safely remove them and store on an external drive?

### Backup Plans

As I said before, your hard drive will fail at some point and you will most likely suffer data loss. If your images are backed up in at least two places, you can recover them. You also need a plan in place to back up the rest of your data. That includes all your business files, customer files, and the rest of your digital documents.

- *On-site backup.* An onsite backup is a copy (that you keep right in your office) of the important information needed to run your business. This is the easiest type of backup and most of it can be automated. For example, the Apple OSX operating system has Time Machine built right in. This backup solution automatically backs up your computer every hour to a local hard drive. The downside is that the backup copy is not protected in the case of any disaster that could happen where your equipment is located.

- *Off-site backup.* This is where you back up your data and store it someplace other than your office. We store images on hard drives located in a large safe deposit box off-site. Geoff and I had our entire equipment collection wiped out once during a flood, but our off-site backup saved our business.

# You need a backup plan in place before catastrophe strikes and wipes out your images, and possibly your business.

■ *Cloud backup.* This is probably the best solution to the backup issue. It backs up your data to a secure area on the Internet, which allows you to access the information from anywhere. However, be prepared for a lengthy initial upload time, depending on the size and number of files.

Make image backup a high priority. This is one area not to cut corners. You do *not* want to be the photographer that loses clients' once-in-lifetime-wedding photos. It can destroy your business.

There is one other type of backup system I recommend, and that is to keep a list of your software application serial numbers on a cloud backup service such as Dropbox or Evernote. This allows you to get your applications back up and running if (and when) you have a system crash.

## Automating and Streamlining

The more time you spend on business paperwork and office work, the less time you have available for taking photos and getting new clients. A great way to save time is to create templates and automate common business tasks.

Using templates allows you to develop a system of doing things in a consistent manner. That can be emails, as well as form letters, folder naming schemes, and so forth. It's a way of streamlining your day-to-day-business activities so you have more time for shooting, marketing, and sales.

### Templates

Templates are a way to batch process routines and activities that you do repeatedly. You can create templates for album design layouts, print border actions, blogging images, emails, and so forth. Look for repeat activities that could be streamlined. Create templates so you aren't repeatedly doing the same steps that could be done at one time.

When shipping print orders, we package them in 8x10 or 5x7 boxes and wrap those boxes in black craft paper (to tie in with our branding). We save time by using a template size for each box so we know exactly how much paper to cut. Instead of getting the paper roll out each time we ship prints, we use a paper cutter to create a stack of papers cut to size for 5x7 and 8x10 boxes. We keep the wrapping papers in stacks in a labeled section of our packaging supply closet, so when we are running low we drag out the roll and paper cutter and batch process a bunch more at one time. This keeps us efficient and streamlined.

Answering emails can be one of the biggest drains on your time. Many times, you will find yourself answering the same 10 questions frequently asked by clients, or writing out the same email to each client who books your services.

Instead of answering the same question each time, create a set of email templates to use for answers to common questions and client information you share regularly. This will save you a ton of time that can be spent on activities that are more profitable. If you use Gmail, these are called *canned responses.*

Here is an example of an email template we send out before an engagement session called, "What to expect at your engagement session."

> Dear Super Awesome Bride,
>
> We're all ready for your upcoming session, and we wanted to give you some final details about what to expect.
>
> First off, don't be nervous! Engagement sessions are totally fun, relaxed, and easygoing. If your guy is nervous, let him know that there will be lots of kissing, and his main job is just to adore you.
>
> A great way to loosen up is to enjoy a glass of wine or champagne prior to the session—if it helps you feel more relaxed, go for it!
>
> Another way to make the most of your session is to play up your relationship for the camera. At first, you might feel a little nervous, but we like to keep things relaxed and fun. The idea is to capture the real relationship between the two of you, and the best way to do that is to act naturally with each other, in a way that reflects your relationship. If you are goofy with each other, then ham it up for the camera. If the two of you tend to be more intimate, go ahead and snuggle up, hold hands, embrace, look into each other's eyes. If you are romantic and tend to be more on the sensual side, don't be afraid to show it!
>
> Be sure to arrive a few minutes early and allow for parking. Since our sessions begin before sunset to capture the best lighting, we only have an hour.
>
> You can expect to see your images (on average, around 50 images) online a week after your session, with any desired products finished about 2 to 6 weeks after you place your order. We look forward to photographing you both soon!
>
> Studio Manager

Here is an email template we use for an appointment reminder:

> Dear Super Awesome Client,
>
> Our home studio is located at XXX XXXX Blvd, City. Take Hwy 280 and exit XXXX XXXX (can only go one way). Go one mile down the hill and we are on the left side. If you hit the stop sign, you've gone too far.
>
> We look forward to meeting with you. In the meantime, we'll be sending you some information by mail. If you have any questions at all, don't hesitate to give us a call. Take care!
>
> Studio Manager

We send this email when a client requests a contract:

Dear Jane,

Thank you for selecting us to capture one of the most amazing moments of your life! We are thrilled to work with you and can't wait to hear all of the planning details as they are finalized. We know it will be a gorgeous and one-of-a-kind moment for you both!

Your link will give you access to your private client area to access your account, which holds your contract, payment, and wedding details. Our policy requires a signed contract and initial retainer to secure your wedding date. Once you sign your contract and pay the retainer, we will send you an official booking confirmation and information about the next step in our photography process with you.

We look forward to hearing from you and please let me know if you have any questions. Let's get started!

Studio Manager

This is what we send out to clients explaining what to expect with the album design process. (It automatically gets sent two weeks prior to wedding date. This email also plants the seeds for additional album page sales.)

Dear Jane and Paul,

I hope your week is going well and all the final planning details are coming together.

I'd like to point out a few things regarding your wedding album beforehand so you know what to expect:

- While you are on your honeymoon, we'll start pre-designing your album. It will be much easier to design your album once you've seen our vision for how your album can look.
- We call this stage the pre-design; for most clients, our designs are spot-on and only need that final 10% or so from you.
- After the pre-design is ready, you'll have two rounds of revisions included.
- The pre-design will be created without regard to number of pages (your package has an album credit) so you can see the full storyline. You are welcome to purchase additional pages or stick to your credit; it's up to you.
- The process is all done online, and you can review the design and communicate all revisions through our password-protected design site.

We'll go over all this again when we present the first draft design to you, but wanted to let you know what to expect. We are looking forward to the big day, and we'll talk to you next week!

Studio Manager

## Automating Tasks

There are a lot of tasks that you do repeatedly. Automating them makes life much easier and frees up a lot of time. Some of the tasks that can be easily automated are emailing invoices and appointment reminders, taking care of credit card payments, printing, drop-shipping to clients, and more.

Here are some of the things you can do to streamline your operations:

■ *Online payment processing.* When we started out, we had clients fill out payment forms and once a week we'd process each payment. This didn't take long—except for charges that didn't go through. So these quick little credit card entries that didn't go through required another call or email to track down a working credit card number. Enter Photography Merchant Systems (photographymerchantsystems.com), with which we got set up to take

payments online. Clients enter their credit card information and the charge goes through immediately. It's connected to both our online print shopping cart as well as our studio management software. Clients receive automatic payment reminders until money is deposited into our bank account. I like it!

- *Print fulfillment.* Many pro labs like WHCC, Simply Color, and ProDPI will drop-ship prints directly to your client (without the invoice), delivered in a nice box. It's another great time-saver because instead of receiving, reviewing, packaging, and shipping prints, it's all done by the lab.

- *Print and bind album services.* In the past, we would have the album pages printed and sent to us, and then we'd check each print, repackage them, and ship them back to be bound. That took a lot of extra time. Now, you can send in the layouts and have the album maker print the images and bind the album for you. It's a great way to save time and get your client albums much faster.

The key is to look at how you run your business and see what repeated tasks can be done automatically. It takes time to get your business systems set up and running efficiently. It might seem odd to think about these things at the beginning of your business, but consider it an investment of your time now for a payoff in the future. ■ ■ ■

## Social Media

Spending some time on social media is a routine part of marketing your business. However, you need to be careful to distinguish business activity from plain old surfing. Don't allow yourself to get lost reading Facebook updates, blog posts, and Pinterest boards. These activities can be fun and addictive, but not productive. Set a timer for 10 minutes to update social media properties, and then close the sites for the rest of the workday. Use automating tools to work efficiently and quickly (like Hootsuite, Post Planner, or Buffer).

# 10

# Client Deliverables

As photographers, we sell more than just images. We sell our expertise, experiences, and products. We aren't simply selling images on a memory card; we sell prints to be framed and viewed every day, visual stories to be experienced, slideshows to be enjoyed, albums to be cherished.

As a photographer, images are your raw output. Depending on the type of photography you do, your product may be delivered in a variety of ways. If you are a photojournalist, you deliver the straight digital files to a news agency. Wedding photographers may deliver a beautiful custom album to their clients. This chapter not only covers the different ways images can be delivered, but it also deals with how many photographs to deliver and the delivery schedule—one of the more difficult parts of the job for many photographers.

## Prints

There is nothing quite like holding a print in your hands or hanging it on your wall. Prints are still the most profitable way to deliver images to clients. They can be individual images printed on traditional photo media paper or on canvas or metal, or delivered in frames or albums.

Some photographers prefer to do their own printing. If this is something you are considering, here are some things to think about:

- *Printer cost.* You need a printer that is up to the job and can print images at the sizes you want. These printers are more expensive than standard office versions.

- *Paper and ink cost.* There are tons of great papers available for printing at home. As with everything else, the better the paper quality, the more expensive it is. If you aren't using the printer weekly the ink can dry up and clog the printer.

- *Time.* Printing takes time. Setting up the printer, creating the proper color profile, testing out combination of inks and paper, printer maintenance, and standing there while the print emerges from the printer all take time.

There are some reasons to consider doing the printing yourself, especially if you are a fine art photographer. In the same way you control all the settings on your camera, doing your own printing gives you control over every aspect of the final product. You can make sure the print looks exactly how you want before shipping it to the client.

## Photography Vendor Resource Guide

Overwhelmed with trying to figure out all the vendors you need to get started? Download PhotoMint's Ultimate Resource Guide for Photographers, a free download filled with my personal vendor recommendations, at photomint.com/resource-guide. The free guide contains tools and vendor resources for fast-tracking branding, production workflow, business operations, education, and more.

Most photographers, though, end up using a professional print lab. We started out making our own large prints but found it wasn't worth the time and hassle for the few large print orders we do.

### Full-Service Print Labs

There are many print labs out there, but for professional results and pricing, look at one of the professional labs that deals exclusively with professional photographers. These labs offer a wide variety of products and are set up for easy file uploading and print delivery.

It's important to know what you are looking for. What is most important to you: quality, price, turnaround time, ease of ordering, selection of products? Would you prefer to deal with someone face-to-face or does online ordering suit you?

Before choosing a lab, get test samples from each lab or provider you are interested in, preferably using your images. Choose a set of five or so images that represent your photography and the things you want to see in a print. I recommend choosing images featuring the following:

- Richly toned black and white with dark darks and white whites

- A sepia-toned image, if you offer that

- Images with vibrant color such as fuchsia or bright red flowers

- Wide-open blue sky

- Skin tones, particularly different ethnicities

- Indoor bright lights

These images represent a range of difficult printing challenges and test prints will show you how the labs handle each type of image.

When evaluating the quality of prints from a lab, here are the things to consider:

- Are the images sharp?

- Is the density of the blacks and whiteness of the whites correct?

- Do the bright colors show a range of tonality? For example, an image of bright red flowers should have detail and range in the red.

- Do skin tones look accurate?

- If you do catalog work, is color matching accurate?

## ROES—The Easy Way to Order Prints Online

Most of the professional labs use a Remote Order Entry System (ROES), which allows you to easily upload your images online to be printed. Each lab has its own ROES system, which is usually a free downloadable program that lets you upload image files and pick the products to be printed, and shows the current prices.

- If you photograph weddings, can you see detail in the white dress and black tuxedo?

- If you are an event photographer, do indoor lights appear green when they shouldn't?

- For outdoor photography, can you see a smooth transition gradient in the sky?

- Are the quality of the paper and finishing options agreeable to you?

When you pick a full-service lab to work with, the quality of the products is important but there are other factors to consider as well:

- How is the customer service and do they help get your account set up and test prints completed?

- Is there someone you can call or is all the help via email?

- How fast can the lab turn around your order? This is key when discussing delivery times with clients.

- Does the lab offer drop-shipping? This means they will send the product directly to the client, which cuts down on your delivery time and packaging costs.

Here are some of the labs I recommend:

- *WHCC* (whcc.com). White House Custom Colour has grown to be one of the worldwide leaders in photographic printing. WHCC offers a lot more than standard prints; you can get proofing albums, canvas wraps, business cards, stickers, framed prints, and even metal prints. WHCC will not let you place an order until you have set up an account and sent them five 8x10 images so they can send you test prints before you place an order.

- *Simply Color Lab* (simplycolorlab.com). This lab is an offshoot of Simply Canvas, and the same care and quality that goes into their canvas prints goes into the traditional prints. They offer a wide variety of products ranging from paper prints to iPad covers. They also offer complete

marketing kits for your business, including everything for in-studio sales and even trade show booths.

- *Millers Professional Imaging* (www.millerslab.com). Millers offers a wide range of professional products from business cards to photo dog tags. They also offer Mpix Pro, which caters to the single studio photographer looking for high quality at good prices.

- *Camera House* (camerahouse.com.au). Based in Australia, Camera House offers a full-service print shop for the Australian market. They offer photo books, prints, canvas prints, and a wide variety of print products.

- *Loxley Colour* (loxleycolour.com). Based in the UK, Loxley Colour is a professional lab offering a wide range of products including giclée prints up to 60x40. They even have an app that lets you place orders and check the status right on your tablet or smartphone.

## Canvas Wraps and Metal Prints

Offering products that can't be created by consumers is a great idea. These specialty products offer something that can't be done at home and can help take your product mix to the next step.

- *Simply Color Lab* (simplycolorlab.com). This company offers prints on both metal and canvas and can even do round metal prints. One fun product is canvas clusters, which hangs together a series of images printed on separate canvases. This is where I get my canvas wraps done.

### Choosing a Print Lab

When choosing a lab to work with, send a selection of the same images to a number of labs to see how each handles color, black and whites, and difficult printing issues like the color fuchsia and pure white areas. You'll be surprised at the variance in print quality, turnaround time, and customer service.

- *Artistic Photo Canvas* (artisticphotocanvas.com). All this company does is create canvas prints from your artwork. Their customer service is superb and the quality is top-notch, but the real bonus is they offer professional photographers the option to include their own promotional material in every drop shipment to a client. Plus they offer a nice discount to professionals; all you need to do is call them and get approved.

- *Genius Printing* (geniusprinting.com.au). Based in Australia, this print lab offers high-end canvas printing along with traditional fine art printing.

- *Metal Mural* (metalmural.com). This company prints on square metal tiles or you can create larger works by combining multiple tiles. The tiles can also be used outdoors (3- to 4-year life span), as they come with a coating to protect them from the elements.

## Albums

Albums are a great way to deliver images to your clients. In the wedding niche, albums are a main product, but you can also use them for portraits, engagements, events, family photos, and just about any other time you deliver a final set of images to the client.

Here are some of the companies I use (or recommend) to create albums. The key is to pick a few of the albums and work with design templates so the album creation process doesn't take up much time.

- *Leather Craftsmen* (leathercraftsmen.net/joomla1). Leather Craftsmen offers high-end matted and flush mount albums with customization options including leather and cloth fabrics for the cover, imprinting, and custom cover photo plates. Leather Craftsmen also offers a design as well as a print-and-bind service, which cuts down on the delivery time to the client.

- *Asuka Book* (asukabook.com). Asuka offers a contemporary style coffee table book in several sizes. They also have their own album design plug-in for InDesign. We rely on Asuka Book for our vendor marketing program because it's quick, easy, and affordable to create albums for vendors that can be ordered in multiples.

- *Queensberry* (queensberry.com). This New Zealand company offers one of the highest quality custom albums on the market. They currently offer six different albums, all of which are customizable. We offer these albums to our most

discerning clients who are looking for a traditional matted album with a contemporary flair.

- *GraphiStudio* (graphistudio.com). This popular Italian company produces high-end albums combining handmade binding with the advances in digital processing.

- *Folio Albums* (folioalbums.com). This album company is based in Britain but ships internationally. They offer a range of albums, with cover choices ranging from leather to silk or colored cotton. Each album comes in a cotton bag and presentation box. Albums are printed using fine art papers to give the book a classy matte finish.

None of these companies sells directly to the public, which means your clients can't get these albums without you or see the wholesale pricing. If you have never ordered an album before the price may come as a shock. Albums are not cheap. We spend anywhere from $100 to over $1,000 per album, and that's *our* cost.

## Frames

Selling framed artwork can take your sales to the next level. It's great to offer customers a product that they can hang right on the wall and enjoy every day. Here are a couple of frame companies that we use who offer a great variety of products.

- *GNP Frame* (gnpframe.com). This company sells traditional frames for single images and those with multi-opening mats for collages. Pick a few pieces that match your style and offer those. This keeps things simple and the

## Time-Saver Tip: Print-and-Bind Services

You can save a lot of time by having the album company print the images and bind them directly into an album, a process called print-and-bind. To take it a step farther, many album companies offer design services as well. Simply send the selected images and they create the design for your clients. This is a great way to start if you aren't ready to take on album design software or would prefer to focus on your sales and marketing.

work to a minimum. If you use WHCC as your print lab, you can upload your print order directly from the ROES system and GNP frame will frame and drop-ship to the client—a one-step process for you, saving a lot of time.

- *Wild Sorbet* (wildsorbet.com). For those wanting a less traditional look, check out the Wild Sorbet collection. These frames come in all sorts of fun colors and shapes.

Another option is to find a local custom framer and work together in creating a few products. This is also great when it comes to networking, because the framer could recommend your services and you could bring in a steady amount of work for them.

## Digital Files

Digital cameras changed how clients expect to receive their images. With film, it was relatively simple; you delivered the negatives or slides, or prints. As covered earlier, you can still deliver prints from the digital files but many clients want the digital image files. There are three different aspects of these files to consider when determining how and what to deliver:

- Image resolution (the size of the file)
- Format of the file (the type of file being delivered)
- Color space (how the image will appear both on-screen and on paper)

### Resolution

The resolution (the size of the image file) is made up of three parts:

- Pixels
- Dots per inch (DPI) or pixels per inch (PPI)
- Actual inches of the printed image

This can get a little complicated, but I will try to keep it simple. It is important to understand these terms and concepts.

Here's an example of what can happen if you don't understand resolution: You could unknowingly send a client a file with too high a resolution, enabling them to print the image themselves and depriving you of sales. Send your file with too low of a resolution and the client might not be able to use the image at all. For example, say they ordered an image for their social media site and the image you sent is too small to use, making your work look bad.

Pixels are the dots that make up your image. The image is measured in the number of pixels down and across. The pixels make up the actual size of the image, the dots per inch (DPI) or pixels per inch (PPI) are how it's rendered on-screen or in print. The combination of the number of pixels and how many are displayed is the resolution of the image.

In short, take the output DPI and decide how many pixels are needed per side to get the size needed. The good news is that image editing applications can do all the work for you.

## File Formats

One of the decisions you have to make is in what file format to deliver your images. If you are interested in learning all there is to know about color space and digital file formats, I recommend reading one of Jeff Schewe's latest books, as he is *the* expert in that field. Since this book is focused on business, however, we are going to keep things very simple. For those of you who aren't technical, there are two basic file outputs you need to understand: JPEG and RAW.

Basically, JPEG is the universally accepted file format for consumers. If you provide clients with digital files for personal use, JPEG is the way to go. The client can walk into any department store and have her image files printed.

For your internal production, I highly recommend RAW. This format is akin to the full digital negative. It records all of the information in the same way as a negative does, whereas JPEG is a consumer format with limited information.

I recommend you use a system of outputting image files into two folders, one for clients' and one for your internal workflow. Here's what that looks like:

- *Client output.* JPEG format in sRGB color space is best for consumers. It's easy to email, view, put online, and print, and doesn't require special software. sRGB color space is what most consumer labs use, which gives clients a consistent color.

- *Internal workflow.* For your own use, output files to RAW format. This gives you the most options and doesn't throw

# A Primer on Color Space

Color space is a mathematical way to describe the color in digital image files. The wrong color space can cause the colors in your image to look weird. It's important to know about the most commonly used and the difference between the CMYK and RGB color spaces, especially when working with professional print labs.

- **CMYK.** When you print a photo, you use four basic colors of ink: cyan (C), magenta (M), yellow (Y), and black (K).

- **RGB.** Pixels on the computer screen are made up of three colors: red (R), green (G), and blue (B). The images displayed on-screen are all created from those three colors of light. Different equations are used to render the images as accurately as possible. The three most common RGB color spaces are:

  - **Adobe RGB.** The Adobe RGB color space is used in most professional imaging workflows as it is a wider color space than sRGB, allowing for better color representation especially when creating prints.

  - **sRGB.** The sRGB color space is used by most consumers. It has the narrowest range of colors so it is more limited in what it can reproduce, but it's also the easiest for most clients to deal with. If you are starting out and not technical, this is where I recommend you start.

  - **ProPhoto RGB.** ProPhoto color space has the widest range of colors of the RGB color spaces. This allows for accurate editing and color adjustments, but it doesn't work well on the Internet and needs to be converted when printing. This is what we use because it allows you to adjust images without getting banding or clipping issues. However, we have a highly technical production approach, and I do not recommend it for beginners.

away as much of the detail as a JPEG does. You can use RAW files to color correct and create client products. Especially important for wedding and event photographers who are working in constantly changing lighting conditions, RAW gives the opportunity to recover lost detail in postproduction.

If you are not familiar with color space, I recommend you start out using sRGB for everything, as it is the easiest option to begin with. What's most important is that you streamline your internal production so you end up with a system that you understand, that works well for you, and that allows you to focus on the sales and marketing aspects of your business.

## Online Image Galleries: Yes or No?

One of the questions I often get from new photographers is whether or not they should offer online viewing for clients. The answer is: it depends on what type of photographer you are and what your profit model is.

If print sales are an important piece of your profit plan, I would not recommend it. The reason is that clients can experience all the joy of seeing the images online and sharing them with friends and family, without purchasing a single print. If you are a portrait photographer planning to do in-person sales, I would not offer image viewing online at all. Instead, educate your clients on the value of your professional opinion and ability to help them choose finished products to enjoy their images, instead of just online. It may take some time to work out the kinks, but you'll make much more with in-person sales than online viewing.

On the other hand, if you are a wedding photographer who includes digital files as part of a package, you probably are not losing out on many print sales if the client is receiving the files anyway. In this case, you'd probably be better off to use online proofing galleries in order to generate occasional print orders from friends and family. It also helps spread the word about your work when your clients forward the gallery to their friends and family members all across the world.

### Delivery Methods

Delivering digital files is not as simple as it used to be. Ask me how I delivered our files a few years ago and the answer would have been, "on a disc." But that is changing fast. Discs are on the way out. Some computer manufacturers —Apple, for example—are now selling laptops without disc drives. There are two other options: using a flash drive or online digital delivery.

- *Flash drives.* These colorful memory sticks plug directly into a computer's USB port. These little drives can be branded with your logo, delivered in a nice looking box, and can hold a lot more than a single DVD (capacities can run from 128MB to 32GB). The best part is this type of delivery option is becoming much more common and the prices are reasonable. I highly recommend Pexagon Tech (pexagontech.com) for a great selection of brandable flash drives.

- *Digital delivery.* As digital camera sensors increase in size, so do the file sizes. The advantage to using an online delivery service is that the files are delivered immediately so there are no mailing costs or delay. New companies are popping up to offer this solution for photographers who need to deliver digital images.

One method of delivering proofs is an online gallery that allows clients to see and select the images that they want to order. For example, let's say you shoot a wedding in New York, but the groom's family lives in Colorado and the bride's family lives in Ohio; they can all use the same online gallery to order the prints they want. Beware that the longer the galleries are available online, though, the lower the chance of getting any print orders since the client can see (and enjoy) the images anytime they want online. Online galleries also tend to drastically reduce your ability to sell prints and products, so keep that in mind.

## How Many Photos to Deliver

The number of images you deliver to your clients depends on the type of photography you do. If you are shooting sports for a wire service, then 6 to 8 images during halftime and another 20 at the end of the game is reasonable, while photographing corporate headshots might mean delivering 4 to 6 images of each person. With weddings and portraits, the range varies depending on the photographer. The key is to make sure you and your clients both know what to expect after the shoot is over.

As the expert, it's important to manage your clients' expectations to prevent future problems. I *always* make sure my clients know how many images will be delivered in the final set. We usually take between 2,000 and 3,000 images over the course of a wedding and deliver between 500 and 700 proofs to the client. That means culling the images to about 1/3 of what we've taken.

Giving the client all the images from your camera is a mistake, and here is why: it dilutes the impact of the great images because your client has to slog through all your so-so images before getting to a good one every once in a while.

Think about eating at a fine restaurant. You order the meal and eagerly await its arrival, and when it comes it's perfect. Now consider that same meal arriving at your table, but the plate is surrounded by the food scraps, peelings, and garbage left over from creating the meal. Not very appetizing and, in fact, brings down the quality of the whole meal, doesn't it? It's the same when it comes to delivering images to your client. Do you want them to enjoy the full fine dining experience or are you going to ruin an otherwise nice meal by including the slop that should be tossed in the trash?

Seems obvious, however, many photographers do themselves and their business *irreparable damage* by showing all or most of the images taken. This is not a professional approach, as you are indicating to the client that you simply press the button, and that they should be the ones to decide which poses, lighting, and angles are best.

Picture the client going through all the mediocre photos until they finally come across a spectacular shot, followed by another group of so-so shots, and then finally they get another great one. By the time they get to the end of all 1,000 photos they will have probably picked out a few of the great ones but they will get lost in looking at all the mediocre images.

# Letting clients see all the images creates a situation where the **great images are overpowered and diluted by the mediocre ones.**

On the flip side, it won't take you long to weed out the bad photos from the good. This will train your eye to look for the best composition, lighting, and poses. As you sort through your images, you will learn what works and what doesn't, because you are forcing yourself to *choose* the best images rather than simply *look* at them. When you make a decision about which images are better, you train your eye to see the world that way, and your composition, posing, and understanding of lighting will improve over time.

The more years you have under your belt as a professional photographer, the fewer bad shots you'll take. There will *always* be bad shots, even from world-class pros, but you'll never see their average shots because they *know better* than to show those. By only putting out their best work, it gives the impression that every single photograph they take is amazing.

## Delivery Schedule

With images and videos being uploaded to Facebook, Instagram, and YouTube mere seconds after they have been taken, people are expecting photos faster than ever before. This can be a problem, if you let it.

It is up to *you* to educate your clients how long it will take to get their images and what a realistic time frame is. This is called managing client expectations, which we talked about in Chapter 8.

Some jobs require that images be delivered in a certain time frame. Photographers working for wire services and news organizations need their images to be available quickly since they have limited life spans. For example, if you shoot a press conference, the images need to be sent in while the event is still news. Take too long and there will be no buyers for the images.

When it comes to photographing weddings and portraits, there can be a much longer period between taking the images and delivering them due to the additional time spent processing a large number of files. The one key thing is that you need to know how long your production workflow takes and follow it so you can accurately estimate how long it will take to deliver images to your clients. Workflow suggestions are covered in Chapter 9.

In our business, it takes a minimum of four weeks to deliver prints, and toward the end of the wedding season when we are at our busiest, sometimes six weeks. Because we know exactly how long the process takes us, we schedule each job on our production calendar, keeping us on top of priority projects that are coming due soon.

Here's our basic schedule:

- *Week 1:* Download the images.
- *Week 2:* Sort and cull the images.

- *Week 3:* Color correct images, add actions, create product suggestions (such as album predesigns), and order proofs if needed.

- *Week 4:* Create an online gallery and slideshow, and deliver the final images.

We discuss the image delivery schedule with our clients several times so they are clear on what to expect. It's brought up in the initial meeting, stated in the contract, mentioned again in an email confirmation, and then again before the wedding day.

If you are a portrait photographer, then the timeline might be one to two weeks, as there are fewer files to handle. Some portrait photographers do the sort with the client during the shoot, which narrows down the editing time dramatically and gives the photographer insight into what images the client likes. ■ ■ ■

# Sales and Growth

# Getting Sales

If images are the soul of your business, sales are the heart. Without sales, your business will not survive. It's common for creative people to feel ambivalent or even scared of sales. In essence, you are selling yourself—your vision, your talent, your art. However, sales are critical to a photography business. People who are successful with sales tend to approach selling as a way to help clients create memories and enjoy their images for many years to come. Think about it—will your clients get more enjoyment from their images sitting on a hard drive, or beautifully finished and displayed in their homes?

Different people have different talents, skills, and personality types. One photographer might win clients over with her great personality. Another photographer might use her quirky personality to attract like-minded clients. Figure out what *your thing* is and hone it in order to draw the right clients to you. What are your strengths? Why do you win out from your competition? Why do clients book you? If you can figure out the answers to those questions, you can focus on that type of client and refine your sales approach.

This chapter is about how to sell yourself and your work. Once you begin thinking of sales in terms of helping clients realize their vision, it becomes easier to feel confident, and eventually selling will feel natural. First, let's start with some basics.

## Be Attentive

When meeting with clients, make them feel as though they are your only priority. Eliminate distractions and give them your undivided attention. Do not check your phone, answer calls, or act distracted in any way. Ask questions and show excitement. Make it enjoyable for clients to deal with you and develop a personal bond.

## Be Prompt

Being on time for meetings is imperative, but it's just as important that you respond promptly to questions and emails. It's up to you to make your clients feel that they are your number one priority.

## Sell the Experience

Create a great experience for clients during your first meeting. Allow prospective clients to share their ideas and excitement for the project, and then build on that by showing them how you will exceed their expectations. Instead of focusing on technical details, focus on the experience. Use storytelling as a way to build emotional connections between your clients and your work.

## Be Creative

Listen carefully and think on your feet. Pay attention to what your clients are asking for, especially in the first meeting. You might

### The Art of Storytelling

An easy way to incorporate more storytelling in your presentation is to select a dozen or so prints and have them printed at a large size, such as 11x14, and matted or mounted on foam core. Choose images that you can use to tell a great story about the moments captured to warm your clients' hearts and create a connection.

hear them mention something that you never thought of offering. Is it something you can do? Can you do it without hurting your business? Will it add value without hurting your profits?

Sometimes being flexible and willing to step outside the box can make or break a sale. I once had a client ask about hand-coloring of photos, something I don't normally do. However, I could see how excited the client was and didn't want to burst her bubble, so I agreed to do it. Several other photographers had flatly refused this request, and she felt they were not flexible or considerate of her ideas. In the end, she went with us (and ordered a three-volume wedding album).

## Consultations: The Key to Sales

The key to sales in the wedding and portrait industries is the consultation. Here are the things to do to book more sessions and earn more money.

To making a living as a photographer, you must be aggressive. The competition has never been fiercer and the barriers to entry have never been lower. In this economy, I assure you, business isn't coming to you. You have to go out and get it. The soft approach—"you call me when you're ready to make a decision"—no longer works because the market is oversaturated. Who can choose when there are a hundred options? It's overwhelming for the client. Stand out from the crowd by being memorable.

When you get an inquiry, the first thing to do is *call them back as soon as possible.* If you have the good fortune of catching the client at the right time—when they are looking for information—you have a much better chance of setting up an in-person consultation. If you don't reach them quickly, your competition will.

You might think email is easier and faster, but in email you are just another photographer from an online search. On the phone, you have the opportunity to get to know someone a bit and ask questions about what she is looking for while highlighting the experience you offer. If you don't have the opportunity to speak with the client on the phone, respond to email inquiries right away. If you can get a jump on other photographers responding, you have a chance to stand out before getting lost in the sea of photographer emails.

It is important to *follow up* with prospective clients. After you get that initial inquiry, your best shot at booking is to set up a consultation. Clients will likely meet with only a few of the photographers they initially contacted. If you can get a consultation, your odds of booking the job dramatically increase. If all you do is simply email pricing information and wait for a client to contact you, chances are you won't be busy.

In order to make the most of your opportunities, have a follow-up plan. It is critical to getting more bookings; there is no way around it. Develop a system of following up with clients and track each lead and inquiry that comes in so you know when to throw in the towel and when to hang in there. For example, here are the steps you might take in a routine follow-up plan:

1. Phone call, if possible, or

2. Email response

3. Follow-up phone call

4. Mail out brochure or information packet

5. Email follow up with potential consultation dates and times

6. Phone call to book consultation

By following up with interested clients not only do you increase your odds of booking, you also show off your customer service skills.

## Increasing Your Odds

By looking at booking trends over the years, we have found them to be consistent enough that we can tell once we get to early spring how many more bookings we are likely to get for the year. This allows us to forecast expected earnings and manage our cash flow (see the section on tracking in Chapter 15). It also allows us to stay laser focused on bookings, knowing that we need to schedule two to three consultations in order to secure one booking (that's our booking rate).

In order to figure out your booking rate, simply count the number of consultations you've had and divide by the number of bookings for a period of time. It might be one in five; it might be one in two. If your work is good and your pricing is affordable, you might be able to book almost everyone you meet with. However, a 100% booking rate is usually an indication that your pricing is too low.

Here are some reasons a client goes with another photographer:

- *Budget.* Strictly a money issue, you are out of their price range.

- *Personality.* They might have liked you but *loved* another photographer.

- *Not a style match.* When your portfolio is not what a client is looking for, they will go elsewhere.

- *Other options.* Maybe they were on the fence between you and another photographer, and the other photographer undercut your pricing or threw in a freebie and that sealed the deal.

If you find that you are not booking many of the clients you meet with, reevaluate

your technique, pricing, marketing, and target market. Ask for feedback from colleagues, friends, and even the clients you met with.

## Selling Add-On Products

What are add-on sales or upselling? Anything not included in the basic package. This could be a framed wall print, extra album pages, a parent album, a DVD slideshow, an engagement album, a baby's first year album, and so forth. This is where many successful wedding and portrait photographers make most of their money.

With upselling, the idea is not to push the customer to something more expensive but instead to show them options, including ones that might be better quality. For example, let's say you are making a major purchase like a new car. Would you prefer the salesperson assume you can't afford any of the upgrades, like leather seats, or do you want to hear about all the options and decide for yourself?

When upselling, you show clients product ideas beyond what they originally came for. Because you don't incur additional marketing costs and you already have the images, add-on sales are great for boosting your bottom line. Add-on sales can be effective because you are selling to people who already love your work.

You need to do three basic things to start increasing add-on sales:

- Possess sales tools.
- Create a sales environment.
- Plant seeds for a sale.

## Consultation Tips

- *Send out reminders.* To ensure clients show up to the consultation, email reminders the day before with time and directions. This will cut down your no-show rate, and is another opportunity to showcase your customer service skills.

- *Dress to impress.* You are representing your brand. Taking the time to look great is important.

- *Conversation starters.* If you are a bit of an introvert, it helps to have some conversation starters ready. For example, I like to ask what made them choose that particular location to get married. After they answer, I can agree with them on the beauty of that venue, and highlight my knowledge of the location and how best to capture it.

- *Be ready to sign.* Have all the paperwork ready. Don't let them go home and think about it if they are ready to sign right then.

- *Have a take-home package ready.* After the consultation is finished, give the client a take-home package. A brochure, pricing, a slideshow—anything to remind them of your brand when they are making their final decision.

## Sales Tools

Have you ever heard the saying, "you sell what you show"? You are more likely to sell products you have on display or share during client meetings. Sales tools are things you use to increase sales—everything from product samples, education, handouts, etc.

It is easier to make a sale when the customer can hold a sample of a fully printed album or gallery wrapped canvas print in her hands, or see photos of a finished product. People like to be able to touch and feel the products with their own hands. This is one reason in-person sales result in higher sales than online galleries.

It takes time to create your sales tools; consider it an investment in your business. Here are some tools that can help you make the most of your sales.

- *Portfolio.* Your portfolio should show your best work and target your audience. For example, if you shoot sports and are showing your work to *Sports Illustrated*, all your portfolio images should be amazing sports images. When you print your portfolio to show to photo buyers or editors, make sure that it is printed on high-quality paper and has a professional appearance. Every detail counts.

- *Website and blog.* Many times prospective clients visit your website to see your work before they ever make contact. Your website should be easy to navigate. If you sell prints directly from your site, it needs to be simple for clients to place orders. You can also use your website or blog to show off different products and suggest ways in which they can be used. This allows clients to see the final products in different way. For example, we noticed an increase in sales of products that had been featured on our blog.

- *iPad presentations.* It is easy to load up your tablet with images and create a slideshow. Some event photographers send the images to the iPad during the shoot so that clients can see them in close to real time and order images while the event is still taking place.

- *Album samples.* Whether you offer albums à la carte or in packages, it's important to have a few sample albums to show clients exactly what they will be getting. Most album companies offer discounts on sample albums, and they often will help you select popular cover choices. People need to touch and feel the pages and see the quality of the album.

- *Product samples.* You need samples of products you would like to sell. If you want to sell large custom wall portraiture, display that instead of 8x10's. People are more likely to buy what they can see and touch in person. Most print labs offer a wide variety of products, so it is easy to order some samples of wall prints, albums, cards, and so forth. Even if the lab you choose to work with offers 1,000 different types of products from mugs to mouse pads, focus on just a few to start with. Once you start getting orders and seeing what your clients like, add in more product offerings.

■ *Product guide.* Once you have decided which products to offer, create a product guide to share with your clients. You can give these out to clients at consultations or email them prior to sessions. This way, clients start thinking beyond digital files and start considering finished products.

■ *Tear sheets.* For photographers who work in the fashion, news, and editorial fields, tear sheets are imperative to show their work as it is published. These can be a part of your portfolio and your website.

■ *Foam boards.* If you plan to sell large prints, a handy sales tool to have during meetings are black foam core mats in each print size you sell. The average client thinks an 8x10 is a large print, but when you hold that up above a sofa compared with a 20x30, it's easy to see the difference.

■ *À la carte pricing.* If you don't have pricing available to show clients, it is unlikely you will sell à la carte products. I know this sounds simple, but many photographers forget to take the first step of creating a pricing list.

■ *Photos of sample products.* Be sure to take photos of all your samples and client-ordered products. You will find all sorts of uses for these images, from your website, presentations, product guide, and blog posts. It's helpful to have images you can quickly email to a client trying to decide between two options.

■ *Client newsletter.* Collect client email addresses so you can put together an email newsletter highlighting special promotions, new products, sales, and so forth. Email marketing is an underutilized vehicle for photography sales.

# FRAMES & WALL ART

### Elements $495

Relationships are made up of a thousand different smiles, glances, giggles. Capture the essence of your relationship in this series of small images designed to tell your story.

Available with mahogany or black frame.
Finished piece is 20x20.

### Narrative $495

Commemorate your engagement session with this four-image, framed & matted collage.

Available with mahogany or black frame.
Finished piece is 20x20.

### Gallery Wraps

The most contemporary way to display your images. Printed onto canvas then stretched around the frame, and displayed as a finished piece. Comes ready to hang.

| | |
|---|---|
| 20x30 | $650 |
| 16x24 | $450 |
| 12x18 | $350 |

### Signature Portrait $595

A framed image from your engagement session presented with extra large acid-free mat, ready for guest signatures at the reception.

Mahogany or black frame.

Custom framing available

# PRINTS & FILES

## Single Image File                                    $150

A high resolution image file of your choice from any session, retouched. For use in invitations, reception slideshows, postage stamps, prints, programs, newspaper announcements, etc.

## Proof Prints

A complete set of unretouched borderless 4x6 proof prints from your engagement session or wedding.

Engagement                                              $350
Wedding                                                 $500

## Custom Prints

Your selected image is expertly remastered and printed on professional-grade photo paper.

4x6, 5x7, 8x10                                          $50
12x18                                                   $125
*Inquire for other sizes*

## Portrait Digital Negatives                           $800

A complete set of high resolution, unretouched digital negatives from your engagement, boudoir, portrait or bridal session.

*Digital negatives only $300 with engagement product orders over $500*
*Free with engagement product orders over $1,000.*

## A Sales Environment

You need to create a sales environment. That means removing barriers to sales (such as giving away image files along with low session fees) and creating a positive buying experience for your clients. To start, focus on a few popular products so you learn what sells well and what doesn't. From there, it's easy to add on new products and build out your product offerings.

Here are some basic guidelines to help you create a sales environment:

- *Stop including digital files with low session fees.* Otherwise, your clients have no reason to buy, and you'll have to do hundreds of sessions to make ends meet. If you have been including digital files along with a cheap session fee, be prepared for some resistance as clients get used to the new approach.

- *Talk about products on your website and blog.* Highlight products and display images of interesting products people order. Using examples will create interest from clients and reinforce the message that your images are created for finished products.

- *Consider offering a bonus item to reach a certain product total.* This creates an incentive to buy and is a win-win for everyone.

- *Use sales tools throughout the consultation.* Make it clear that you offer many other options (available for purchase). Continually reinforce the message that you create gorgeous products for clients to purchase and enjoy. After all, earning a living is the reason you started a business, right?

## Planting Seeds for the Sale

If you want to sell additional products and sessions to your clients, you need to plant the seeds for the sale. They initially come to your studio with a particular product or session in mind, but that doesn't mean you shouldn't educate them about other products and possibilities you can create for them. Don't spring a big purchase on an unsuspecting client at the last minute, though; it makes more sense to give them an opportunity to think about some ideas before they are ready to commit. Educate them about the types of products you can create for them during the initial consultation. Giving clients subtle indicators of what other clients typically choose will help them feel comfortable in their decisions.

For example, when you are showing the different products you can create, let your clients know what your most popular products are. Talking about finished products early in the relationship allows clients time to think about how great those products will look in their homes.

After you have scheduled the photo session, send an email with your product guide and ask the client to let you know what type of product you should be creating for them (follow the three-step session system outlined later in this chapter). Again, this is a subtle indicator that you are creating the images for a final product purchase, and not just for posting on Facebook.

Follow up with a phone call to discuss clothing selection, locations, and products. Explain that you shoot differently for

## Selling Albums

If you would like to learn more about successful selling strategies for wedding albums, I invite you to head to the PhotoMint blog and search for album sales tips and album pre-designing, where you will find detailed strategies and selling techniques.

different types of products, so you need to know what you are aiming for. For example, if they want an album, that might be a lot of variety of backgrounds and a good mix of close-ups and wide-angle shots. Whereas a family portrait to hang above a sofa is more likely to be a horizontal image of a traditionally posed or casual grouping. By understanding what style and products the client is looking for, you can ensure you capture what is needed during the session.

If you want to sell add-on products, you'll need to implement each of these strategies in your business. One will not work successfully without the other two. It may take you several seasons to get everything into place and refine your process; don't be discouraged if there are a few bumps along the way as you figure out the best methods for you. It's about finding the right mix that works for you and educates clients on the benefits of owning beautiful finished products.

## Set Up a Product Shoot

An easy way to start building your sales tools is to photograph your product samples. These images will be invaluable to your business, as you can use them to create a product guide, to show products you can't bring to the meeting, to email clients who might be interested in a particular product, and also for use on your blog, in newsletters, and on your website. As product orders begin coming in, be sure to photograph those completed items as well so you have sample photos of different customization options.

## In-Person Sales

In-person sales tend to be a turning point for many photography businesses. If you don't do in-person sales, you are missing out on one of the most *important keys to success* for portrait and wedding photographers.

In the film days before digital came along, the standard photography business model was to set low session and creative fees with the understanding that most profit would come from print sales. Within this model, it was clearly understood that the photographer was being paid to *create* the images, and clients would then meet with the photographer to *purchase* the images they wanted. Photographers could count on meeting a certain minimum with print and product sales.

However, since the introduction of digital, that model has slowly eroded away. Unfortunately, the concept of an affordable creative fee and backend sales has been replaced with an affordable creative fee and little expectation of after sales. Without the after sales, it becomes difficult to make a living as a photographer.

A common approach among new photographers is to simply put images in an online gallery and hope for the best. But what usually ends up happening is that after sales are dismal at best.

There are a couple of reasons for this. Without your expertise and guidance, the client is often unable to make a decision. There are too many choices; since it's online, the client figures they can always go back later and decide. If you provide digital files with each session, obviously the client has no reason to order products from you, as you have given away your most valuable commodity free of charge. Finally, by being able to look at the images whenever they want, clients enjoy the images online. The emotional experience of seeing, sharing, and enjoying your work has been provided for them, so there is little incentive to spend more money when they are already getting that emotional high.

That's why it's so important for you to embrace in-person sales. In-person sales enable you to show clients how their images will look printed and finished. You can walk them through the entire process—picking out the best images for various products, increasing your sales, and ending up with happier clients.

Getting started with in-person sales is easy. Your first task is to either remove online galleries or only offer them *after* the in-person sales session or as a bonus for meeting a certain minimum order. The second thing to do is schedule the ordering session at the same time as the photography session, without exception. If you don't have meeting space, in-person sales sessions can be done in the client's home.

Once you have set up the in-person sales session (also called the ordering session), order a set of print proofs to sort through and create product ideas with the client. The easiest way to do this is to ask the client to sort the proofs into *yes, no,* and *maybe* piles. Start with the *yes* pile and begin to suggest products, laying out images for the client. For example, let's say the client indicated they would love something above the sofa; you might choose three images that work well in a grouping and suggest those (at appropriate sizes) for above the sofa. You can talk about canvas wraps or perhaps frames in colors that match their décor to solidify the vision.

By taking the attitude that you are there to provide expertise and gorgeous finished products, the pressure is off you—and your clients are in for a great experience.

## Use a Projector

If you have your own presentation space, use a projector to emphasize the wow factor that comes with large wall prints. Seeing images projected on a big screen has more impact than viewing them on a computer monitor. Bigger impact equates to more sales.

When it comes to a successful in-person sales meeting, keep the following tips in mind:

- *Make it an experience.* Use a projector if possible, offer refreshments, and make it a fun experience.

- *Have samples.* Have samples (or photos) of all the products you offer so you can discuss all the options available.

- *Show product suggestions.* Show image collages or groupings to help clients envision finished products.

- *Price list.* Make sure your clients have seen a price list before the meeting so they know what to expect and don't feel blindsided. It is difficult to get a good sale on the spot if the client is reeling from sticker shock.

- *Ask about usage.* Find out if the client wants albums for family members or if they are looking to fill a certain spot on the wall. This helps narrow down the choices and saves everyone time.

■ *Price properly.* Ensure that your sales sessions reach a minimum financial goal. If you add up the hours you put into each session, most likely you aren't making profit from the session itself. With that in mind, price your products to ensure that your sessions are profitable once you factor in the average sale.

■ *Accept all types of payments.* Set yourself up to take orders and accept credit cards on the spot. The easier it is for clients to pay, the more likely they will be to order.

■ *Offer payment plans.* Sometimes clients love the images and want to order more than they can afford at the time. By offering a payment plan, you increase the likelihood that they can get what they want without a single, large payment.

## Successful Portrait Sales

Successful portrait sales depend on in-person sales sessions. It's not as easy as simply emailing out a link, but the increase you'll see in profits and client satisfaction is worth the time. Successful portrait sales is a three-step process that depends upon scheduling three meetings (referred to as sessions here):

**1.** The planning session

**2.** The photo session

**3.** The ordering session

During these sessions you educate the client, understand what they are looking for, create an amazing experience, and finally, present them with product suggestions. In the end, you have provided a customized and enjoyable experience for your clients while at the same time maximizing your profits.

### 1. The Planning Session

The process begins with an in-person planning session. The purpose of this session is to educate your client on how to get the most from their session—discuss clothing, location, and activity options, and most importantly, get a sense for what finished products they are interested in. By going over the product options you offer and seeing what they are interested in, the client has time to consider the price and imagine the pieces in their home. Think of it as planting the seeds for the sale.

Tie in the discussion of finished products with their home décor. For example, if they are looking for something to hang in their family room, what colors would look best in that room? Do they prefer a single wall portrait or a collection of images? By getting an idea of the type of products a client wants, you'll be better able to create images that work well for the products they have in mind.

The other thing you want to do is get pricing out of the way at this session. The last thing you want is to invest many hours in creating gorgeous images for them only to have them end up buying a few 5x7's.

### 2. The Photo Session

Once you've had time to sit down and discuss options, review policies, and go over client needs in the planning session, you will be well prepared for the session itself, and so will the client. Ask questions during the planning session to get to know

your clients better so you can help them relax during the session. For example, let's say the session is for a five-year-old girl and her mom tells you she loves horses. During the session, ask her about horses and you'll make a friend and get a smile.

At this point you should have a good idea of the types of images your client wants. Do they prefer a casual family portrait or more formal, everyone-looking-at-the-camera type of image? What do they like to do as a couple or as a family, and how can you incorporate that into the session? After the session, be sure to remind clients that you look forward to sharing the images with them at their upcoming ordering session.

### 3. The Ordering Session

This is often mistakenly called a *viewing session*. It's important to give clients the message that they are not coming in to *view* the images; they are coming in to *order* images. It means they should be prepared to place their order right then and there. This is a subtle but important distinction to make.

If you do not offer online viewing, and there is no other way to see the images, it will ensure you actually *make sales* and *earn a profit* from your work. By putting galleries online and hoping for a sale, you are allowing the client to enjoy your hard work and talent without spending another dime.

Make sure the ordering session is fun and full of emotional high points as you present proofs and product suggestions based on the information you gathered at the planning session. Be prepared to offer a payment plan and collect a deposit before the ordering session ends. Once the session is over, future sales are less likely to happen as the emotional high wears off, so it is important to create the sales environment and have the sales tools that will ensure a fantastic sale on the spot. It takes practice and fine-tuning, but after a couple of great ordering sessions you'll never want to do it any other way.

## Ordering Session Tips and Tricks

- Make sure that clients understand this is the *ordering session*, not a viewing session; this is when they will be *placing their orders*.

- Be sure all decision makers come to the ordering session, so the meeting doesn't end with…"Oh I'll have to talk to my husband about it" and the excitement wears off—and you've lost the sale.

- Offer clients a glass of wine to help them relax and unwind.

- Greet clients warmly, with excitement for what you are about to show them.

- Start with a personalized slideshow set to music.

- After the slideshow, let them know you created some product suggestions based on what you talked about during the planning session.

- Create a product suggestion sheet for them with product images mocked up (without pricing).

- Introduce each product suggestion according to where in their home the product will be placed or who it's for, such as, "this is what we created for above your living room fireplace" or this is, "the piece we designed for Aunt Maggie." This helps clients visualize the products in their homes.

- If they ask about pricing, hand them a price menu and point to the price rather than say it out loud. This classic fundraising trick (from my fundraising days of asking donors for $5,000) helps ease the awkwardness of that sticker shock moment.

- Point out how certain pieces were created with a room's décor in mind (discuss home décor in the planning session).

- After going through the product suggestions, review the rest of the images for print orders and family gift prints.

- Offer a payment plan to help them afford everything they want.

- Put purchased images online (blog, Facebook, etc.) only *after* the ordering session is complete.

- Don't add up the final cost of the order until it's complete (you want them focused on how gorgeous the images are, not the cost).

- Perhaps offer digital files as a bonus for any images included in the order, or offer them at a reduced rate once a minimum order has been met.

- Take a deposit immediately in order to secure the sale.

## Promotions

Promotions are a way to drum up business when you need to fill some calendar dates and can introduce your services to new clientele. Many people think a promotion means deep discounts but that's not always true. The idea is to get people interested in your products and services.

Some examples are:

- *Seasonal product promotion.* Plan a promotion a few months before a seasonal holiday. Offer a discount to those who sign up early for holiday photos or family portraits. For example, you can book the sitting for your regular fee but offer 25% off the cards.

- *Portrait parties.* A portrait party is a group of people getting together for back-to-back photo sessions, usually with one backdrop and less camera time. You get to introduce your services to a wider audience, and clients get a discount on regular session fees. For example, a good client of yours may invite her friends to a special boudoir event, where each woman arrives early for makeup, enjoying a glass of champagne while waiting for her turn in front of the camera.

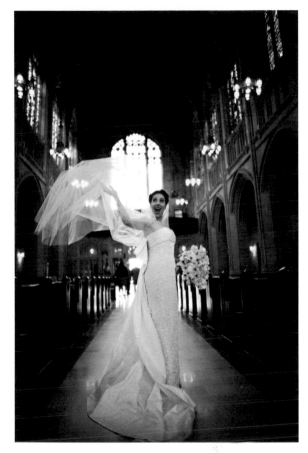

- *Mini sessions.* Mini sessions are organized around a theme or event, typically quick sessions done in the same location. For example, you might offer mini sessions in the fall for family holiday cards, scheduling a number of sessions back-to-back, with just enough time for each group to get a nice family portrait done. This way, you are keeping your calendar full and creating images that will generate product sales, and your clients get the opportunity for frequent portraits without the typical investment.

**Industry Insiders:**
# Lauren Lim of Photography Concentrate Shares Tips for Shy Photographers

Lauren and Rob Lim are wedding and portrait photographers in Edmonton, Canada. They are the genius team behind *Photography Concentrate*, an educational website for photographers. They are passionate about helping photographers and create free guides on topics such as posing, interacting with your subjects, presets, and (one of my favorites) *The Shy Photographer's Guide to Confidence*. Lauren shares her best tips for common obstacles faced by those on the shy side.

## What are some advantages to being a shy photographer?

"Shy people tend to be better listeners, and listening is one of the most important skills a person can have. When you let someone else talk, you're showing them you're interested, and that they are important to you. And that's a great recipe for getting bookings! Listening also helps you understand what your clients are looking for, which helps you present the right products and get better sales. So if you're shy, make sure to play up your listening skills and you'll see that your business will be just as strong as a people person's."

## Do you have certain things you like to say to couples to help them relax when you are shooting a session?

"I usually prepare a list of questions to ask so that I can keep the conversation flowing without having to stress about it. Things like "How did you meet?" "What's your favorite movie?" and "What do you do for fun together?" One of the best tricks to get people to relax is to get them moving. Start with easy things, like walking, and then you can add in fun things like spinning around holding hands. They'll focus on the activity, start laughing, and before they know it, they're totally relaxed. Movement is magic!"

## One thing that makes many shy people nervous is talking on the phone. How do you handle that?

"We almost never use the phone for business purposes. It's not something we've ever been comfortable with, so we built our business around email communication. The bonus of using emails is that it lets us take our time to discuss things together before replying, and we can easily send stunning PDFs. We love those benefits of email and have never felt like we had to use the phone. Our business never suffered because we only emailed!"

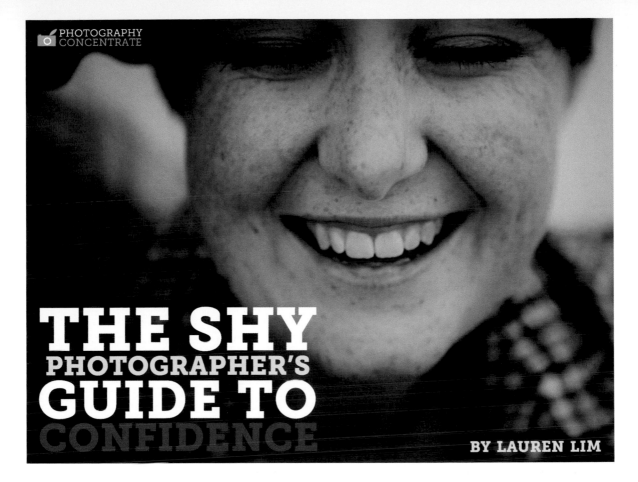

# THE SHY
## PHOTOGRAPHER'S
# GUIDE TO
## CONFIDENCE

### BY LAUREN LIM

## Are there certain marketing methods or sales strategies that you feel work better for a less outgoing person?

"Letting your clients do the talking for you works great for shy people. Once you give an amazing experience to your customers, let them know you appreciate referrals to their friends and family. You can put in a simple card with their prints, or offer a formal referral program that gives bonuses when they send new bookings to you. Referrals are very strong sources of business, and require little self-promotion, which shy folks generally dislike!

And for sales, it's that listening I was talking about. Ask your clients when they first book what they're hoping to do with their photos. Get them thinking about products from the very beginning. If they say they want an album, you can present a pre-design to them at the sales meeting, and since they've already said they were interested, it's going to be way easier to sell. Don't try to sell them things they never wanted in the first place. The key is to ask, and then deliver. No hard sales necessary!" ■ ■ ■

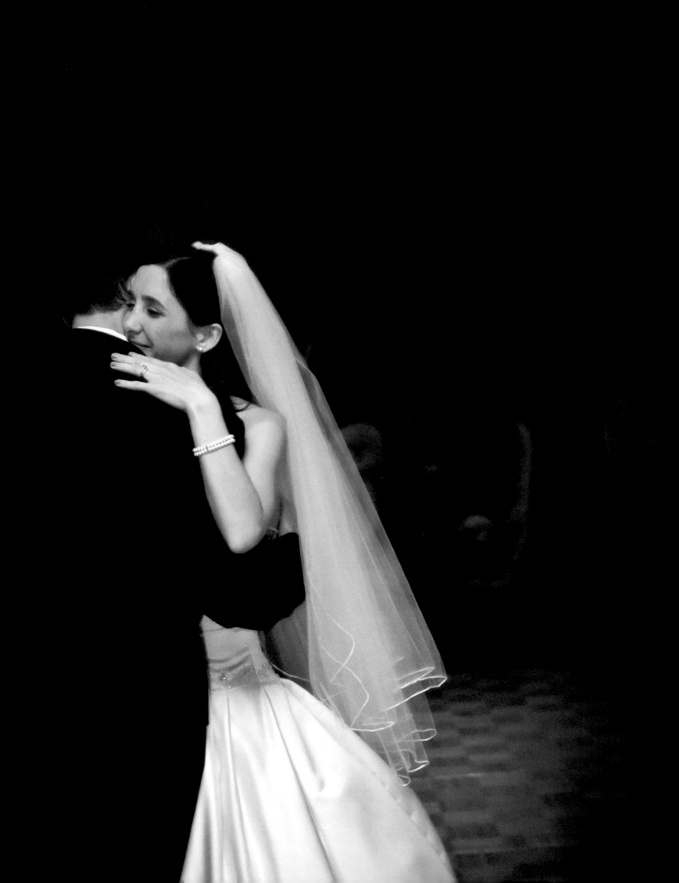

# Growing Your Business

After a few years in business, you might feel ready to take your business to the next level. Growing your business takes thought and planning. Otherwise, the day-to-day operations can keep you stuck right where you are.

In Chapter 9, we talked about getting organized. Every new business owner experiences some level of chaos in the beginning. That's normal for start-ups. However, if you want to grow your business, it's critical to get your business operations running smoothly. It creates a strong foundation to build your business on.

Understanding your finances top to bottom is critical, and it helps to work with a mentor who's been there. In this chapter, we look at considerations in growing your business, typical challenges, and strategies to help you move to the next level.

## Grow or Stay the Same Size?

You might enjoy keeping your business as a small boutique operation where you control every aspect of the business. If you are happy with the volume of business you have and enjoy working alone (or with a partner), staying the same size is a great option. You don't *have* to expand. If you have more people interested in your services than you can provide, you can choose the jobs you want and even raise your prices.

On the other hand, you may be ready to take on a new challenge. Growing your business comes naturally when you are doing well. There are different reasons for growing your business, including a desire to fill an unmet need in your niche or community, wanting to hire staff to help manage aspects of the business, or to increase your income. Before deciding what makes sense for you, there are some things to consider:

■ *Personal time.* You might want to hire staff to ease your schedule and get some personal time back. Geoff and I did exactly that. We hired a full-time studio manager to handle the day-to-day operations and customer service. It allowed us to focus on other aspects of the business while at the same time freed up our schedule. We also hired another photography team to take on some events, and this gave us some weekends off to recharge. When you expand your business for income reasons, however, you usually end up with *less* personal time. There's more to look after and more demands to be met.

- *Income.* If you hire additional photographers or expand your product line or services, you are likely to see more income. However, if you hire staff to get some personal time back, their salaries will eat into yours if you are not using the extra time to focus on more profit-generating activities. It's a personal decision, and the answer is different for everyone.

- *Resources.* When contemplating the growth of your business, consider the resources needed to make it work. You may need additional space, staff, and time to implement new services.

## Annual Business Retreat

One of the best things you can do to help your photography business grow is plan an annual strategy retreat. A strategy retreat is simply taking a day (or two) out of the office to evaluate your business goals and challenges. It works best to choose an outside location where you can get away from the phone, emails, and office tasks.

The strategy retreat is a period of reflection for your business and future planning. Review what you have accomplished during the past business year, and where you have struggled. Address those struggles and strategize how to improve those areas. If you have staff, getting their input and buy-in can be rewarding for the team.

All year long, most of us are caught up in the day-to-day, putting out fires, responding to client needs, and working on postproduction and bookkeeping, answering emails, and so forth. You don't have the time to reflect because you are focused on moving forward. The best time to hold your annual strategy retreat is at the beginning of your studio's slow season or at the end of the year.

The retreat can be a single day off-site or a two- to three-day affair, at local cafes, tea rooms, hotel lobbies—anywhere you (or you and your partner) can sit and work undisturbed. Allocate time to plan for marketing, studio promotions, goals, and improvements to areas that have not been effective.

There are a few planning items you can complete to help you get the most from your retreat:

- *Get your studio budget up-to-date.* You can't examine the financial results of your business if you do not have an accurate budget to work with. You need to know in which areas you overspent (consider why), in which areas to invest more, and what marketing campaigns were financially successful.

- *Make a list of what you want to achieve from your retreat.* Do you need an improved production workflow? More bookings? Fewer hours at the computer? Stronger relationships in the industry?

**Be the CEO of your photography business and grow it to the next level.**

# Preparing for a Strategy Retreat

The more preparation you do,
the more you get out of a retreat.

*Review the current year budget:*

- What has been your biggest expense?

- How can you reduce expenses? (One year we noticed we were spending over $7,000 on paper proofs alone. We cut those from packages the following year and no one noticed.)

- What areas of after sales are dismal? What can you do next year to improve those areas? (We cut digital files from sessions and instead offer a $100 print credit with each session. Now our sessions average about $1,000 in product orders.)

- Are you making a salary this year?

- How much did you spend on marketing and was it effective?

*Start putting together next year's budget:*

- Can you afford to invest in studio management software? If you are starting to feel like you could use some part-time help, think about investing in studio software instead. It's *much* more affordable.

- Do you need to invest in any new equipment or gear? Be careful to distinguish between what your business needs and what you want personally.

- What kind of marketing do you need to invest in to meet your income goals for next year?

- Are you ready to outsource some work, and can you build the costs into your fee structure?

*Gather booking statistics:*

- How many total jobs did you have?

- Where did they come from (how did they find you)? Count each one.

- What was your average sale per client?

*Identify bottlenecks and trouble areas:*

- Are you satisfied with your vendors?

- How long does it take you to deliver a job to a client?

- Does customer service take a hit during the busy months?

- Are your prices so low you feel you are being taken advantage of by clients?

- For partnerships, are roles clearly defined?

- Are you getting referrals?

- Are marketing methods working to bring in new business?

- Is your reputation well established?

- Do your style and offerings match your branding?

This is by no means an exhaustive list, just some ideas to get you started. Take the time at least once a year to take a step back and reflect on the improvements you want to make, set goals for yourself, and better understand your finances. If you want to take your business to the next level, get your financial house in order so you can see what's going on.

- *Make a list of your business pain points.* What is *not* working in your business? Where are the bottlenecks? What areas of your business are you struggling with?

It's natural to get so caught up in the daily running of your studio that you often miss the forest for the trees. Frankly, it's unavoidable when you are running a small business, as you need to wear many hats (often at the same time). However, if you want to grow your photography business to new heights, don't miss out on this opportunity to make meaningful changes to your business.

Here are some examples of topics to consider during your retreat:

*Goals:*

- Create or implement a task management system.

- Increase revenue stream (book more jobs, develop referral business, add a new service, increase rates, add new products, and so forth).

- Get production workflow under control.

- Put a studio management system in place.

*Pain Points:*

- Disorganized client workflow, sense of not knowing what the next task is.

- Not making enough income.

- Expenses are too high.

- Postproduction and product ordering bottlenecks.

## Outsourcing

Outsourcing is a great way to manage your business as it grows. There are lots of different parts of your business that can be outsourced. The best things to outsource are those that you don't want to do or that you don't do well.

- *Retouching.* Many professional print labs offer varying degrees of retouching and there are businesses that specialize in retouching for portrait and wedding photographers. Would you like to spend more time behind the camera than in front of the computer? If you are going to outsource your retouching, discuss pricing, turnaround time, and style so you can make sure it is included in the price of your services.

- *Editing.* There are companies that will take over all or part of your editing process. Companies will take the RAW shoot and return an edited catalog of images, usually 30 to 35% of the original images. They will also do black-and-white conversions, and return the files in Adobe Lightroom or Apple Aperture catalog so the images can be inserted

**There are a limited number of work hours in every day.**
Spend that time doing work that pays a higher return; outsource the work that doesn't.

right back into your workflow. Imagine being able to send an entire job off and have it back, sorted and edited, in seven business days. How much time would that free up for you to deal with booking more clients or working on marketing?

- *Bookkeeping.* Bookkeeping can be a tedious task that many put off, which is a mistake. Hiring someone to deal with that for you will save time and free you up to shoot more. If you don't keep up with bookkeeping, it's impossible to know the financial health of your company.

- *Design services.* Many graphic designers work specifically with photographers. You can hire them to create branding and promotional materials, and even help with website design. For a list of designers I recommend, get the PhotoMint Resource Guide available free at photomint.com/resource-guide.

- *Marketing.* Some types of marketing can be outsourced. You can hire a social media consultant to work on your social media for a few hours per week. This might be a good option for you if you aren't sure how to grow an online presence. You can also work with a company like Marathon Press (marathonpress.com) to handle email marketing and direct mail campaigns.

- *Album design.* Album design can take a lot of time and energy. Why not find a company that specializes in album design to do that work for you? It will free up your time to work on booking more jobs.

## Outsourcing for Photographers

Here are a few outsourcing companies that provide album design and editing services for photographers:

- *Plumeria Album Design:* plumeriaalbumdesign.com

- *Shoot.Dot.Edit:* shootdotedit.com

- *Colorati:* colorati.com

- *Lavalu:* mylavalu.com

- *Photographer's Edit:* photographersedit.com

## Hiring Staff

Part of growing a business often involves hiring staff. You might start with outsourcing and eventually find you have enough work available that it would be more cost beneficial to hire an employee or a dedicated independent contractor.

Hiring staff is a big step and requires a lot of time. You need to put together a job description, and recruit, interview, hire, and train your new employee. How do you know when it's time? If you've been working at 100% capacity and beyond for a while, it may be time to get some help. Here are some positions you can consider hiring for:

- *Office or studio manager.* This is an important hire since he is responsible for first contacts with clients. He answers phone calls, preps for shoots, sends reminder emails, and packages and ships prints. This person handles the day-to-day business tasks. He needs to be detail orientated and preferably have a background or training in business, not necessarily in photography.

- *Production assistant.* This hire needs to have a background in photography since she may be doing the initial image culling, photo editing, processing, image renumbering, image prep for final delivery, album design, and graphic design for marketing.

- *Studio assistant.* Having a second set of hands in the studio can make a big difference when it comes to production. Having a helper to carry gear, move lights, and help set up shots is a huge bonus.

- *Photographers.* If you get to the point where you have too much work and could book additional jobs with another photographer, it might be time to hire one. Make sure that he has a style similar to yours and can do the job you expect.

services are employees or independent contractors. Why? Because you must withhold income taxes, withhold and pay Social Security and Medicare taxes, and pay unemployment taxes on the wages paid to an employee, while you do not have to withhold or pay any taxes on payments to independent contractors.

- *An independent contractor.* This person offers her services through her own business. She has more control over her time, her work hours, and how she approaches the job. You are interested in results instead of the methods used to achieve them. According the IRS, "The general rule is that an individual is an independent contractor if the payer has the right to control or direct only the result of the work and not what will be done and how it will be done." If you hire an associate photographer, chances are she falls under this category.

- *An employee.* An employee is someone who works for you, and you control what work will be done, and how and when it will be done.

Your control over the how the person does the work is the key part of deciding if he is considered an employee. For example, if you hire an office manager or a studio assistant who has to work at your place of business during hours you set, doing work in a manner you control, she is most likely considered an employee.

If you aren't sure of the best route, do further research. Once you have determined what type of hire makes the most sense, fill out the proper paperwork with the IRS.

### Employees vs. Independent Contractors

When you hire someone, there are a two options—hire an employee or hire an independent contractor. There are specific differences between the two and it's important to distinguish them.

According to the Internal Revenue Service, it's critical that business owners correctly determine whether the people that provide

When hiring an employee, there is a lot more legal and tax paperwork to be done. Independent contractors take care of most of the legal requirements themselves, but you will need to get 1099 forms out to your contractors at the end of each calendar year. Here is a list to get started with a new employee:

1. *Get an employer identification number (EIN).* File IRS Form SS-4 to get your EIN.

2. *Set up a payroll system to withhold taxes.* You'll need to withhold employee taxes as well as Social Security, Medicare, and other tax payments. Look for the current year's *Employer's Tax Guide* from the IRS to walk you through this. You may want to consider using a payroll service, especially if you plan on hiring more than one employee.

3. *Create an employee handbook.* An employee handbook is a great resource for new hires, letting them know about policies on using social media, texting, web surfing, and so forth during work hours; dress code; and general expectations. It helps set the tone and creates a professional experience.

4. *Register for your state's labor department.* You are required to pay unemployment compensation taxes for each employee.

5. *Buy workers' compensation insurance.* Workers' compensation insurance is required in most states, and protects workers from on-the-job accidents.

6. *Create an employee contract.* A contract is an often overlooked but critical step in hiring employees. The employee contract should cover things such as wages, confidentiality, non-solicitation of your contacts and clients, and at-will employment status. I recommend working with an attorney to create this.

7. *Report to your state's new hire reporting agency.* States require employers to report new hires for collecting child support. Locate your state's reporting agency here: acf.hhs.gov/programs/css/employers/new-hire-reporting.

8. *Have new employees fill out Form I-9 to verify work eligibility.* This form is required by the U.S. Citizenship and Immigration Services to verify work eligibility.

9. *Have employees fill out a W-4.* This form lets you know how many allowances an employee is claiming so you can withhold the right amount.

## Associate Photographers

If you've got all the bookings you can handle, yet you are still getting a lot of inquiries, it might be time to think about adding additional photographers to the roster. This is a great way to keep clients happy and increase your studio's revenue. It's a business decision that should not be taken on until operations are strong and business is stable, though.

There are some real benefits to having a second photographer:

- *Sell the same date twice.* No more worries about double bookings or having to turn away a client because you are fully booked. That means more income for you.

- *You can take a break.* Not having to work every job means that you can take a break if needed. This is especially important if you need to spend more time with family. Of course, if you are paying someone else to shoot, your income will be lower since the cost of the second photographer comes out of your profit.

- *New services.* A new photographer joining your team might have specialized in maternity photography, for example, before joining your organization and she brings that skill to your company.

If you are looking to expand and grow your studio to six-figure profits, this is a great way to do it. Before you make the leap, here are a few things to consider:

- *Price.* If you are turning clients away due to being out of their price range, consider an associate pricing structure. If it's more about wanting to double book yourself for key dates that sell out, consider keeping rates the same. Just because you aren't the one doing the shooting doesn't mean the quality isn't equal to yours. The Geoff White brand has been a luxury brand from day one, and we felt strongly that we would not discount the services of our associate photographer. To clarify this, we call him a *lead photographer* and placed his portfolio on our website before Geoff's, as a way to give it more prominence.

- *Skill.* Make sure that any photographer you take on as an associate has the skills to produce work at the same standard of quality associated with your brand.

- *Commitment.* When asking a photographer to join your team, it is imperative that he has a high level of commitment to the job and your clients. You cannot risk your reputation by having a photographer who shows up late, doesn't perform, or acts rudely.

- *Contract.* If you take on an associate photographer, be specific about what you expect from her, copyright of the images, and what you will pay her. Typically you would have a work-for-hire type of contract, meaning your company retains copyright and ownership of all images created.

Hiring an associate is not without its challenges. Initially we considered completely changing our studio name, but ultimately decided it was too risky. We spent a long time creating our reputation and branding. In the end, we did change the name slightly from Geoff White Photography to Geoff White Photographers.

We experienced the greatest resistance from wedding and event planners, not brides. The planners that wanted to work with the big name had trouble accepting that we'd made a change in our business. Venues, however, had no problem with it, as most venues are more business oriented and understand the value of an expanded team.

Hiring an associate is a good way to expand your services and reach your financial goals, but it does require a lot of thought and preparation. It might take you a couple of years to work out the kinks, so

# Hiring Tips

Hiring for the first time can be exciting and challenging at the same time. Here are some tips for hiring key positions.

*Office Assistant or Studio Manager:* Someone to help you manage some of the day-to-day aspects of running the business, including answering the phone, responding to emails, running errands, and so forth.

- Meet with potential studio assistants in a neutral environment to give the meeting a more casual tone. This allows you to get to know the candidates in a more relaxed manner.

- Set up a round of interviews to take place on the same day, in 1 or 1 1/2 hour intervals, depending on how long you plan to chat with each applicant.

- Prepare a questionnaire of open-ended questions for each applicant to fill out. This will give you more insight into their abilities to communicate effectively through writing. This is an important skill for someone answering client emails.

- Look for someone with people skills, the ability to multitask, attention to detail, organizational skills, and good customer service.

- Invite your top two candidates to come into the office for a paid trial day. Have them work on a project that uses skills critical to the job. It's easy for someone to say he is a whiz at Excel; it's quite another thing to watch him organize a spreadsheet of data. Other activities you might have them do include answering the phone and packaging up prints. Be sure to take each top candidate out to lunch to get to know them on a more personal level.

*Production Assistant:* Someone who works with the images and graphic design. You might hire her to do color correcting, editing, graphic design, album designs, and retouching.

- For positions dealing with images, it's helpful to set up a couple of tests related to the job position. This will offer insight into their abilities and speed. They might interview well and claim to be a Photoshop expert, but sit them down and watch them do it, and you may find they are not as comfortable or knowledgeable about the tools as they claimed.

- For album design, give each candidate a collection of 25 images and ask him to choose a few to create an album spread. Without further prompting, you can get a sense for how his design sensibilities would work with your style.

- Ask interviewees to do some simple retouching. From watching the tools they choose you will get a sense of how well they know the software.

prepare to revise as you go. Make sure you write up a proper contract, consult with a lawyer, and confirm that the photographer understands your expectations.

Once you hire a photographer to join your team, it is up to you to sell him. Look at all the selling points he brings to your business. What are the advantages of hiring this certain photographer? For example, our associate photographer speaks Cantonese and this is a huge selling point with our Chinese clients.

When you are booking a client to work with your associate, instead of playing up your abilities, focus on the associate's talents.

Our associate photographer Kelvin Leung actually mentored Geoff initially, and we let people know that. We are setting an expectation: *You think Geoff is good? Well, you can hire the photographer who mentored him.* This has been a great selling point. Everyone has selling points—find them and work them into the sales presentation.

Being well established and recognized, we didn't need to keep promoting Geoff's name and work, so we focused on promoting Kelvin's work in order to establish a reputation for him as well. We began to use his images in marketing materials and editorial submissions so we

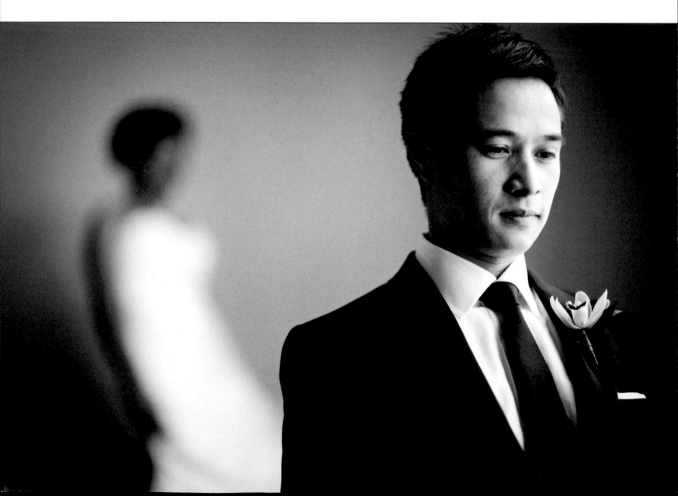

could gather lots of press and publicity to build up his reputation within our studio.

We made a point to have our personal photo sessions done by our new lead photographer, and we proudly state that Kelvin is *our* family photographer. That says a lot to prospective clients.

We also asked brides to write reviews for our lead photographer. All the efforts began to pay off, and after a season of heavy promoting, we were able to book many jobs for him.

## Adding a New Service or Product Line

Once you have established yourself in a niche, you may be ready for a new challenge. Adding a new service or product line offers some great benefits; it's a way to stay creatively challenged, it can bring new life to a stalled business, and it's a way to diversify your income streams.

A friend of mine, Kevin Chin, has established a great reputation as a fine art wedding photographer in San Francisco. He has remained current through several decades by continually sharpening his artistic vision and staying creatively engaged. He recently expanded his business to include wedding cinematography. This move has breathed new life into his business and offered him a new artistic outlet. He has been able to increase his income by offering an additional service to his photography clients, and pick up new clients interested only in his wedding cinema service.

### Expanding a Wedding Business into Portraits

Want to build a portrait line onto your existing wedding business? Consider sending wedding clients a gift certificate on their one-year anniversary for a complimentary maternity or newborn session. This is a natural way to expand your business. Wedding clients can easily transition to a new portrait line if you stay in touch and market to them effectively.

Another photographer I know, an in-house photographer for an event venue, was asked to do some exterior building shots. Later, the photographer was able to use those images to create a portfolio for corporate real estate jobs.

## Raising Your Prices

One of the biggest struggles for photographers is their pricing. As with everything else, you'll want to put some thought into when and how much to raise your prices.

There are two basic approaches to raising your prices: one is to raise prices incrementally over time, and the other is to do a big price increase at once. It's kind of like ripping off a bandage slowly and letting it hurt a little bit with each pull, or yanking it off to get it over with.

## Average Salaries for Home-Based Photographers

According to PPA's 2011 Benchmark survey, here's what average salaries (take-home earnings) look like for home-based photography businesses:

1-5 years: $35,039

6-9 years: $41,052

10+ years: $55,149

With the first approach, you get where you want eventually, but it takes time. You might increase prices by 10% a year, or as you hit certain booking goals. This approach allows you to keep most of your current clients, as they are not likely to leave you over small price increases if they are otherwise happy with your services. If you've built up a strong referral business, this may be the best way to go.

A drastic price increase, on the other hand, might make sense for a couple of reasons. First, if you've priced yourself so low that the business simply isn't working, you know you need to start over in a new price bracket. This might require rebranding, refining your style, and creating new marketing to attract a new batch of clients. Expect a dip in cash flow while you reestablish your brand at the new pricing level.

Another reason to consider a major price increase is to reach a new level of client you want to work with. Your brand perception may be affordable and if you are trying to reach a more affluent clientele or more desirable jobs, a price increase may help you to establish yourself in that new market.

Don't make the mistake of thinking your work will speak for itself, and clients will instinctively know the difference between your work and a lower-priced competitor's. Use your blog and website to communicate the value you offer, the quality of your service, the guidance and expertise you bring to the table, the experience of working with you, and the behind-the-scenes work and care that goes into your imagery.

One thing to consider when thinking about raising your prices—do you have support in place to ensure new business will continue to book you? Our photography business has always been positioned as high-end, and we recently raised our prices significantly in order to focus more time and attention on a small number of clients, and give us more time to pursue other projects (like writing this book and running PhotoMint).

In the recent past, we offered packages starting at $5,000 to get clients interested, but our average sale was between $7,000 and $9,000. After some careful thought, we recently decided to drop our entry-level packages and raise our starting price to $12,000. (Don't be intimidated by these numbers. There are specific factors that allow us to charge and get these kinds of rates.)

If we did this at random, it would most likely flop and we'd be back at our old rates within a year. However, we knew that raising our prices drastically required a change in the overall structure of our business.

We have strong relationships with high-end venues and event planners that send us their top-tier clients. We've changed our business model from booking 30 to 40 weddings at $7,000 per year, to now booking between 3 to 6 weddings per year at $12,000. Could we book 30 to 40 weddings a year at $12,000? No. Can we book 5 clients a year at that price who end up buying lots of extras like multi-volume albums? Yes, because we have *the relationships* in place and a strong reputation to support that.

We sell additional album pages for $150 per page (one side). This 4-volume set is 239 pages. We sell multi-volume albums about once a year to our biggest clients with extravagant weddings and it's always a nice bonus. These have allowed us to increase our rates and serve fewer clients.

**Business Snapshot:**
# 3 Years in Business
# Emma Case Photography

In just a few years, Emma Case has taken the UK wedding scene by storm. Together with her husband Pete, they formed Emma Case Photography (emmacasephotography.com). With a focus on alternative weddings, the couple has built a large and loyal following of blog readers and active social media followers.

## How long have you been in business?

Emma Case Photography began in January 2010. I'd been shooting for only about a year so it was quite an accelerated process. I photographed a friend's wedding and it was picked up by a wedding blog. We started getting inquiries and had to make the decision whether to start a business at that point.

## What was your first year like?

*Crazy.* In our first year, we photographed just over 30 weddings all over the UK including a destination wedding in France. We were learning so much, but at the same time we weren't charging enough so financially the business didn't flourish as quickly as it could have. However, we were getting a lot of publicity, as wedding blogs were snapping up our alternative-styled weddings, so we were able to get our name out there without having to pay for advertising.

## Is this a full-time venture for the two of you? How do you divide the workload?

I've been full-time since it started. My husband Pete joined full-time two years ago. We both shoot weddings and I handle the editing, designing, blogging, editorial submissions, and packaging. Pete handles much of the administrative and day-to-day operations.

## Do you outsource any parts of your business?

We started outsourcing some of the basic editing to Fotofafa. It has completely changed the business and given me so much more time. One of the projects we were able to do is start offering Welcome Home workshops, where we help photographers find their artistic voice and develop their brands.

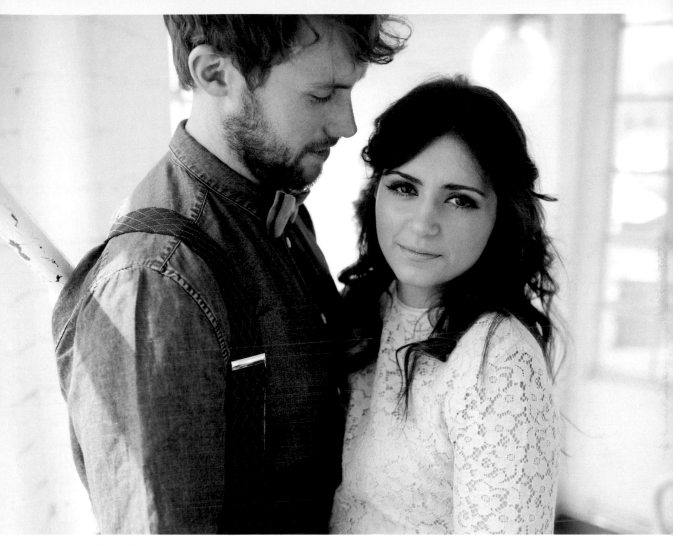

© Emma Case Photography

## How did you know you could make the business plan work financially?

Our finances before this business were pretty tight and previous jobs had never been huge earners, so starting our own business was an opportunity for us to be more financially secure.

## What kind of start-up costs did you have, and how did you finance them?

We took out a small loan for some basic equipment including cameras, lenses, and essential office equipment. This business has been a real slow burner and it's only really now that we are starting to see the fruits of our labor in terms of the equipment investment. We also now have an office, which was a huge move.

## How long did it take before the business became profitable?

This is a tough one as for the past three years we've always made money but there was always something new to buy for the business—cameras, computers, packaging, a new website, a car, and so forth. We have been reinvesting everything we can back into the business. Hopefully this year things will even out financially and we might have a holiday!

## What has been your biggest struggle?

The workload. Even with two people working full-time there is always so much to do. When you run your own business, you never think of all the behind-the-scenes work that needs to be done.

Along with the workload of a new and growing business, sometimes it can be a challenge to make sure we take some time off. Having your own business and one that you love means that you would happily spend 24/7 doing it, but it's not healthy to do that. Step away occasionally, turn your phone off, and go out and have some fun.

## Why do you think you've had early success while others are floundering for those first few years?

I think we've stayed true to who we are from the beginning and have always been honest about who we are and what we do. We share a lot through the blog, so people feel connected to us and have watched us grow. We also had a clear idea of what we wanted from the start and didn't follow what was expected.

## How do your fees compare to your competition?

There are a handful of UK photographers priced similarly to us. We tend to work together, discussing our prices and supporting one another to ensure we are charging what we are worth. By collaborating with my colleagues, we are able to ensure that clients book us because they want to work with us, not because we are cheaper.

© Emma Case Photography

## Would you consider yourself affordable or expensive?

We offer a few different packages to suit most people's budgets but we are at the more expensive end for wedding photography in the UK. Our pricing begins at £2,000 (about $3,000 U.S. dollars) for a set number of hours, and most couples add 1 to 2 hours on top of the base coverage.

## How has your pricing strategy impacted your business?

We have literally been at every price point you can think of, but it was always in line with our experience and skills at the time. At the beginning, it was easy to secure a booking when we were super cheap. The free marketing we were getting from wedding blogs helped get our name out there and build our portfolio and reputation.

As we increased our prices, we would get couples that couldn't afford us or would rather prioritize their budget on something else. We concentrate on making our service the best it can be—everything from the images, website, client communication, presentation, packaging, and so forth. We want our couples to have the best experience possible when working with us.

## How many weddings did you shoot each year?
## Is this a good amount financially and in terms of maintaining a reasonable workload?

Each year our business has grown. In 2010 we shot 32 weddings, in 2011 we shot 36 weddings, and in 2012 we shot 40 weddings.

I think we'd be happy with about 30 weddings per year. This would give us enough time to devote to each couple and give them the attention they deserve. It would also give us space to have a personal life!

## Besides wedding fees, how else do you add profit to your business?

Besides weddings, we do occasional commercial jobs, engagement sessions, and family portraits. We don't sell too many albums or prints at the moment. Adding after sales is an area of the business I would like to grow in the next couple of years.

Last year we started offering our workshops and have now done four, with another two scheduled for later this year. They bring in the equivalent of a few weddings but there are also more costs involved, such as a venue, travel, goodie bags, and so forth.

## What kind of hours are you putting into the business?

Too many! I can't imagine anyone running his or her own business would say anything different. At one point, it was literally all day, every single day.

## Do you feel that amount of time is related to your success?

Not necessarily. I think there is always room for being more productive in the time you give yourself. That is definitely one of my downfalls. I reckon I could do everything in about half the time…but you learn as you go along.

## How has social media impacted your business? Has it proven to be a good source of clients?

Social media is everything. We have a strong following on Twitter and Facebook, and we have good relationships with editorial blogs and other wedding vendors. We do everything online and people get to know us through the blog and stay updated with our work and us. It is invaluable.

## How has the press and editorial impacted your business? Has it proven to be a good source of clients?

We have had features in magazines and have awards from two wedding publications. I wouldn't want a couple to book us just because we have an award, but the press and editorial coverage has helped us reach a wide audience, which is always great for business. We might not be the right photographer for everyone but what we put out there should help the couple to make that decision pretty early on.

## Would you say that you have a defined style that draws clients to you?

Our style and our ethos are the two things that our couples tend to come to us for. We have a definite style but we also have a definite idea of what is important to us. Our couples get that and it is important to them too.

## What's your Facebook secret? How have you built up such a loyal following that is highly responsive to your Facebook updates?

It's just been slowly creeping up over the past three years. To be honest, we've never been big on asking for followers or "Like this page" kind of thing. We have just got on with what we love doing and people seem to be interested and follow! We enjoy interacting with people on Facebook and Twitter and have always been SO grateful for the support. I think in a weird way people have always identified with us. They've been on this journey with us, so they have an investment in the relationship. I do it myself with other blogs and photographers—you follow their journeys, cheer them on when things are going well for them. You feel like you know them and want to see them succeed.

## Advice to new photographers?

Do the best job you can possibly do. Be yourself. Put out there what you want back.

**Business Snapshot:**
# 5 Years in Business
# Elizabeth Halford, Gracie May Photography

Elizabeth Halford is a wedding and portrait photographer based out of Hampshire, England. Besides her photography business Gracie May Photography, Elizabeth is best known for her photography education site, ElizabethHalford.com. With over 15,000 fans on her Facebook page, Elizabeth is well-known and respected by photographers across the globe. She breaks down business and marketing strategies into easy-to-understand plain English, so that everyone can benefit from her knowledge. In this interview, Elizabeth candidly shares what her photography business looks like at the five-year mark.

## Getting Started

Prior to starting her photography business, Elizabeth was a professional makeup artist. Over time, she says, it slowly became evident to her that she was more drawn to the photography. A natural at sales, Elizabeth was selling at an early age to family and friends from church. Instead of asking "would you like to buy…" she'd say instead "which one would you like to buy?"

## Getting Profitable

The initial start-up period of a photography business generally requires 1 to 2 years before a profit is realized. There are several reasons behind this—initial equipment investments, the cash flow cycle, and the time for word-of-mouth marketing to grow. Typically, photographers need to market their services for several months before customers start coming in regularly. If you are a wedding photographer, you might get a small deposit 6 to 12 months before you get the final payment, making it quite a long wait between opening your business officially and seeing a profit. In addition, word-of-mouth marketing takes time to develop. You might make a great impression on wedding guests, but it's a year or more before those guests need a photographer.

Elizabeth was able to turn a solid profit after two years of investing in her business. Initially, she spent a lot of money on computers, lenses, and camera equipment. She advises photographers to be careful about overspending in this area and make purchasing decisions based on your business needs, not whatever the latest toy is.

She highly recommends photographers ease into their businesses over time, maintaining an outside job initially and cutting back on full-time hours as the business grows.

© Gracie May Photography

## Finding Her Niche and Market

Elizabeth typically photographs about three portrait sessions per month and a small handful of weddings each year. While she used to do all types of portraits, she now photographs families and weddings only. By not offering other types of sessions, she is able to keep her focus and style consistent.

Her market is families and couples that she personally identifies with. She has set her pricing to be affordable, allowing her to work with the clients who are drawn to her images. She also works with a lot of photographers, which is no surprise given her popularity.

She maintains her photography business part-time (about 5 to 10 hours per week), allowing her time for the other side of her business—teaching photographers through her wildly successful blog ElizabethHalford.com—as well as spending time with her family.

## Consistency

Like many photographers starting out, Elizabeth tried to be all things to all clients. She was having a hard time getting work. Over time, she began to narrow her focus as she realized what she most enjoyed photographing—couples and families. She started working frequently in the same location, and her work began to look very similar. As her style and look became more and more consistent, she began to get more bookings.

> ## "The more my work started to look the same, the more work I got."

Another benefit to maintaining a consistent style is that clients know exactly what they are going to get. Whereas she used to get complaints from clients who were disappointed or expecting something different, now she hardly ever gets complaints, as clients have clear expectations that are consistently met.

## Marketing Strategies

Elizabeth finds that her best marketing strategies have been Facebook and email marketing. Her Facebook page is regularly updated with an intriguing mix of recent sessions, customer testimonials, charity work, products, news, and personal updates. Her clients obviously enjoy following along in her business adventures, and that builds loyalty among her fan base.

The other strategy Elizabeth relies on is email marketing. Collecting emails from customers is a top priority, and she emails past clients about mini sessions, upcoming promotions, holiday card orders, and so forth. She also likes to send her wedding couples a happy anniversary email, as a way to stay in touch with clients at the time they are starting to grow their families.

## Biggest Marketing Mistake

Elizabeth's biggest marketing mistake was spending £1600 on a full-page magazine ad. She thought it was a no-brainer since she only needed to book two sessions to recover the costs. Unfortunately, it was an expensive lesson in what not to do, and is all too common among photographers. She vowed never to pay for a print ad again.

## Pricing

Elizabeth's wedding fees are £2,000 (about $3,000 U.S. dollars), and family sessions range from £80 for the session only to £450 for the session and digital files, available only to out-of-town clients. She is able to keep her creative fees low because she is confident she will earn a profit from add-on sales, which take place at the ordering session.

Her strategy is to be priced enough to be valued, yet affordable to her target clientele. Her pricing allows her to keep client expectations normal. This translates into a relaxed work environment, as there's no pressure that often comes with providing a high-end service.

> "Set your prices strategically—not based on a competitor's pricing, and not pulled from thin air. Otherwise you'll second-guess your rates and start discounting."

## In-Person Sales

Elizabeth credits in-person sales as the key to making her business work. Originally, she made images available in an online gallery. It's no surprise that her average sale was… nothing. Once she started doing in-person sales, her average order went up to £1,000 (about $1,600 U.S. dollars). It's no surprise; when you offer your expertise, show images on your properly calibrated monitor, and walk your clients through the decision process, of course you will see better sales. In fact, most photographers report their average sales at least doubling after requiring ordering sessions as part of their business.

> "Call it a design and ordering appointment, instead of a viewing session. That helps clients understand their job is to make selections and place an order."

Her session fees are priced affordably, but clients cannot schedule a session without also committing to the ordering appointment. Rather than beat around the bush, Elizabeth explains her process from the beginning. When explaining her services, she matter-of-factly tells clients "we do the session, and then a week later I come to your house and show you the images, and that's when you place your order." Simple. She emails her product pricing with the contract, so there are no surprises in store for the client. ■ ■ ■

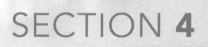

# SECTION 4

# Marketing

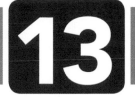

# Understanding Your Clients

It would be wonderful if you could just sit in your office and wait for clients to come to you. That doesn't happen, though—especially when you are just starting out. The simple fact is that your future clients don't know you exist yet. You have to go out and find them, and then get them to hire you.

New businesses often overlook this one thing. You need to know what type of client is going to be interested in hiring your photography services and where to find them. And once you find them you have to get them to want to work with you, and then hustle to keep them as clients. How do you it? This chapter will tell you.

## Finding Clients

Some clients hire you to take photographs and others just buy the images after they've been taken. For example, one client books you for a portrait shoot and then she ends up with the images. The other type of client is one looking for a specific type of image and pays to buy or use it. This is how stock images and many wire services work.

Where is the best place to find your clients—especially your *first* clients? That depends on you and your business. The right answer for you may be completely different from the right answer for me. That's why it's important to put together a business plan before investing much time and money.

To find your clients, start thinking like them. Where do they shop? What is their age range? What books and magazines do they read? What are their values? Where do they search when looking for photography services or images?

When looking for your first customers, the first thing to do is define who your typical clients are. Most first-time business owners are too broad when it comes to defining their target customers. For example, if you are a pet photographer based in the Pacific Northwest, your target clients are not pet owners. Your target clients are pet owners who live in the Portland, Oregon, and surrounding areas who want professional photos taken of their pets.

The more specific the niche, the easier it is to market to them. For example, if you are looking for pet owners in Portland, you can concentrate your marketing to places that pet owners shop or go, like pet stores and veterinarian offices in the area where you work. You might also focus on a certain type of pet, such as dogs or horses.

My first clients came from bridal shows. It was an expensive way to acquire clients, but it gave us our start. At first, I didn't know much about my clients, my only focus was getting some. After a while, I started to see trends in the types of clients that were a good match for us. Couples that booked certain venues, hired planners, and placed a high value on photography tended to be a good match.

## Match Your Marketing to Your Audience and Style

The style of your images and your marketing needs to match what your target clients are looking for. I know this seems obvious but it's important. Many times

### Selling Your Images

One item that can help when it comes to finding clients who buy photos is the *Photographer's Market* book (not applicable for portrait and wedding photographers). There is a new edition every year. The book lists publications, newspapers, book publishers, greeting card companies, stock agencies, advertising agencies, and even photo contests. It lists the outlets that purchase images, and the best way to submit your images.

photographers starting to go pro try to be everything to everyone, and in doing so don't really reach anyone. You'll book more clients and be able to charge higher rates by specializing in a certain type of photography.

The question to ask yourself is, "Since I want to work with this type of client, what kind of images and marketing do I use?" For example:

- I want to work with rock bands, so I need to show images of live music that match the type of images that the bands would want. The images they see on my website, portfolio, and marketing materials need to be the type that bands want to see of themselves. Therefore, a shot of classical music or a DJ won't speak to a rock band.

- I want to shoot destination weddings, so I need to show images that showcase beach locales and smaller, intimate ceremonies. The bride and groom want to see themselves transported to that location. Showing a hotel ballroom and a standard church setting isn't going to cut it.

- I want to shoot corporate work, so I need to show clean portraits in the style of news magazines. It won't work if my portfolio shows parties or maternity work, since that's not what the target clients are looking for.

The same holds true for all types of photography. Every image you have on your website or in your marketing needs to be on target for your type of client.

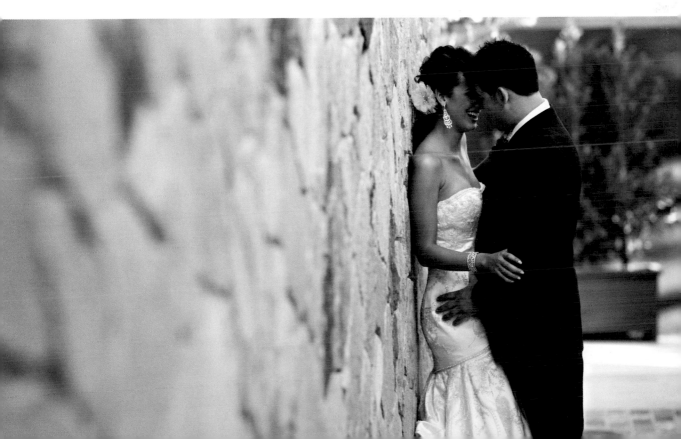

## Knowing What Your Clients Want

Many of your customers don't exactly know what it is they want and it's your job to help them figure that out. If you can meet their needs, wants, and expectations, you will have a happy client.

Some general questions to start with are:

- What do you plan on using the photographs for?

- What are you hoping for, in terms of hiring a professional photographer?

- Have you ever hired a photographer before? If so, how was the experience?

- What style do you prefer (candid, posed, outdoors, and so forth)?

After the general questions, work on narrowing down what it is they specifically want from the shoot.

Ask your clients questions to determine their needs, wants, and expectations from the shoot.

### Event photographers:

- Is there a certain person who needs extra attention?

- Is there a certain part of the event that needs special coverage?

- What is the goal of the images?

- How will the images be used?

### Wedding photographers:

- What is your vision for your wedding?

- Have you seen a wedding photographer in action at another wedding?

- What struck you as positive or negative?

- Show me or describe some of your favorite portraits.

### Portrait photographers:

- Why do you want these photos taken?

- Where are these photos going to be used?

- What's your best feature?

### Sports photographers:

- What team are you there to cover?

- Is there a certain player who needs extra attention?

- Where will the photos be used?

- What is the purpose of the images?

It doesn't matter what type of client you have, asking a few questions will enable you to do a better job. Go into each shoot with an open mind and listen to the answers to the questions.

## Client Referrals

Client referrals are awesome. Every business loves them because they are more likely to turn into paying customers. Since they are recommended to you by your happy clients,

**Ask your clients questions to determine their needs, wants, and expectations from the shoot.**

they already think you do great work. With referrals, you still have to earn their business, but you have a head start.

The first step is to *ask* for referrals, usually mentioned after receiving a compliment—tell your clients, "The best compliment you can give me is to refer someone." The next step is to give clients something designed specifically to show off. Consider some of the following products as a way to get your clients to show off your work, and therefore send referrals through word of mouth.

- *Wallpaper or Facebook image.* Nearly everyone owns a computer, a tablet, and/or a smartphone. A great extra for your clients is a wallpaper image that appears as a background on their device or something to share on Facebook.

- *Smartphone/tablet cases and skins.* You can give clients a case or skin that features an image on the outside of the device. Look at gelaskins.com for a wide variety of cases and skins for all devices.

- *Mini books.* You can create small books that customers can easily take with them to show off their images. Portrait and wedding clients especially love these.

To take full advantage of happy clients, create referral cards with their images that clients can give away. Another way to develop a referral base is to offer some type of incentive for referrals, such as a credit or a free session. Not only does this provide clients a good incentive to send referrals to you, it also helps you to schedule repeat business with the referring client.

When we order vendor sample albums (from Asuka Book) for marketing (discussed in Chapter 16) we often get smaller purse-sized albums (5x5) as gifts for brides. These go into brides' purses and get shown to everyone they know.

## Meeting with Prospective Clients

If you don't have retail office space, where do you meet with clients? At your home office, or at clients' homes or a public location? Let's look at the pros and cons of each option. I've done both, and each has its advantages and disadvantages. Sometimes you don't have a choice, and circumstances force the decision for you.

Home Studio Pros:

- When you have appointment no-shows, at least you're still home!

- Any space in your home 100% dedicated to business is eligible for a tax write-off.

- There's no commute.

- You don't have the overhead costs of a rented space.

- You control the environment: the temperature, the wall art, the noise level.

- Your artwork is on the walls.

- You can add warm and cozy touches: soft music, candles, wine.

Home Studio Cons:

- You have to keep the entire path from door to meeting space spotless.

- Your family has to be virtually silent or leave the house during consultations.

---

# Client Closing Strategies

Consider offering a booking special that is time-limited. This can be effective for price-conscious clients. It might be a $300 print credit or a complimentary session for all bookings during a certain month. It gives clients a reason to make a decision.

Another strategy is to step out of the room toward the end of the consultation, letting them know you are going to give them a few minutes to discuss the packages or any questions they have. It's a subtle indicator that it's time to make a decision. It also gives you a chance to answer their questions in person; sometimes they just need a moment to discuss their options privately. I have booked a number of clients this way.

---

- A key part of your home (like a living or dining room) gets taken over by your business.

- When you have a scheduling mishap (like totally forgetting to put an evening consultation on the calendar), you might accidently open the door in your pj's to find clients expecting a consultation. I guess this is only a con if it actually happens. (I don't want to talk about it!)

- When a client is 45 minutes late, you can't just leave.

- Pets can be a...challenge. Not only for clients with allergies, but it is distracting to hear a dog barking throughout your presentation.

If meeting in your home (or retail space) is not an option, what should you do? First off, think of it as an *advantage* to the client and keep that attitude in your mind. Focus on the positives. From experience, I can tell you that you can make either option work; it's about your commitment and attitude. If you show confidence and grace, you will put your clients at ease.

Outside Meeting Location Pros:

- The meeting location can be convenient to the client.

- It takes the formal edge off the meeting and sets a friendlier, casual vibe.

- You can keep your home space private. This can mean a lot, especially if you have gone the home meeting route for a couple years. (Trust me, hiding family gets old after a while.)

- If the client is a no-show, you can leave.

- There is no extra overhead other than those coffees you'll be buying for clients.
- If meeting at a client's home, you can scope out the wall space and décor to recommend wall art to match.

## Outside Meeting Location Cons:

- You need to arrive early in order to secure a table and set things up.
- You may feel uncomfortable. Practice and prepare until you are comfortable.
- You can't permanently display wall portraits or use a large slideshow presentation, so a nice laptop or tablet is the way to go.
- You can't always use your own music for slideshows.

- You can't control the environment.

Another option to consider is a photo studio co-op, where two or more people share a space and split the rent. It could be a small retail space for holding client meetings, or it could include space for shooting. This type of arrangement works well for many photographers, as it offers the best of both worlds—you get the professional space you need but you don't have to pay for the space when you aren't using it. To see some examples of co-ops at work, check out the websites of RockerDown Studios in North Carolina (rockerdown.com), and The Collection Event Studio in Sonoma, California (thecollectioneventstudio.com).

Until recently, this was our home studio where we met with clients. The space set the right tone for our clientele.

 **Industry Insiders:**
# Jody Gray, of Zach & Jody, Nashville Photographers

Named one of Nashville's top wedding photographers, Zach and Jody Gray (zachandjody.com) have gained national recognition for their photography and business savvy. I had the chance to chat with Jody about how she found her market and how she markets specifically to her ideal clientele.

## Figuring Out Your Market

One of the key things to master in growing your business is figuring out who your market is, and understanding how to reach those ideal clients. It's not something that comes easily; it takes time to discover your photography style and your personal style. From there, figure out how to match your marketing and branding to connect with a specific type of clientele you want to reach.

> # "Our market is interesting because rather than a specific demographic, it's people who value photography."

Jody's clients tend to be professionals from diverse backgrounds—lawyers, designers, other photographers. What they have in common are great personalities and a strong belief in the value of images. When you are working with a specific demographic, it may be easier to connect the dots in terms of marketing approach. In Zach and Jody's case, they built their branding around their distinct personalities, and it requires time to develop that voice and connect with the right people.

## It Takes Time

Jody explained that at first they took every wedding that came their way. They quickly found, however, that they clicked with certain clients and when that happened it led to a better experience for them and the clients. It took them several years to understand how to seek out clients they clicked with, and say no to clients they didn't. They realized they enjoyed working with people who had great personalities, so they began putting their own personalities into the business more—in talking with clients, on the blog, and so forth.

© Zach & Jody

# "The more we put ourselves out there, the more people who are attracted to our style and personalities started connecting with us."

© Zach & Jody

Jody mentions a local colleague whose demeanor is more quiet and introspective, and his website reflects that; it feels calm, quiet, and intimate compared to Zach and Jody's vibrant website and bubbly personalities. What this does is draw people to him that are more on the quiet, introverted side, so he attracts clients that are a good fit for him.

## Matching Your Marketing to Your Target Clientele

Jody shares one of the secrets to connecting with your clients is by sharing little things about you and your personality. Zach and Jody are known for their love of Starbucks and their cat (named Starbucks). You will find blog posts related to potty training their cat and a trip to the first Starbucks. It's a way to share themselves and enable their clients to connect with them on a personal level.

After figuring out how to build their marketing around their personal style and personalities, Zach and Jody hired a branding specialist who helped them create a website design based on their personalities. For example, their blog welcomes readers to "come on in and grab a cup of coffee" alongside an image of a coffee cup. One of the main colors of their site is tan, the color of coffee (with cream). It's all in the details.

## Matching Your Branding to Your Target Clientele

Jody recommends finding things about yourself and personality that clients can relate to. If your focus is on your kids, but your niche is weddings and your clientele typically don't have children, it may not be a good idea to blog all those cute photos of your kids. That's not to say you should hide who you are, it's simply about finding ways to connect with people.

# "Don't be afraid to share who you are; put your style and personality out there."

At the same time, it's important to realize that you are not going to click with everyone, and that goes both ways. "Some people get on our website and they are sold on working with us before ever speaking with us. Other people visit the site and realize we are not a good match for them, and that is fine."

# "It's about you fitting to them and them fitting to you."

Jody recommends finding the little things you like about your style and your personality, and amplifying them by 100 times. She suggests asking friends what they think your personal quirks are, and looking for those things that make you uniquely you. ▪▪▪

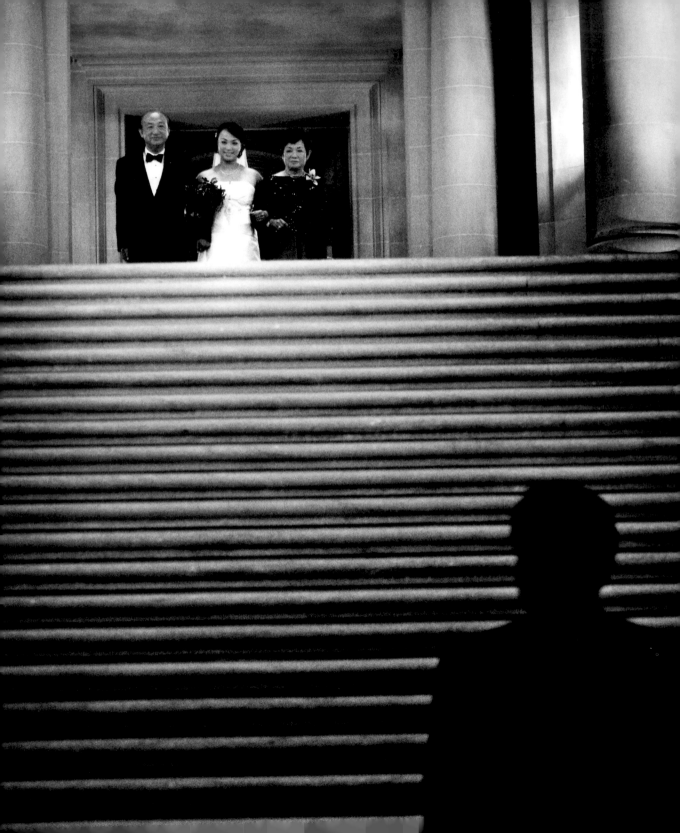

# 14

# Style

If 10 photographers photograph the exact same scene, you will get 10 different photographs. Each of those images will have a different style. As an artist and a photographer, you need to figure out what *your* unique style is and how to convey that to your market. You also need to make your style match what your clients are looking for.

Many times photography *styles* are confused with the *subject* of the photography. Ask a photographer what her style is and chances are you will get an answer such as street photography, black-and-white photography, or the popular photojournalistic style. Photographing black-and-white landscapes is not a personal style. This chapter is about finding your own style—the look and feel of your images that make them yours.

## Developing Your Photography Style

Finding your photography style does not happen overnight, it is a journey that takes time. For many photographers, that journey takes years. Be patient with yourself and keep practicing. The more time you spend with your camera, reviewing your own work and looking at the work of others, the more you will start to recognize elements of different photography styles.

Your style can be shown through your lens choice, composition, lighting setup, use of color, angles, and even post processing. As you start developing your photographic style, you will likely go through different stages:

■ *Imitating others.* One of the first steps to working out your style is to look at other photographers' work. Chances are you saw images that made you want to pick up a camera in the first place. It could have been the sports photography in the pages of *Sports Illustrated* or the fashion images in *Vogue*. It doesn't matter where, what matters is that at some point you wanted to make images like ones that you saw. It's a great starting point in developing your style.

■ *Refining the look.* Once you have imitated other photographers for a while, it's time to see what works for you and how to refine that into a style of your own. Do you like to shoot tight or

do you prefer a wide-angle look? Would you rather work with posed subjects or do you prefer to capture spontaneous moments? Are there common elements across your images that point to a certain style?

■ *Don't force it.* Don't push yourself too hard to pick a personal style when starting out. Let the process take it's time. Your style will evolve naturally over time; don't obsess over style with every shot.

■ *Study your work.* Look through your portfolio and pick out your favorite images, the ones that speak to you. Now ask yourself, "What is it about these images that appeals to me?" Come up with elements common to all the images and, more importantly, think about how to describe your style in a simple sentence—such as "emotive and compelling documentary wedding images," which is how Jeff Ascough (one of my favorite photographers) described his style.

## An Exercise to Figure Out Your Style

Here is an exercise I learned in a workshop with Julia Woods, which helped Geoff and me understand our style.

Choose your top 10 favorite images you've shot, and then ask people whose opinion you trust to look at each of them. Ask each person to write down a single word impression for each of image. After doing this with several people, look at the results.

You will find that certain terms keep popping up. This is what your images are conveying to others. Is this the message you thought you were sending? If it is—great. If it isn't, find out why the message you think you are sending is not the same message the viewers of your images are actually getting.

This exercise was very helpful for us. We kept hearing the words *fun* and *funny*, but the thing was—we didn't want to be known for that. We didn't want to relate to funny couples, we are more on the serious, quiet side. This made us realize we wanted to be known more for striking, moody images, and not fun images.

We removed the images that were giving the wrong impression from our portfolio and replaced them with ones that more clearly represented our style. By doing this, we attracted more clients that were drawn to heavily vignetted images with a moody, sensual style. We got a lot of positive feedback on the images with strong lines and bright pops of color. We started including these elements more in our images as we continuously refined our style.

Our style has evolved over the years and we periodically repeat this exercise to make sure we are still on the right track.

■ *Know your photography style.* Once you can accurately describe your style in a simple sentence you can start to consciously create images that match it. The clearer your style, the easier it is for your clients to recognize it and know what they can expect. This makes it easier to book clients who want the style you offer.

■ *Change.* Your style can and will change over time. It might be a subtle change or a more drastic one. As an artist, doing the same thing repeatedly can get boring, but you have to balance consistency for your brand. It's important not to try out radically new things on unsuspecting clients. Instead, work on personal projects when trying out new styles. Your clients hired you for a certain look; you need to deliver that look consistently.

We built our brand on our style to stand out from the romantic, soft, dreamy type of wedding images that are more common. Our images have strong lines, bright pops of color, and a masculine feel to them. This difference in style has helped us stand out from our competitors.

It takes a while but once you start to see a pattern in your work, you can project that style even more. Then, start communicating that style in your web design, brochure, sample albums, and marketing materials. The more you showcase your style, the more like-minded clients will find you.

Here are some common examples of styles within certain niches. Where does your style fit in?

## Knowing Your Personal Style

What type of person are you? Other than a love for photography and an artistic flair, what do you like? Are you an artistic type of person who enjoys crafts and do-it-yourself projects? Are you dreamy and romantic? Do you find beauty in unusual places? Do you enjoy learning to control lighting and working in a studio setting? Do you focus on manipulating a scene to create a specific type of image, or do you prefer to work with available light and capture life exactly as it happens? Knowing your strengths (and weaknesses) will enable you to connect better with your clients.

■ *Newborn photography:*

- Black-and-white studio work

- Focus on props such as baskets and bowls

- Home environments with available lighting

■ *Kid photography:*

- Natural settings

- Classic portraiture (more serious expressions)

- Fun and goofy—kids being kids

- High-key style with bright color pops

- Traditional posing
- Classic black-and-white with controlled lighting

■ *Boudoir:*
- Pinup style
- Beauty
- Fine art nudes
- Film noir
- Sensual
- Glamour style with dramatic lighting
- Tight cropping with a focus on body parts
- Focus on outfits and props

■ *Weddings:*
- Romantic, soft, dreamy
- Unexpected angles and perspectives (quirky)
- Traditional, with lots of posed shots
- Photojournalistic, over-the-shoulder
- Fashion-inspired
- Funny moments, people having a great time
- Personal connections between family

■ *Portrait:*
- Traditional
- Glamour
- Lifestyle
- Environmental
- Candid

■ *Fashion:*
- Lifestyle
- Beauty
- Haute couture
- High fashion

■ *Editorial:*
- News (photojournalism)
- Magazine shoots

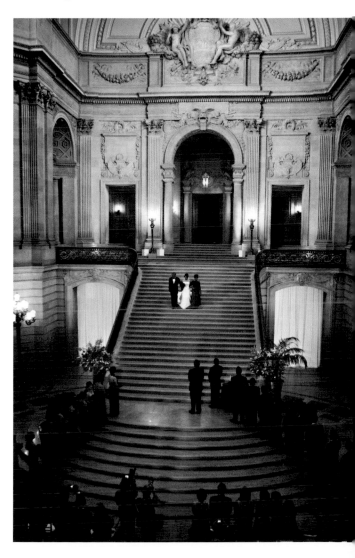

## Matching Your Style to Your Niche and Market

I would *love* to have some rock 'n roll types of brides as clients, but that's not our client base, and probably never will be. It's not a match for our style, it's not a match for our personalities, and it's not a match for our pricing and product offerings. We don't show that style of weddings, and we don't try to appeal to that market. Because we don't book those clients, it means I can't photograph those clients—does that make sense?

We go after the type of brides that book us. Our referrals come from country clubs and expensive venues, and our whole

system is built around those types of brides. We just refine and refine and refine that system to create better marketing, better sales meetings, and a more consistent studio brand, all to meet the needs of our typical client.

What that does is create a lot of consistency around our style and our brand. Clients booking us know what they will get, and that helps us book more of our right type of client—the classic country club bride. This is perfect, because I understand that and cater to my audience.

Look for consistency in your past clients. What do they all have in common?

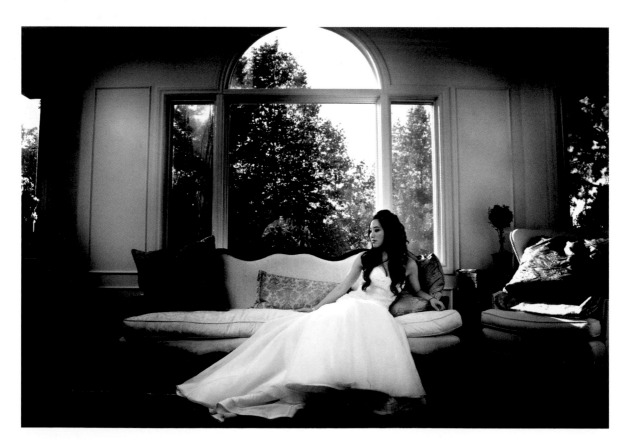

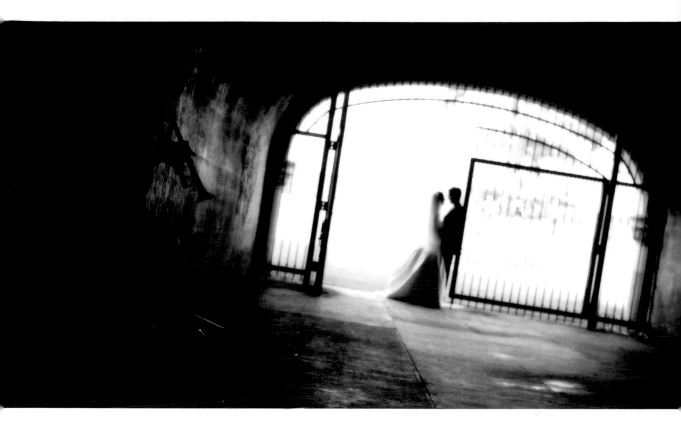

## Matching Your Branding and Style

Your personal style and photographic style need to match your branding. You need a united look and feel to everything you do.

Our branding is simple, classic, and timeless, and that speaks to our market. Our branding is not overly romantic, as that is *not* our style. You won't find us using soft, feminine colors and shapes. Our brand has no hint of DIY style, as that is not part of our style. The colors, the font choice, and the lack of an identity mark within our branding all work cohesively with our classic, timeless photographic style.

Think about how to match your brand to your style. If your style is classic and timeless, choose colors, fonts, and shapes that are classic and timeless. If your style is modern and edgy, carry that theme through your branding. Just remember that as an artist, your style will likely evolve over time. Enjoy the journey.

## Industry Insiders:
# Christine Tremoulet on Finding Your Style

Christine Tremoulet (christinetremoulet.com) has been a leader in the photography industry for years, known and respected for her honesty and desire to give back to the community. She started in weddings but eventually realized her true calling was helping women feel beautiful. She decided to take a leap of faith and transition over to boudoir, and hasn't looked back since. I was thrilled to speak with her about her journey of discovering her true style and calling.

## Business Snapshot

Christine currently photographs between 50 to 80 sessions per year. Thanks to in-person sales, her average sale is between $1,000 and $1,500. She prefers a boutique approach yet wants to ensure her services are accessible. Her current financial goal is to reach $100,000 in annual sales. More important than the earnings, Christine is deeply fulfilled and happy from her work. She has more time (evenings and weekends) to herself and work is not as physically demanding as it once was with weddings.

## How She Found Her Calling

Originally, Christine thought she wanted to do children's photography. However, she quickly realized that kids don't take direction well, and she didn't enjoy that aspect of the job. She started her business as a wedding photographer, and was able to book jobs initially through her personal blog and contacts. After a year in business, she decided to rent a studio.

She started offering boudoir sessions and really enjoyed them. Helping women feel beautiful was something that resonated deep within her. After being in a relationship with someone who made her feel like she was never enough, she wanted to empower women with the message "you are enough," and that continues to be a theme of her work today. She noticed people were talking more about her boudoir work than her weddings. But she wasn't quite ready to give up weddings just yet.

In 2010, she attended a workshop with Jeff Jochum on selling to millennium brides. While in the workshop, she began to realize that as an older photographer, she related more to older couples. After considering this for some time, she came to the realization that she most wanted to work with moms.

She continued mentoring under Jochum, and he helped her better understand her style and navigate her path. After a time of doing both weddings and boudoir, he helped her realize she would be happier to specialize with a single focus. It took 16 months to make the full transition. Within 6 months she was surprised to find that she was making the same money doing only boudoir as she had been doing both.

# "Once I knew *why* I was doing what I was doing, I was able to hone my message."

My Superpower: Helping Hot Mamas grow their CONFIDENCE by rediscovering their BEAUTY!

... My session with you was one of, if not the, BEST things I have ever done for myself.
— Ms. J

Home   About Me   Your Session   Pricing   Travel Dates   Contact Me!   Rave Reviews!   Blog   Weddings

## Christine Tremoulet — The Hot Mama Photographer

For most of my life, I have been in the process of learning to love myself – just as I am. Mass media works just as hard telling me that I'm not good enough. They. Are. Wrong! My epiphany was recognizing that I have awesome *superpowers*, even if I don't fit the *supermodel* prototype. We all do. We are freakin' FABULOUS just the way we are!

My Superpower is helping Hot Mamas grow their CONFIDENCE by rediscovering their BEAUTY.

## What Makes Her Different

There are numerous different boudoir styles, including glamour, pinup, fine art, film noir, natural, and beauty. Christine's style leans towards natural beauty. She feels strongly that her clients should not experience the supermodel-for-a-day treatment. Instead, she strives to help women feel beautiful exactly as they are. She rarely liquefies (reshaping clients' bodies in post processing), and her clients don't request it. Her editing is clean, consistent, and true to life. This approach fits perfectly with her message.

> ## "My superpower: Helping hot mamas grow confidence by rediscovering their beauty."

She finds that her branding and message begin working before the session starts. Clients come in with a clear idea of what to expect and are excited to work with her.

> ## "You will draw certain people to you. Use that to move your business forward."

## In-Person Sales

Like many photographers, Christine was initially resistant to in-person sales. The turning point came for her when a client mentioned that when viewing her images online for the first time, her response was to criticize herself, and she had to stop looking at them. During the session, Christine is a constant cheerleader, making women feel excited, confident, and beautiful. But she realized that by not being there when women first saw their images, she was not able to create a positive experience and override those negative voices women have in their heads. That incident made her decide to stop offering online galleries. Besides increasing her average sales, she also noticed clients were happier with their experiences.

## Finding Her Ideal Clients

All the pieces began to come together. With her ideal client identified, and a clear message, she was able to refine her brand to reflect that. She uses soft, feminine colors and shapes that appeal to women. She collected testimonials and featured them on her front page, along with accompanying images. Instead of the common, "I picked up a camera when I was twelve," About Me page, she wrote about her journey to discover her true calling, and it speaks directly to her ideal clients. The point is, some people will identify with her story, and some people won't. That is exactly what she wants: to find her right people.

© Christine Tremoulet

## Industry Insiders:
# Lindsay Adler on Working in Fashion Photography

Lindsay Adler (lindsayadlerphotography.com) is a fashion and portrait photographer based in New York City. She got her start in high school when she started photographing upperclassmen and their families. Only in her twenties, her photography has received much acclaim, and her editorial work is regularly featured in fashion publications. In addition, she regularly contributes to industry magazines such as *Professional Photographer* and *Rangefinder*, and frequently teaches at WPPI, Pro Photo Plus, and more. She shares her advice for photographers looking to break into the world of fashion photography.

## Making the Transition from Portraits to Fashion

After college, Lindsay opened up a portrait studio about three and a half hours outside New York City. She started building a career in fashion by networking in NYC while her portrait business paid the bills. Eventually she built up some clientele within the fashion industry, and put in many hours commuting back and forth to NYC. One relationship with a stylist, however, led to her making the move to NYC. She became the stylist's main photographer, and this relationship enabled her to pursue fashion full-time.

## Biggest Mistake with Marketing

Lindsay's biggest mistake with marketing was having a mixed message about her brand and her style.

> ## "Clients want to know you have that particular style they are looking for."

Her portfolio used to be a mixed bag of portraits, weddings, and fashion, featuring a variety of styles from romantic to soft and dreamy to edgy. At the time, she thought it best way to try to appeal to everyone. Instead, though, she found that her portfolio appealed to no one, because it wasn't memorable.

> ## "By being an everything photographer instead of a specialized photographer, your portfolio won't stand out for any particular style."

© Lindsay Adler Photography

## Biggest Success with Marketing

Lindsay feels that the key to marketing in the fashion industry is developing relationships with stylists and makeup artists. If you have good relationships, those people will recommend you to their clients, and of course, you would recommend them to your clients, making for a mutually beneficial relationship. Those relationships are built on trust.

**"My biggest success with marketing has been building a strong creative team that gets me work."**

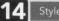 

## Biggest Misconceptions About the Fashion Photography

Lindsay shares that the biggest misconception of photographers trying to break into the industry is the myth of the big break.

> ## "People think that if you get a big break, whether it's shooting a celebrity or getting featured in a magazine, that's going to make your career."

The reality is that just because your work gets featured in a magazine, that's not likely to mean your business is going to take off from there.

Another misconception Lindsay frequently hears is the freedom of being your own boss. Lindsay knows (as all successful business owners do) that the freedoms that come with being your own boss often having nothing to do with the hours you work.

> ## "I work 7 days a week, often 14 hours a day, and I've been doing that for many years."

## Working with Agents

Lindsay shares that agents are great to have, but these days, you can't count on them to do the legwork for you. They'll do estimates, invoicing, and some work behind the scenes, but not necessarily get work for you consistently. Typically, the best jobs come from relationships you have within the industry. That's why it's so important to network and build up your contacts.

## Getting Work as an Intern or Assistant

There are two paths to working as an intern, and Lindsay recommends them both for different reasons.

The first path is assisting with a photographer whose work creatively inspires you. Learn from their lighting, styling, and shooting techniques. Soak up as much about the art of photography as you can.

The second path is to intern with a photographer who runs a successful business. She says that most of the time, these two qualities do not go hand-in-hand. In this opportunity, learn all you can about invoicing, bidding for jobs, licensing, insurance, and the business side of photography.

Many fashion photographers get their start by assisting. This allows you the opportunity to begin networking in the industry and building relationships with stylists. You'll learn how to pitch to clients and what to avoid doing.

# "Day rates for assistants range from $150 per day to $300 per day. The competition for these jobs is high, and the jobs are not usually regular."

## Making the Move to New York City

Making the move to NYC is tough and Lindsay cautions it shouldn't be done without some advance planning. The first thing she recommends is having more savings than you think you'll need, because it takes a while to establish yourself and get paying jobs. She recommends planning to live outside of NYC and commuting while building your reputation. If possible, start networking and building relationships with stylists and makeup artists at least a few months prior to moving. She also recommends photographers be prepared to completely redo their portfolios upon moving to New York. ■■■

# "Once you come to NYC, you'll most likely need to redo your portfolio with NYC models and fashion."

# 15

# The Value of Marketing

Marketing is one of those words that many people don't truly understand. Marketing is the constant delivery of the same message—in your case, that your company is the solution to the clients' photography needs.

Many photographers confuse the concepts of sales and marketing because it is difficult to tell them apart. Marketing is the collection of activities you engage in to generate leads for your business—brand awareness campaigns, advertising, social media, email campaigns, and so on. Marketing is more of a macro activity: being actively engaged in promoting your photography services to a variety of prospective clients in hopes that people will be interested in learning more about your services. Marketing strategies are covered in-depth in Chapter 16. They include:

- Print advertising
- Networking
- Blogging
- Mailing brochures to local businesses
- Advertising online
- Fairs
- Events
- Social media (Facebook, Pinterest, Twitter)

- SEO (search engine optimization)
- Direct mail campaigns
- Getting published or editorial coverage
- Handing out business cards
- Partnership marketing
- Email marketing to existing clients

Once you identify a prospective client (through your marketing efforts), the micro activities to turn that lead into a client are considered *sales*. Sales are when you are actively engaged in trying to sell your services to a prospective client.

To run a successful business, you need to understand how marketing is different from sales (which was covered in Part 3) and how to implement it successfully. First, let's start with what marketing should actually do, and then move on to creating a marketing plan.

## What Marketing Should Do

When you start a business, one of your first goals is to get your name out there. Figuring out how to do that, though, can be confusing and frustrating. Should you be listed on different websites, do you send out a mass mailing, and what about Facebook and Twitter? Do you need to attend fairs or events?

Unfortunately, there is no single answer to these questions. What works for one photographer may not work for another. Whether a certain type of marketing is effective depends on many things, including your personality, location, price point, clientele, and niche. For example, many photographers have great success with search engine optimization (SEO), while others don't. In my case, my clientele of high-end brides are not searching online for their wedding photographers. They are apt to find their wedding photographers through trusted recommendations, and therefore my marketing efforts reflect that.

As an example of what effective marketing does, let's look at the benefits to a wedding

photographer of being published and how it ties into marketing (the same benefits do not apply to portrait photographers). Brides don't see a photo credit in the crack of a magazine and beat a path to your door begging you to shoot their wedding at any price. That's *not* how it works. If used correctly, though, editorial coverage *will* lead to more bookings for a wedding photographer. It's just a matter of doing it effectively.

It's not getting published itself that gets you more work; it's how you use that feature as a *tool* for your own publicity, photography brand, and marketing. It's a piece of big news that you can use to further your brand's reach. One of the most powerful ways of doing this is to use that publicity to reach out to the other vendors on that event or wedding.

Make a point to share the credit with them and offer them copies of the feature so they can share with their clients and use as part of their own publicity and marketing (and, in turn, they are marketing you). Send copies to the bride, the planner, the designer, and the venue. They are going to be thrilled and will in turn show the piece to as many brides as possible, and of course be *talking about you* (marketing your company for you) to brides. And not just in a perfunctory "here's the name of a photographer" way, but in a giggly, breathless way that is pure excitement.

I tell wedding planners we work with that we get many of our weddings published. If they are interested in increasing their marketing, it's a huge advantage to work with us (i.e. refer us to their clients).

# In the minds of brides, your brand is now associated with excitement, coolness, and most importantly, exclusiveness.

Vendors are usually thrilled to get published, so they like to send us referrals so we can work together. When a bride comes into our studio, she might have been told about our work from another event professional sharing the latest feature on a wedding blog or magazine. We might have a sample album from a wedding that's recently been published, and she recognizes the wedding (which is exactly what we intend) because she has seen it in a magazine.

As she leaves the consultation, we hand her a gift bag containing a magazine with another editorial feature. Those elements are incredibly effective when debating a luxury purchase. Why do clothing designers spend so much money and time getting their goods worn by celebrities? Because it connects their brands to a celebrity thrill factor. Same idea.

## Putting Together a Marketing Plan and Budget

Developing a marketing plan is critical to your success. Without this roadmap, you won't know where you are going or what you want to achieve. The marketing plan needs to detail the strategies you will implement to bring in more business. Without a plan in place, you won't know how much time and energy to put into any single strategy and you won't have a way to evaluate its effectiveness.

Without a plan, you are reacting to the day-to-day issues and concerns of running your business. You have a mom on the phone threatening a bad review, so you respond to that. A client needs his product rushed, so you scramble to make that happen. You need the business, so you are constantly treading water.

We've all been there, but that's not an effective way to run a business. When you have a marketing plan to follow, you have taken the time to select priorities for your business. When that next great new idea comes along, you won't get distracted because you already have a plan that you are following. Perhaps that great idea gets jotted down for your annual business review when you plan *next* year's activities.

Your marketing plan should be broken down into three parts:

1. Goals

2. Strategies

3. Budget

The first step to putting your marketing plan together is to develop goals for your business that you would like to accomplish through marketing. Goals are the outcome you would like to see for your business, such as to increase overall profits by 15% or increase portrait sessions to 50 per year.

## Biggest Marketing Flop?

If you ask, most photographers will tell you that spending their marketing budget on a single full-page ad was the biggest marketing mistake they ever made. Print ads can be effective if done repeatedly, and as part of a brand awareness campaign. However, most people do not find them effective in directly generating leads or booking new business. The ad pictured here was placed in a local newspaper as part of a special wedding insert, and I thought it would make a big splash. Not only did I not get a single call, apparently not even the bride or her friends and family saw it! That was an expensive lesson to learn.

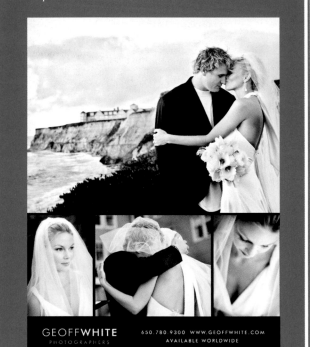

The second step is to choose the marketing strategies and the estimated time frames for each. You need both long-term and short-term strategies, as some things take more time and focus while other strategies require minimal effort and can be done during your busier times. The different types of marketing strategies are covered in Chapter 16, but you should also refer back to Chapters 13 and 14 to help you choose strategies that will reach your target market. For example, high school seniors are more likely to be looking at Facebook for their senior portrait photographers and not in print media.

A short-term strategy would be to develop a Facebook business page, and begin promoting via your blog, website, and email signatures. It might take a few weeks to create a viable community, but after that, the time required would be minimal.

A long-term strategy would be developing strong contacts within your industry that lead to more business for you. In the fashion industry, that would be makeup artists and stylists, while in the pet photography niche that would be pet groomers, veterinarians, horse-riding academies, and so forth. This type of strategy takes more planning and effort to implement, and the results take longer. However, the payoff is likely to be much greater.

The third part of the plan is to calculate what you can spend on marketing. For my studio, the marketing budget ranges between $10,000 and $30,000. Usually the marketing budget is directly tied to the amount of gross revenue you are

bringing in, so if you are starting out, you might allocate a few thousand dollars to marketing while pursuing free and low-cost marketing activities that require more time than money. As you get busier and have less time, you might move toward strategies that cost more money but require less time, as I have.

Keeping your social media up-to-date and blogging are practically free and are great ways to market your business without a huge budget. Networking and developing contacts who will refer business to you is another effective strategy that costs little money, but requires more time.

## Scheduling Marketing Throughout the Year

One of the biggest marketing mistakes you can make is to believe you can do some marketing at the beginning and then ignore it. Marketing is something you need to do *all year long* and continually update. Even if your business comes from word of mouth, you still need to stay in touch with your referral base, otherwise they may stop referring you over time.

Within your marketing plan, you want both short- and long-term goals and strategies that you work toward each week or month. This ensures your business is moving

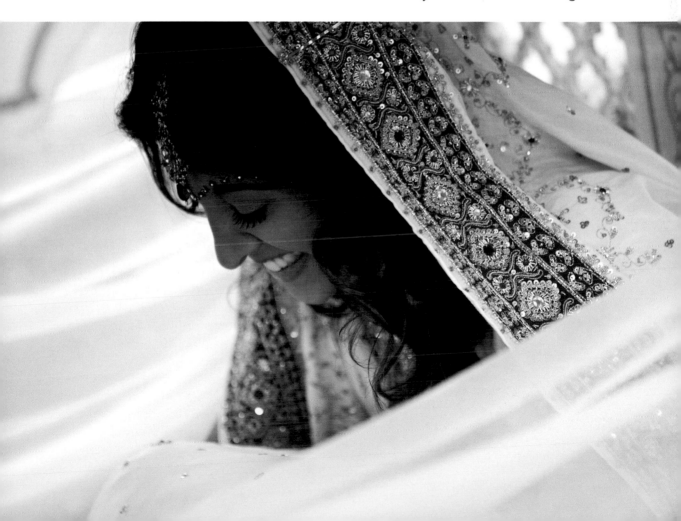

# If you don't know where you're going, how will you know when you've gotten there?

forward. Break down the marketing plan into time frames—things that can be done immediately for a quick return and tactics that take a longer time to work, but with a bigger payoff over time.

Photography businesses ebb and flow. You will have slow times or a slow season. That is a great time to focus on your marketing. For our wedding photography business, that slow time starts in December so that's when we focus on marketing. This allows you to break the year into sections, with a shooting season and a marketing season.

## Don't Forget About Marketing

Don't make the mistake of forgetting to do marketing when you get fully booked up, or think you don't need to do marketing anymore. One year our studio got so busy with bookings that we completely forgot to spend time (and money) on marketing that year. The result? We had to play catch up the following year, and did not get as much business as we had hoped to because we didn't have active marketing campaigns out there working for us.

Think about how *your* business works. Do you have a certain time when you get a lot of bookings? Or are your bookings spread over the year? The idea is to match the timing of your marketing so that it is out there working prior to when your clients are most likely to book you. You need to start marketing several months in advance so those efforts have time to pay off. Plan your marketing so that people not only know about the new offerings but they know about them at the right time.

Think of marketing in terms of campaigns. Break down the services you offer, and market those to specific clients. For example, if you want to offer family portraits as a holiday gift idea then you need to make sure that the marketing hits when people are starting to think about the coming holidays, like September and October. Just because you have a special, a new service, or a new product, it doesn't mean you will automatically book up. You have to let people know about it, and it usually takes hearing about the promotion several times before it starts to click with customers.

This could mean several seasons of refining your marketing before your efforts start to pay off. For example, when I first began offering holiday print sales, I didn't sell many prints. It would have been easy to give up and say, "print sales don't work for me." In fact, that wasn't the case at all; it was that I did not know how to do them effectively. I

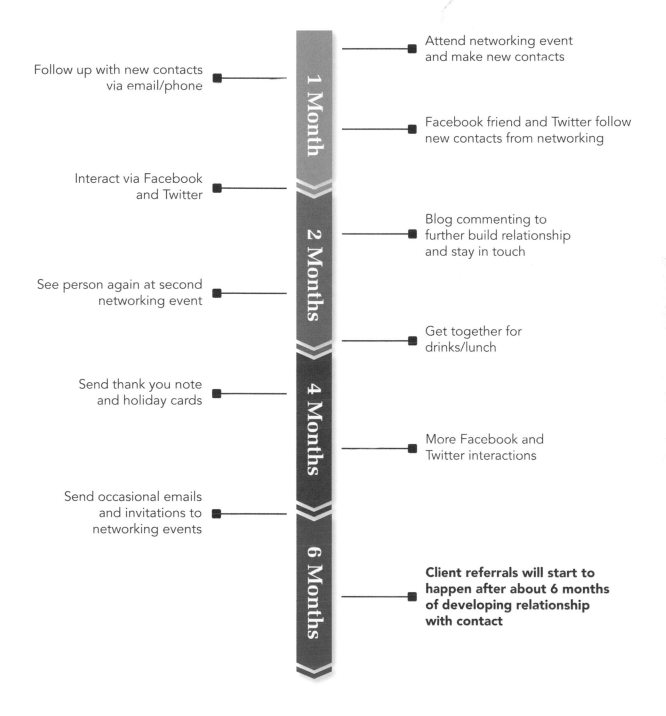

Follow up with new contacts via email/phone

Interact via Facebook and Twitter

See person again at second networking event

Send thank you note and holiday cards

Send occasional emails and invitations to networking events

**1 Month**

**2 Months**

**4 Months**

**6 Months**

Attend networking event and make new contacts

Facebook friend and Twitter follow new contacts from networking

Blog commenting to further build relationship and stay in touch

Get together for drinks/lunch

More Facebook and Twitter interactions

**Client referrals will start to happen after about 6 months of developing relationship with contact**

Some marketing strategies, such as networking and growing your contacts, take longer before you start to see results. However, networking is widely cited by successful photographers in many different niches as one of their most effective marketing strategies.

thought if I sent out one email and posted about the sale on my blog, people would get the message and buy prints if they wanted to. However, it wasn't until I refined my strategy over several attempts that I realized I needed to send out multiple emails in order to remind people about the sale. Instead of thinking of it as harassing them, I had to think of it as helping clients take advantage of a great deal.

## Evaluating Effectiveness

You need to evaluate the effectiveness of your marketing, otherwise how will you know what works and what doesn't? There is no point in spending money on marketing plans that don't work for you.

Ask your clients how they heard about you. This lets you look at what worked and what didn't, what you want to change, and how to implement new changes in the coming year.

Here are some questions to ask yourself:

- Where did the majority of your leads come from?

- What marketing efforts brought in few or no leads?

- Do you have a strong reputation established yet, or should you focus more on brand awareness?

- Do you have a clear message and distinctive style?

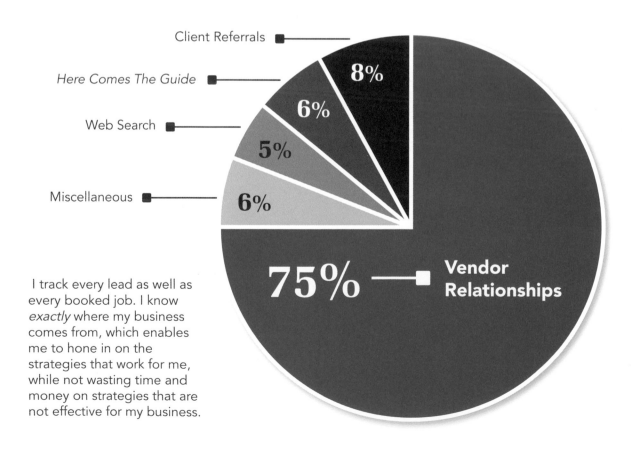

I track every lead as well as every booked job. I know *exactly* where my business comes from, which enables me to hone in on the strategies that work for me, while not wasting time and money on strategies that are not effective for my business.

- Who is recommending you?

- What is your social media reach?

- How do traditional marketing efforts compare to web marketing and social media?

- How effective are contacts and industry relationships compared to time spent networking?

- How effective have events, shows, and fairs been, and what's the cost per lead?

- What is the effectiveness of editorial submissions and publicity?

The answers to these questions will help you choose the right marketing strategy for your business. So, how do you find out the answers to these questions?

You have to track your leads and booked jobs, and talk to your clients. Do you know how many bookings you got from Google, versus a doctor's office with your artwork and brochures, versus the fair you participated in last month? If you don't know *exactly* how many bookings you've gotten from each marketing effort, that is where you need to start.

If you aren't basing your marketing decisions on where your past bookings have come from, you are making a huge mistake. The only real way to see if something is working is if you are getting paying clients from it. For example, if you invested in 6 fairs this past year and you got only 2 bookings, you can conclude that it is not an effective strategy for you at this time—the cost per lead is too high. Compare that to the 12 new clients and numerous inquiries you got from a mini

session weekend you did at a children's clothing boutique. That is probably a much better use of your marketing time and money, as some of those new clients will become repeat clients.

Remember, effective marketing is not the number of leads you generate but the number of *actual clients you book*.

## Wedding Photography Marketing: Sample Albums

Sample albums are an effective part of our marketing strategy. We create these for our best weddings and vendors we would like to give us more referrals. This is our system; you might want to tweak it to suit your company. Depending on the vendors involved and the ability for that particular wedding to help sell the vendor team, we determine which weddings to use for sample albums.

Big, glamorous wedding with tons of unique details? Absolutely. Small, intimate, second-marriage wedding with minimal details? Less likely—unless that venue specifically needs a tool to reach that segment of the market.

We get the most referrals and bookings from venues. One album is designed for the vendor team, with all the details that highlight the vendors worked into the design. Typically, the venue, planner, floral designer, and sometimes the caterer all have their work highlighted. There are no family portraits, and the few portraits of the couple showcase the venue.

Some albums pay off in spades while other albums never get seen. Don't take it personally. If something is not working for you, ask yourself why. Try to figure out how you could have done better. Would a different size have been more effective? What about a more eye-catching cover material? Did your design and layout not sell the venue, making it of little use to the salesperson? As you refine and improve your process, you will increase the value of each sample album you create. Over time, you will find certain relationships blossom, resulting in many new bookings for you.

## Develop a Tracking System

We use a simple spreadsheet, named *Booked Weddings*, to track our bookings. Each year, we track every booking and the key details in the spreadsheet. This helps us look back over the years and see what has worked and what hasn't. Here is what we track in our spreadsheet:

- Photographer
- Wedding date
- Booking date
- Months between booking and wedding date (this helps us estimate the total number of expected bookings for the year)
- Client names
- Total spent
- Venue
- How they found us

| Wedding Dates | Booking Date | Mths betw sign & wed | Customer Name | Price | Location | Referral Category | How they heard about us? |
|---|---|---|---|---|---|---|---|
| 4/16/2011 | 8/11/2010 | 8 | Jane Smith & John Martin | $13,000 | Ritz Carlton | Coordinator | Morgan Doan |
| 6/18/2011 | 8/3/2010 | 10 | Julie Mason & Matthew Chen | $19,000 | Private Residence, Atherton | Venue | Helen @ Sharon Heights |
| 6/18/2011 | 9/23/2010 | 9 | Laura Scholl & Timothy Regan | $7,900 | Silver Creek Country Club | Venue | Silver Creek Country Club |
| 7/30/2011 | 10/16/2010 | 9 | Jennifer Gray & Michael Hernandez | $9,942 | Villa Montalvo | Venue | Todd Outhouse |

If you are a portrait photographer, your spreadsheet might look like this:

- Photographer
- Session date
- Client names
- Total spent
- How they found us

Update this spreadsheet regularly. At the end of each year, you can analyze the information in your spreadsheet, deciding which marketing worked and which didn't. The strategies that prove effective get allocated more money and time for the next year to expand those efforts, while of course strategies that failed are given less money and time or stopped completely. This is extremely effective, and helps you avoid making the same costly mistakes year after year.

This spreadsheet also lets you review the trends in your customers and their habits. You can look at average money spent to see what the trends have been, and this helps you understand how to adjust your pricing to make sure you are calculating the overhead and cost of goods sold (COGS) correctly.

If you haven't been collecting this information for your business, it's not too late. You might be able to go back through old emails to find the "how you heard

about us" details. It's worth the time to set yourself up for this. You can also send out an email to past clients asking them to answer a quick couple of questions, including how they heard about you.

## Do More of What's Working

As you begin to see what is effective and what is not, refine your system by doing more of what is working and less of what isn't. If you are getting bookings from your Facebook page, that would be an area to put even more time into in order to see if you can further improve the results. If jobs are coming from certain contacts, make sure you do everything to keep those relationships strong. At the same time, you'd want to focus more time and energy into building new relationships as

well, since that strategy has proven to be effective for you. If online search is bringing in business, invest more time and effort into SEO.

Once you figure out what is working, see what you can do to expand those results. Drop the less effective or more costly strategies in order to give you time to dig deeper into the most effective strategies. Now that you know how to think about marketing and put together a plan, let's get to marketing strategies in Chapter 16. ■ ■ ■

# Fantasy vs. Reality

| | |
|---|---|
| Getting that big break that will launch your career into a huge success. | Getting a big break is great, but it doesn't do much without you capitalizing on that break to be successful. There is no sitting back and waiting for clients and jobs to roll in. |
| Launch your website and business will start pouring in. | Having a website is an important part of your marketing plan, but it won't magically bring in business. In 2012 there were more than 225 million domain names registered according to VeriSign. And that number grows all the time. You have to get your marketing in front of potential clients. |
| If your work is good, you don't need to market yourself. | There are plenty of great photographers out there and they have no work. The reason is that no one knows who they are. You not only need to be good, but you need people to know you are good (through effective marketing). |
| Advertising is usually effective for photographers—place an ad and wait for the phone to ring. | Advertising is not the most effective strategy for photographers. You have to do the work, not simply throw money around. |

# Marketing Strategies

There are many ways to market your business. In the past, it was all traditional marketing like direct mail, print advertising, and networking. With the rise of social media, there are now many more ways you can market your business, often with much lower costs. The key is to figure out which methods work best for your business.

Every business is different, and what works for another photographer may not work for you. It depends on your niche, target market, personality, location, and available time and money resources. That's why it's so important to track the effectiveness of your marketing campaigns—so you know which methods bring in business and which ones don't.

One of the biggest mistakes photographers make when it comes to marketing is thinking that prospective clients will simply come to them. Effective marketing means getting out there and *bringing business in to you*. This chapter is an overview of some of the strategies you can use to market your business effectively.

## Traditional Marketing Methods

You've probably heard that if you aren't on social media, you aren't doing marketing correctly. While it's true that many photographers are finding success with online marketing methods, that doesn't mean that traditional marketing methods are not effective. In fact, this couldn't be farther from the truth. Traditional marketing methods such as networking, partner marketing, and publicity are my most effective marketing tactics for Geoff White Photographers. It simply depends on your business model.

Are your clients online or are they more likely to see your work in magazines or by picking up a brochure in a partner's retail location? Using traditional materials to direct clients to your website and blog is a great way to drive prospective clients to your online marketing before they have officially begun searching for a photographer.

### Networking

I cannot stress enough the importance of networking; it is one of the best things you can do for your business, period. In order to get results, you need to take it seriously.

We have tried many different methods of marketing, and networking is one of the *very best*. It doesn't happen overnight. It starts with attending networking events, and the goal is to build strong relationships with people, which takes time and effort.

The most important thing to remember with networking is that it's about *people*. You can't expect vendors to start referring clients to your business after simply handing out business cards at a networking event. And pushing your portfolio on people while they're enjoying a martini is *not* the way to go either. Take your time and get to know people—show you are interested in them. When you go to networking events, the goal is to make new contacts. This usually means walking right up to strangers and introducing yourself or asking friends for introductions. It's that hard, and it's that easy.

After an event is over, it is important to follow up. Hopefully, you met several people in your industry. Here are some options for following up with a new contact:

- Phone or email the next day and invite them out for drinks or lunch.

- Send a handwritten note with your brochure, letting them know you enjoyed meeting them and look forward to working with them in the future.

Reaching out and contacting someone you've recently met via phone or email can be scary, yes. What's the worst that can happen? They say no or ignore your email. You've lost *nothing*. It's as simple as this.

Networking is a great tool to grow your business *if* used correctly. If you are shy and can't bring yourself to talk to people at events, networking might not work for you. If you don't actively follow up with contacts

**Networking is the foundation upon which successful business relationships and partnerships are built.**

## Books to Help You Become a Networking Ninja

■ *How To Win Friends and Influence People* by Dale Carnegie

■ *Networking for People Who Hate Networking: A Field Guide for Introverts, the Overwhelmed, and the Underconnected* by Devora Zack

after meeting them, networking is going to be a much slower process. Remember, you aren't going to these events to kill time and have cocktails; this is a serious marketing strategy to grow your business and develop contacts into relationships. It's up to you.

### Fairs, Shows, and Events

Bridal shows, baby fairs, county fairs, pet adoption events, arts and craft fairs, and community festivals are all places you can exhibit your work and meet with prospective clients. This type of marketing often requires an investment in the booth design, space rental, and marketing materials to hand out. Here are some fairs and shows to consider, based on your niche:

- Pet shows and events
- Baby fairs
- Bridal shows
- Fine art exhibits
- Lifestyle and gift expos
- Women-focused expos to promote boudoir photography
- Back to School Nights for senior photography
- Customer events in boutique retailers
- Wedding fairs at local venues

# Bridal Fair Tips

Here are some things to keep in mind to have a successful bridal show:

- *Booth position is key.* There are certain booths you do *not* want to be next to: DJ's (too loud, tends to drive people away), bakeries (people will skip over you to get to free cake), and tuxedo rentals (they tend to bring an army of people to steal every client who comes down the aisle). Some of the best spaces are corner booths (you'll get cross traffic) and in the middle. Spaces near the entrance tend to be ignored, as people are just getting into the show.

- *Come armed with handouts.* Have your best marketing materials ready. Make sure your brochure stands out and isn't just a photocopied price sheet. You never get a second chance to make a first impression.

- *Network with other vendors.* During bridal shows, there is usually a fashion show or a period when the expo is slow. Use this downtime to network with vendors, and even other photographers. Set up your booth early so you can walk around and meet with other vendors.

- *Book then and there.* Have your calendar ready and suggest brides book a consult with you then and there. Have contracts on hand so you can book on the spot if the opportunity arises.

- *Follow up.* After all the work and expense of being at the show, follow up with every lead. Have brides fill out contact cards with name, email, phone, address, date, and location (ask only for what you need), and use the back of the card to jot down notes after talking with them. You might offer a complimentary engagement session for couples filling out the card, or have a drawing, and these sessions can lead to bookings or more work for your portfolio.

## Studio Events

For studio photographers, events are a great way to generate buzz in your community and get people into the studio to see what you have to offer. Chamber of commerce mixers, high school senior events, a client holiday party, a boudoir-a-thon, and Halloween pet portraits are a few ideas. To make your event successful, consider having mini sessions on site, goodie bags, and a fun atmosphere.

## Partner Marketing

Consider cross-marketing and partnering up with another business, where each business pools resources to help one another get new business. The idea is simple and can offer benefits.

The reason this works well for small businesses is that each business benefits from the other's marketing, products, and services. If you choose a business with clients likely to be interested in your services as well, you've got a great potential match.

Partner marketing has been my best marketing strategy by far, and it starts with networking. From there, build relationships over time. Use images to help your partner with their marketing, and in return they may start sending you more business.

Find businesses targeting the same clients you are, but for other products or services. For example, you could approach a children's clothing store about offering a photo shoot with their latest clothing collections, perhaps even featuring the kids of their best customers. In exchange for the co-marketing and access to clients, you could offer the storeowner images for a direct mail campaign or wall prints at cost. This concept can be applied to any type of photography.

Boudoir photographers can team up with makeup artists and lingerie boutiques. Pet photographers can find ways to partner with grooming services, pet stores, and so forth. It's all about being creative and putting your marketing money and energy to good use. Wedding photographers should network and build relationships with venues, planners, florists, caterers, and other industry professionals.

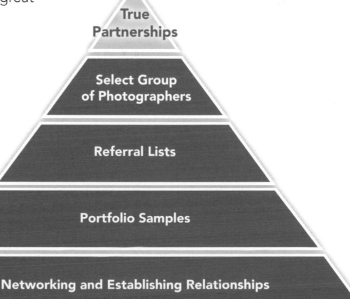

True Partnerships

Select Group of Photographers

Referral Lists

Portfolio Samples

Networking and Establishing Relationships

## Referral Gifts

Referral gifts are appreciated by vendors that have given business to you. A headshot session or family portrait is a way to keep it inexpensive. Once they've gotten to work with you directly, their referrals will be even more enthusiastic.

### Referrals and Word-of-Mouth Marketing

Happy clients can help you grow your business by referring friends and relatives. What better way to thank them and encourage referrals than by offering an incentive? You want to offer clients something of value (something such as a service or product that has high perceived value) but that doesn't cost you much.

To build a solid referral stream of business, let your clients know through repeated messages how much you appreciate their referrals. When you say things like, "my business is based on referrals from happy clients," and, "the greatest compliment you can give me is a referral," you are letting your clients know what you would like them to do that for you. As with any marketing, it takes time to build up a good base of referrals. Referrals were covered in more detail in Chapter 13.

### Charity Marketing

Giving back to your community is good for you and your business. Showing that you care about your community, or a specific cause, can go a long way in fostering good will and support. Plus, it helps get your name out there, which is great marketing.

There is a difference between doing charity *work* and charity *marketing*. Charity *work* is done without expectation for any kind of a return or marketing value for your business. Charity *marketing* is a collaborative effort where you are working with a charity for both altruistic reasons as well as potential benefits to your business.

As with many marketing strategies, it may take time to find the right technique and the right charity to work with. You can start by approaching the charity with an offer to donate services to an auction or provide event photography for community events.

To get the most from partnering with a charity, keep the following in mind:

- *Passion.* Work with a charity you are passionate about. This will create a great synergy between you and the charity.

- *Pick the right charity.* Choose a charity that is a good match for your services. For example, if you are a pet photographer, working with a dog rescue makes sense.

- *Stay with it.* It will probably take more than one event to show some return. Follow up and see how you can improve the results.

- *Branding.* Make sure your logo is featured on your work and in any related marketing showing your work.

- *Keep records.* Track the time, money, and other expenses tied up with the charity, for tax purposes.

## Publicity and Media

Getting press and publicity is something that eludes many photographers. It's actually not as difficult as it seems; the secret is in knowing that publicity and media typically don't come to you, you have to go to them. In order to do that, you need to offer something newsworthy—a story angle, a new trend in your niche, a report, and so forth.

If you have recently received an award or honor, that *might* be interesting to a small community media outlet. Once you have a story or something to share, it's up to you to contact various media relations to see if there is any interest in your story. When you hear about a photographer getting interviewed or being quoted in the media, more often than not it was the photographer who approached the media with the idea.

One of the best ways to get media coverage is to build relationships with media. Start by building a list of media in your area that are focused on your niche. When you have newsworthy events or story angles, contact them with a few sentences, and if they are interested they will let you know. Be genuine and helpful, and when they need an expert in your field, they may call you.

Take the time to do some promotions (such as blogging or social media) to get the most benefit from press and publicity. Getting a mention in your local paper, being interviewed, or having an image published in a magazine is wonderful, and there are ways that you can get even more mileage for your studio. Look for the "Make Publicity Work for You" section later in this chapter for ideas.

## Where to Find Free Publicity

One of the best sources for finding potential media coverage and publicity opportunities is a free service called HARO (helpareporter.com). Sign up to receive daily requests from reporters looking for an expert to quote or a certain story to feature. The faster you respond, the more likely you are to get contacted. The key is in finding angles to pitch that will appeal to the reporter. For example, if someone is doing a feature on home decorating you might pitch a story that features large wall print landscapes or family portraiture as a new trend in home décor.

## On Spec Work

A photographer is working *on spec* when he submits unsolicited material to an editor or prospective buyer in hopes that the person will find it interesting and accept it for publication or purchase it for advertising.

Most shoots on spec are done without knowledge of the intended buyer, in hopes that once they see it, they will be impressed and want to purchase it for an advertising campaign for their product, for magazine publication, or for a news piece. This method is often used by fashion photographers hoping to drum up business, photojournalists with a great

story in mind but no assignment, or by a commercial photographer. It's risky because you may end up doing a lot of work without getting paid for it.

### Direct Mail

Direct mail is a marketing method that involves mailing out brochures, postcards, or letters to a large group of prospective clients. Direct mail typically involves renting a mailing list that targets a specific group of people—grouped by zip code, profession, age, gender, or interest. The most important factor is the quality of the list you are using. Sometimes people will mail out simply according to zip codes, but that is not usually effective. Instead, you can rent lists from magazines or local organizations according to interest. For example, families with young children may subscribe to parenting magazines or early childhood type magazines, and you could rent a list of those subscribers.

If you are interested in trying direct mail, I recommend contacting Marathon Press. It is a full-service marketing firm for photographers, and they can help you with renting mailing lists, as well as putting together your direct marketing pieces.

With a good, targeted list of prospective clients that has been recently updated, coupled with a great offer that matches the clients' needs, you can expect to see about a 1% response rate on average.

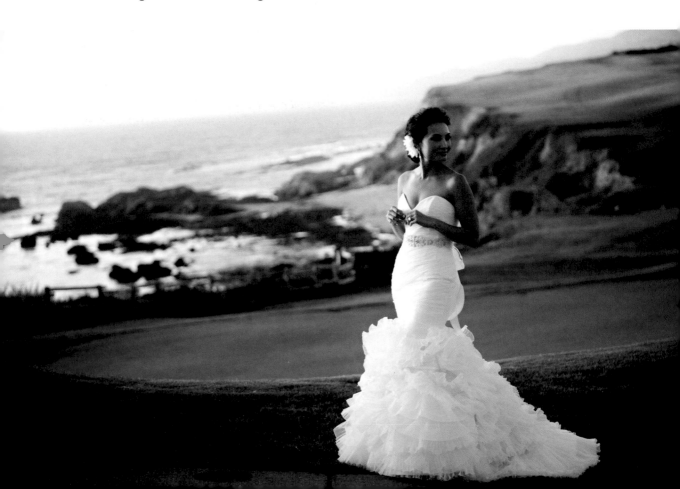

That means if you mail out 2,000 postcards to local homes with high school juniors offering a great package for senior photography, you might get responses from about 20 potential clients. Before launching a direct mail campaign, consider the cost of the mailer, the bulk mail rates, and the list rental compared to potential earnings. If your business is based around acquiring clients initially and then working with them for years to come, the investment in the initial client acquisition may be worthwhile.

Other types of direct mail campaigns might include mailing a postcard about headshot packages to local real estate agents, a newborn photography mailer to expectant mothers, or an ad for family portraiture packages to families.

## Targeted Mailings

Targeted mailings are directed to a smaller, more specific audience. You might do one to promote autumn family portrait sessions to past clients, or send out a mailing to local pet stores, groomers, and trainers if you are a pet photographer.

One year I put together a small brochure mailing to local wedding vendors such as planners, caterers, facilities coordinators, and florists around Valentine's Day. I included a note talking about all the couples getting engaged around this time, and how we'd love to work with them (the vendor). This effort paid off, and I got referrals (and bookings) from several planners who were interested in working with us, simply because we contacted them at the right time, in the right way.

## Print Advertising

Print advertising is typically expensive and more of a long-term campaign to create brand recognition instead of a quick way to get your phone ringing. Don't make the mistake of thinking a single magazine ad will get you lots of new business. Most likely it won't (ask any established photographer). Placing monthly or quarterly ads over a period of one to two years will start to build brand recognition as long as you use the same ad each time.

## Thank You Notes

A personal touch goes a long way in making people feel special and increases the chances that they will recommend you. Send out thank you cards as part of your weekly routine. To maximize marketing impact, use your own images on your cards. Send thank you's to prospective clients you've met with, contacts who refer you, and new clients.

## Marketing Tools

Let's focus on some traditional marketing materials/tools. Business cards, brochures, and postcards are *not* marketing. They are tools you use to market your business. Getting the marketing tools into the hands of potential customers is marketing.

### Business Cards

Your business card is often the first thing a prospective client sees and it needs to make a great impression. For more on business cards, check out Chapter 6.

## Personalized Strategies

As your marketing tools start to work, you can begin to personalize strategies to make them even more effective. We noticed one of our vendor contacts likes to display business cards on custom card holders. So of course, we ordered this special cardholder (on Etsy) to prominently display our business cards and increase the odds of our cards getting handed out.

### Brochures and Postcards

A postcard is great for making a strong visual impact with an image or two, whereas a brochure can share more information about your services along with some images. It all depends on the purpose and type of information you want to convey.

Here are some uses for brochures and postcards:

- Mail to clients about a special promotion or upcoming special sessions

- Hand out at shows, fairs, and events

- Include in client consultation packets

- Put in media kits

- Leave with venues, makeup artists, stylists, real estate offices, art galleries—wherever your target clients might visit

- Mail to local school activities offices for prom photography, sports photography, or senior photography

- Leave with industry partners such as boutique children's clothing stores, preschools, daycares, or doctors' offices

- Leave with karate centers or other places frequented by families

## Online Marketing

Besides a website, there are other online avenues to consider such as blogging, email marketing, online advertising, search engine optimization (SEO), and online directory listings. Let's start with your website.

Oversized postcard sample.

## Website

Your website is the first place that many prospective clients see samples of your work, and the impression it makes is long lasting. Your website needs to not only show what you can do, it also needs to show off your style. Here are a few website basics:

- *Use a custom URL.* Use your business name as your web address, such as www.geoffwhite.com instead of geoffwhite.smugmug.com. This might seem obvious but I see many photographers botching this. Once you are serious about your business, you need a custom URL.

- *Include your portfolio.* Your website needs to have samples of your best work, so clients can see exactly what to expect from you. As we talked about previously, hone in on the certain type of photography you are offering and include only relevant images.

- *Make sure the site style matches your work.* When a client goes to your website, the whole look and feel needs to match the style of your photography and business. Do you specialize in corporate headshots? Do you specialize in child photography, sports, or weddings? The whole look of your site needs to reflect that.

- *Make it smartphone and tablet ready.* If your website will not run on a smartphone or tablet, then you are going to miss out on a lot of prospective clients.

- *List your contact information.* Make sure people can easily get in touch with you and understand where you are located. You know you are located in Birmingham, Alabama, but that doesn't mean that someone who lands on your website knows that.

- *Make it easy to update.* No matter what type of website you end up with, you want something that allows you to update your portfolio easily.

- *Avoid flash sites.* These used to be the rage, but since they cannot be viewed on an iPhone or iPad (and take forever to load) you lose prospective customers who might look you up on their smartphone or tablet.

## Meta Descriptions: How You Get Found Online

Have you heard the term *meta description*? When searching for something online, you type what you are searching for into a search engine like Google or Bing. Once you get results, you'll see a couple lines of text for each listing.

If you search for *PhotoMint*, the first result that comes up is our website, and right underneath are a couple of sentences describing our company. That text is the meta description, and you can write it yourself. Are you an award-winning photographer? You can say that in your meta description. Work with your webmaster to find the meta description for your homepage and update the meta description text. It's what the search bots pull up to let searchers know what a website is about. Meta descriptions are important because it's how a searcher (a human) determines which link to click.

**PhotoMint** — Photography Business | Photography Marketing
www.**photomint**.com/
**PhotoMint** is the leading resource for photography business owners. Photography marketing strategies and business solutions that work.

### Blogging

A blog is a great way to communicate what you are all about and what you can offer your audience. Your blog is a blank canvas on which you can express creative ideas, post recent work, share bits about your personality, educate clients, and share products you can create for them. A blog is marketing time well spent. It's a major project, but you can start quickly and simply with a WordPress (wordpress.org) blog.

To understand the difference between the two, think of a website like a brochure, while a blog is more like a conversation.

Many photographers are finding success with blogging, as followers get to see a steady stream of new work and get to know more about them and their businesses. Some photographers are booking clients specifically through their blogs.

When we started our blog, we sent out an email blast to clients and wedding vendors, and one particular wedding planner that we'd been networking with for years suddenly began sending us referrals.

Setting up a blog is easy, and you can find template designs created for photographers with custom photo portfolios. You can integrate the blog

directly into your site or you can use WordPress to create both a blog and a website in one location.

The key to successful blogging is to make sure you update with fresh content on a regular basis, even if business is slow. Blog about new trends, recent shoots, charity work, client testimonials, new products, client education, and personal tidbits.

Another huge benefit to blogging regularly is the natural SEO benefits (see the next section for more on SEO) gained from blogging frequently. Blogging has resulted in new clients and many new opportunities for me, and it's something that I highly recommend.

Keep a list of blog post ideas handy and try to write a few in advance so they are ready to go when it's time. You don't have to update the blog every day, even though some do, but a once-a-week schedule is a good starting point.

## Search Engine Optimization (SEO)

In a nutshell, search engine optimization (SEO) involves setting up your blog or website to maximize online search traffic. SEO is not nearly as complicated as it is made out to be, and anyone with a blog can start implementing SEO tactics into his routine.

You want prospective clients to find you when they are in the midst of online photography planning. You can focus on terms like "Miami children's photographer," "London sports photographer," or any other similar terms that you think prospective clients might use to find you.

You would place these terms in the body of your blog, in the tags and title of the post, and in image naming. You can create a blog post about each location or venue in your area that you work in, and include sample images. For example, you can create a blog post about photographing weddings at the Los Angeles Biltmore Hotel with sample images from weddings you have shot there. If everything is tagged and described using terms such as "Los Angeles Biltmore Hotel Weddings," then anyone searching for those keywords could find your website.

If you want to focus on SEO, check out Photography Web Marketing (photographywebmarketing.com) or get a book that focuses on SEO for photographers.

## Maximizing SEO Benefits

To get the most SEO benefit to your website from blogging, connect your blog to your website. The address should be www.*yourwebsitename*.com/blog. Google favors updated content, and is therefore more likely to send search traffic to your blog instead of your website. By adding your blog as a subpage of your website, both sites will benefit from your blogging efforts.

SEO is not something you work on once and then forget about. Make sure that your blog posts and website are being found using the search terms you want. Consistently tag your images and posts and, over time, you will build up a stronger online presence. It's not something that you can do today to get clients next week, but it's an important part of a long-term strategy.

Google and WordPress work well together, meaning your images and content will be more likely to be found by prospective clients searching online if you name your images properly. Name images with terms you think prospective clients will search for online.

### Email Campaigns and Newsletters

Email newsletters work well when they offer a good mix of promotions, education, and human interest. You can share information about upcoming seasons, give clients pointers on preparing for their sessions, announce events, and feature a different type of portrait session each issue, highlighting one client's experience.

For example, one issue might focus on baby sessions, sharing images from a baby's newborn, 6-month, and 1-year sessions, highlighting how quickly babies grow. It may take a while to build up momentum, but regular communication with past clients is a great way to get them back into your studio. You can automate email marketing by using a company like AWeber or Mail Chimp to create and send out the email materials. For more information about email marketing, see the interview with Jamie Swanson at the end of this chapter.

### Free Online Listings

Not only do online listings help customers find you online, they also give your blog or website more authority according to Google, meaning they have a positive impact on your SEO rankings. This is the one to do right this minute because it gives your website a nice burst of SEO immediately.

All you have to do is check that your business information is listed in online directories like Google Places, Bing, Yelp, and so forth. You can complete this process easily in about 15 minutes or less (more if you add photos), and it is well worth the time.

## Be Everywhere

When you are starting out, you can create the appearance of an established business by creating social media properties and filling out free online directories. If you search for *PhotoMint*, you will find all sorts of hits, including the blog, Facebook page, YouTube channel, and several guest blog appearances. For a prospective client, it's reassuring that I am an established business with a solid presence.

## Social Media

Social media is one of the easiest and most inexpensive ways to market your business if your target clients are online. Facebook, Pinterest, Twitter, YouTube, and Instagram are all being used effectively by photographers to market their businesses and interact with customers and potential customers. Before we discuss specific platforms, here are some things to keep in mind:

- *Interact with people.* Social media is meant to be fun and social. Don't just post updates, but take time to chat with people, respond to comments, ask questions, and generally engage in conversation.

- *Create excitement for your clients/ followers.* Use social media to offer specials and giveaways that will keep your clients excited about following your business.

- *Share stories and images.* As a photographer, your biggest assets on social media are your images and the stories about them. As a bonus, if you feature a client on your social media, chances are they will share that with friends, driving traffic to your page. People love to see images, read testimonials, and hear about behind-the-scenes stories. The more connected followers feel, the more likely they are to think of you when they need photography.

- *Be yourself.* It's important for your clients to feel like they are interacting with you—a person, not a faceless company. Let your personality shine through.

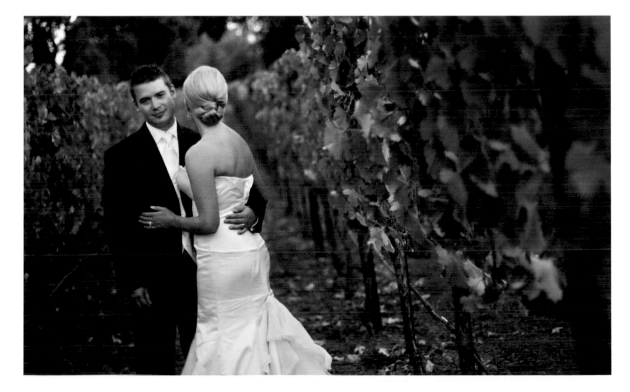

## Facebook

Facebook is a great marketing platform for you to connect with your target audience. If you haven't already set up a Facebook page for your business, do it right away. You'll need a personal account to manage it from, but its best to keep those separate otherwise. Setup takes only a few minutes, and you should do that now even if you aren't ready to update the page regularly yet.

Why would you want to drive traffic from your website to your Facebook page? Because people will not likely look at your website every day, but they probably check Facebook several times each day. By having a strong presence on Facebook, you are able to reach clients more frequently by going where they hang out. In Chapter 13, we talked about understanding your clients and figuring out where they go— if your clients go to Facebook, Twitter, or Pinterest, you want to be there too, reminding them about your services and building a connection with them.

> ## Tips for Promoting Your Facebook Page
>
> Here are some ways to drive traffic to your Facebook page.
>
> - Put a link in your email and forum signatures.
> - Invite Twitter followers by sending out your link in a tweet.
> - Use a blog post to invite visitors to join.
> - Put a Facebook button on your blog or website that links to the Facebook page.
> - Put a Facebook Page "Like" widget on your blog posts.
> - Include your link in online profiles.
> - Put a link on your personal Facebook profile to your business page.
> - If you are marketing to customers who use Facebook, include the page address on your business cards.
> - Ask followers to share your page with friends.
> - Use the "Tell Your Friends" link on your page to import your contacts.

Check out PhotoMint's Facebook page at Facebook.com/photominteducation.

## Automating Social Media Marketing

Social media can take up a lot of time, but it doesn't have to. There are free and inexpensive tools you can use to automate some of the work for you. That leaves you more time to interact with people. Here are some tips:

- *Schedule blog posts in advance.* WordPress has a feature that allows you to schedule a post to go live at a predetermined time, so you can upload several blog posts at once but have them appear online over time.

- *Schedule Facebook page updates in advance.* Third-party apps such as Post Planner, Bufferapp, and Hootsuite allow you to schedule Facebook posts in advance. It can be helpful to batch out a bunch of updates at once, so you know you have regular posts happening. However, you still need to be active on your page to reply to comments and interact with people.

- *Set content to automatically post on Twitter.* Twitter allows you to link to your Facebook page and blog so that updates show up automatically in your Twitter feed. This is a great way to start with Twitter and ensures you have regular content.

- *Batch process watermarking.* Prepping images for online posting and sharing can be a hassle; use a tool like blogstomponline.com to quickly and easily prepare images for online usage.

How many likes do you need? Many photographers make the mistake of believing they need hundreds or thousands of likes in order to look popular. This is not true unless you are marketing to other photographers. As a local business, you are marketing only to potential clients in your local area. Seventy-five likes from real fans of your work will get you more results than thousands of likes from other photographers or fake fans. It's not a popularity contest.

Getting people to visit your Facebook page is only part of the equation; you need to create great content and updates on a regular basis. Here are some ideas to increase interaction on your page:

- Ask questions such as, "Does your wedding have a theme?" or, "What is your favorite cartoon character?" Questions can be related to photography or just for fun.

- Post plenty of new, informative content that people will want to read and share with their friends. The bulk of traffic to your page will be from people sharing your page.

- Link your website and blog. You can set up your blog posts to get posted automatically to your page.

## Pinterest

Pinterest is a rapidly growing social networking site that allows users to create pinboards that contain images of anything they wish. It's a visual medium that's perfect for photographers.

Here are some tips on how best to use Pinterest:

- **Name.** There are millions of users on Pinterest, so make your Pinterest boards stand out. Use a unique, appealing name that describes your business well. For example, "Picture Taker 456" may be a bit dull, but "Vintage Cotton Candy Dreams by Mary Smith" is better.

- **Photos.** Pinterest is all about images, so concentrate on posting your best photos. Group images together on your boards. You can group by themes, colors, or styles. If you are a wedding photographer, make sure to post some detail photos. Brides can never get enough detail photos, and as an added bonus, florists and event planners are always looking for new ways to illustrate a theme.

- **Descriptions.** Make sure you add descriptions to all the photos you pin. This is how other users find them. Refer to the colors and styles (like *soft pink* and *vintage*) so users can find your images when searching for ideas on a particular theme. Add useful links (such as to your blog or website) in the description.

- **User friendly.** Attention spans are short and a frustrated user will move on quickly. Make sure to add a Pin It button alongside your photos to allow others to easily pin them to their pinboards.

- **Interact.** Use Pinterest to share ideas with prospective clients. If a bride mentioned she is planning a barn-themed wedding, why not put a board together with your images to give her ideas? Besides showing her your photography skills, you are also showcasing your ability to listen and go above and beyond in terms of customer service.

- **Find group boards with several contributors.** These types of boards often have large followings, which expands your potential to reach new clients.

## Twitter

Twitter is a micro blogging site that allows users to send out 140-character updates. One benefit of Twitter is that it is a way to connect with people you might not otherwise have an opportunity to talk to. For example, I have connected with many other photographers and high-profile people on Twitter, simply because it's so easy and quick to respond to. If you'd like to connect with me on Twitter, follow me at *@LaraWhite*.

## Contests and Giveaways

Build buzz on your blog or Facebook page by having contests. The easiest contest is to give away something that your followers would love to have. The idea is to generate buzz about your company and products, not just the prize.

For example, if a company were giving away a free camera you would entertain hopes of winning the camera but would probably not equate that with more loyalty to the company. Instead, offer a mini portrait session or a free print of your work—something that will create sharing and excitement. A small word of warning: When it comes to running contests on Facebook, make sure you check the Terms of Service so that you don't run afoul of a rule by mistake and have your account shut down.

Consider offering a deal to everyone who follows you as an incentive. It could be something as simple as offering a discount to all the fans after you reach a certain threshold. For example, you could offer a 5% discount on portrait session when you

## Email Signatures

Use Wisestamp (wisestamp.com) to turn emails into marketing assistants. Wisestamp is a free email app that lets you add an automatic signature to every email you send. This effectively turns every email into a mini marketing campaign for you.

reach 1,000 followers. That way you will get the followers who want the discount spreading the word and trying to get others to be fans of your page. This type of giveaway can get your entire fan base working together to promote your work.

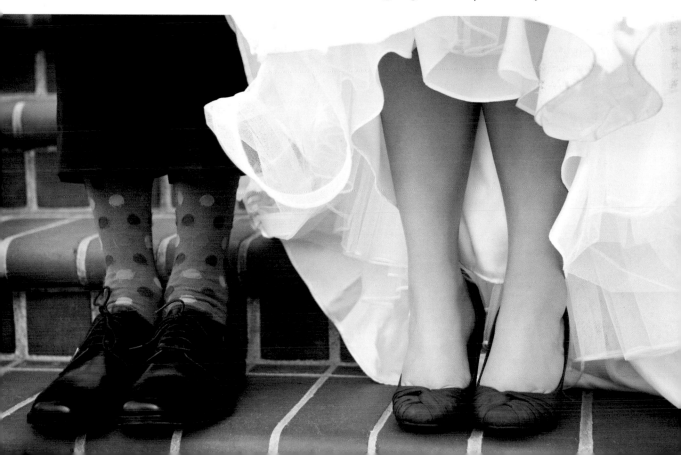

## Getting Published

In Chapter 15 we talked about getting published as a way to get more business and increase the wow factor associated with your work. So what is the best way to get your work published, and what are the benefits? Read on.

Getting published is a tremendous accomplishment for many photographers. However, getting your work published is not necessarily the *big break* that will catapult your business to instant success. For many people, once they get published, they post it on Facebook, maybe send out an email to friends, and that's the end of it. The benefits of getting published don't come automatically; use the publication as a tool to get more publicity and status. This marketing strategy is particularly effective for wedding and fashion photographers. Other niches may not benefit from this strategy.

Getting published can offer the following:

- Greater exposure to more brides/clients
- Exposure to wedding industry vendors
- Higher perceived value from brides and industry vendors

Getting published regularly is an important part of my marketing strategy as a wedding photographer (not recommended for portrait photographers). If you are interested in learning more about this strategy, look for my book *Get Published: A Guide for Wedding Photographers* available at photomint.com.

- More benefits than paying for expensive ads, which may offer little return if not used as part of a full-scale marketing campaign

- More desirability to a high-end bride wanting her wedding published

- Credibility within the industry and among your peers

- Opportunities to promote and publicize your published images

- A more reputable studio in the eyes of key players in your industry

## Make Publicity Work for You

Here are ways to add longevity to your publicity or editorial coverage:

- *Blog.* Spread the news by creating a blog post about it. Remember to credit all the vendors or other people involved in the shoot for making it happen.

- *Social media updates.* Use Facebook, Twitter, and Pinterest to spread the news. Add links and mentions to your blog, Facebook, Twitter, and Pinterest.

- *Scan it.* Create a digital copy of the article, which allows you to place a copy on your blog, and you can offer the digital copies to each vendor for their publicity materials.

- *Email the news.* Instead of sending a link directly to the news, send the link to your blog post since it drives traffic to your site. Make sure you email the blog post to the subject of the photos, encouraging them to share it.

- *Purchase copies of the publication.* Purchase copies to mail to the client, venue, and any other key players.

- *Use tear sheets.* Have tear sheets as part of your consultation package. Clients are impressed when they see your work in print.

- *Newsletter.* If you send out a newsletter, make sure to mention or even send out a special edition dedicated to the great news.

- *Impress new vendors.* When talking with new vendors you want to work with let them know your work is getting published, and if they partner with you chances are greater that they will get published as well.

- *Frame the piece.* Framing the piece and hanging it in your office or studio lets clients to see it without you having to point it out.

- Relationship building with people who can give you more business

- Self-satisfaction and personal achievement

Here are things to do to greatly increase your odds of getting published:

- Buy (and study) the magazines and periodicals you want to be published in.

- Make editorial submissions a regular part of your marketing. By following a process and submitting quarterly, we have been featured in over 70 publications plus many more wedding blogs in just the past 4 years.

- For wedding and event photography, the detail photos are *key* to getting published, so allow plenty of time to capture details.

- Submit to smaller, local publications and trade publications to build up a portfolio and tear sheet collection.

- Use social media to follow magazines. Often being Facebook friends with editors and others in the magazine business or following them on Twitter will allow you to jump on last-minute requests.

- Submit frequently. You will get rejected, especially when starting out—but if you don't submit, you will never get published.

- Follow submission guidelines carefully.

## Client Testimonials

The feedback you get from your clients is important for your business. You need to know if you are doing a great job, or if you are not meeting clients' expectations. More importantly, however, testimonials are a great way to build your credibility and reputation. Here are some ways you can use client testimonials to your advantage:

- Place a great quote on the homepage of your website. Pairing it with an image from the client is even stronger.

- Put together a collection of great testimonials to use as a handout for client meetings.

- Put a testimonial on your pricing page to help customers feel confident about working with you.

- Place quotes directly on images to share on Facebook and Pinterest.

- Put testimonials (and images) on a dedicated page on your website, so customers can scroll through all of them if they want to.

You can find testimonials in emails, blog comments, Facebook page comments, and even given to you verbally.

We've covered a number of different marketing strategies in this chapter, but there's no way of knowing which strategies will be most effective for you. It's a combination of many factors, including your niche, target market, location, personality, price point, and ability to implement strategies to their fullest.

CHRIS & I
# LOVED
EVERYTHING ABOUT
## WORKING
## WITH YOU

Chris & I loved everything about working with you! You always made us feel comfortable and your photography is absolutely amazing, we'll be recommending you to all our friends and family!

CARRIE & CHRIS 2006

EMAIL   INFO   SLIDESHOW   PRINT          32/32

HOME        KELVIN        LARA        GEOFF        HIGHLIGHTS        INFO        PROOFING        BLOG        CONTACT

**Industry Insiders:**
# Jamie Swanson on Email Marketing for Portrait Photographers

Jamie Swanson is a wedding and portrait photographer based in Wisconsin. She's most known for her photography business education site, The Modern Tog (themoderntog.com). She publishes a wealth of free information for photographers, including a free guide to getting more clients titled, "5 Common Mistakes That Lose You Business."

I was thrilled to talk with Jamie about her favorite marketing tool for portrait photographers—email marketing.

## Favorite Marketing Strategy for Portrait Photographers

The #1 most underutilized marketing tool for portrait photographers is email marketing, according to Jamie. Email marketing is collecting emails from your clients and potential clients in order to build an email list and market directly to the list.

With Facebook or even your website, you cannot control who sees your posts or when. With email marketing, however, you are in control of when your messages go out and who will see them. Messages go to people who *want* to receive them. When a client gives you their email, they are indicating that they trust you and want to know when upcoming family sessions need to be scheduled for their holiday cards.

Email marketing for beginners might be sending information about upcoming specials and promotions to clients. For example, if you are promoting a mini session, emailing your client list to let them know about the opportunity is a great way to fill your slots. Another great example would be to let clients know about scheduling their holiday card sessions in the fall, when they might not think to book sessions that early.

There is so much more you can do with email marketing, and that's where Jamie's methods are so effective for marketing. With sophisticated email services like AWeber, you can set up a sequence of automated emails that are delivered according to a schedule you determine. You write the emails and set up the sequence once, and then each time a client signs up for your list, they automatically begin receiving personalized emails in a timely sequence.

## Email Marketing in Action

Let's say you have a mom come in for a newborn session. Before the session is over, you can invite her to sign up for your mailing list to get special promotions, reminders, and so forth. Your sequence could be set to send emails throughout the year, reminding her to book milestone portrait sessions.

# THE MODERN TOG

Home · About · How to Price Photography · Freebies · Must-Have Tools · Categories · Info

## The Ultimate Pinterest Guide For Photographers

by Jamie M Swanson on 01/26/2012

Pin it

[Pinterest](#) is about to take the world by storm.

There's been a lot of buzz about Pinterest in the last few weeks, so I thought it was time to share with you everything you need to know about Pinterest as a photographer.

I've been studying it fairly intensely for the last few months, and I think it's only going to get bigger and more important to helping you market your business.

### Here's what you'll learn about Pinterest:

What is Pinterest?
Why should you care about Pinterest?
Pinterest Etiquette
Strategies for Using Pinterest
Pinterest Tips
Resources for Photographers on Pinterest

So let's get started!

## What is Pinterest?

Pinterest is basically a visual bookmarking site that has a strong social component built into it, making it easy for things to go viral.

Pinterest currently gets about 6 million monthly users and has millions of hits per week, and it's only going to grow from there.

Pinterest accounts are obtained by invitation only. If you need one, [leave a comment on our Facebook page](#) and we'll make sure you get hooked up.

Once you've got a Pinterest account, you'll be able to create boards on which you "pin" things. You can pin images and YouTube videos from around the web on your various boards. Here's what my boards page looks like (click for a larger view):

### The Ultimate
## Pinterest
### Guide For
## Photographers

by
TheModernTog.com

### Follow The Modern Tog

FOLLOW ME ON Pinterest

Imagine your newborn clients automatically receiving a series of emails:

- *3 months:* Hey Jane, it's been 3 months since Miranda's newborn session…
- *6 months:* Hi Jane, It's a great time to schedule another session for Miranda and capture her at this fun stage…
- *12 months:* It's time to schedule a cake smash session for Miranda…

The beauty of this system is that you don't have to remember to send the emails out, they will be sent automatically, at the right time, for every client who has signed up for your list.

## "You don't have to keep reminders on a calendar to remember when to send out emails; you set up the sequence once and new clients automatically get reminders to hire you for sessions."

### Sell the Experience

Jamie recommends that emails be thoughtfully written with your customer in mind. Sell the experience, not the session. What does she mean by that? Instead of just saying, "Hey, it's time to come in for your 6-month baby session." You might instead start with "Didn't this year go by fast? Take some time to capture those memories now."

## "It's a beautiful way to do client management, because once they sign up for that email list, they always get the next email at the correct time."

She says clients don't care about your recent ski trip or details of your life, so focus instead on their lives and the value of capturing moments of their family while they can, as time passes so quickly. Highlight the benefits to the client instead of just getting straight to the offer. It's a way of showing clients you care about them, not just your bottom line.

## Suggested Uses

Wondering how you might use this marketing strategy in your business? Here are a few ideas Jamie recommends to get started:

- Maternity and newborn sessions
- Senior portraits
- Halloween costume mini sessions
- Easter bunny sessions
- Family fall sessions
- Valentine's Day boudoir sessions
- Birthdays
- Anniversaries

## Getting Set Up

Jamie recommends AWeber or Mail Chimp over services such as Constant Contact or MadMimi, which are more geared toward consumers. With AWeber and Mail Chimp, you can schedule emails to go out in a certain sequence, called auto responders. What that means is that you can write out each sequence of emails, such as newborn email sequence, and family and kids email sequence.

Your clients and blog readers choose to join the list and can unsubscribe at any time. It's important to make sure people know what they are signing up for and choose to receive emails; otherwise, it might be considered spam.

You can create targeted lists by asking clients to check off which category applies when they first sign up, so that newborn clients are not getting the senior session emails, for example. You can also send out emails to your entire list if you have an upcoming promotion that would appeal to everyone, such as fall family sessions for holiday cards.

## Start Small

You don't need a huge list. Start with your current clients, even 20 people can be enough to start marketing to. You can have a general list of people interested in your services, and a separate list of clients. Let's say your goal is to get 40 sessions each year. If you email 40 current clients and can get 10 of them to come back for another session, then you only need to book 30 more sessions that year. Over time, your list builds up and you'll need to market to fewer and fewer new clients as you are able to fill your calendar with sessions from repeat clients. ■■■

# Photography Business Secrets

# Index